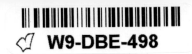
Daubigny, Monet, Van Gogh

Impressions of Landscape

Daubigny
Monet
Van Gogh

Impressions
of Landscape

TAFT MUSEUM OF ART

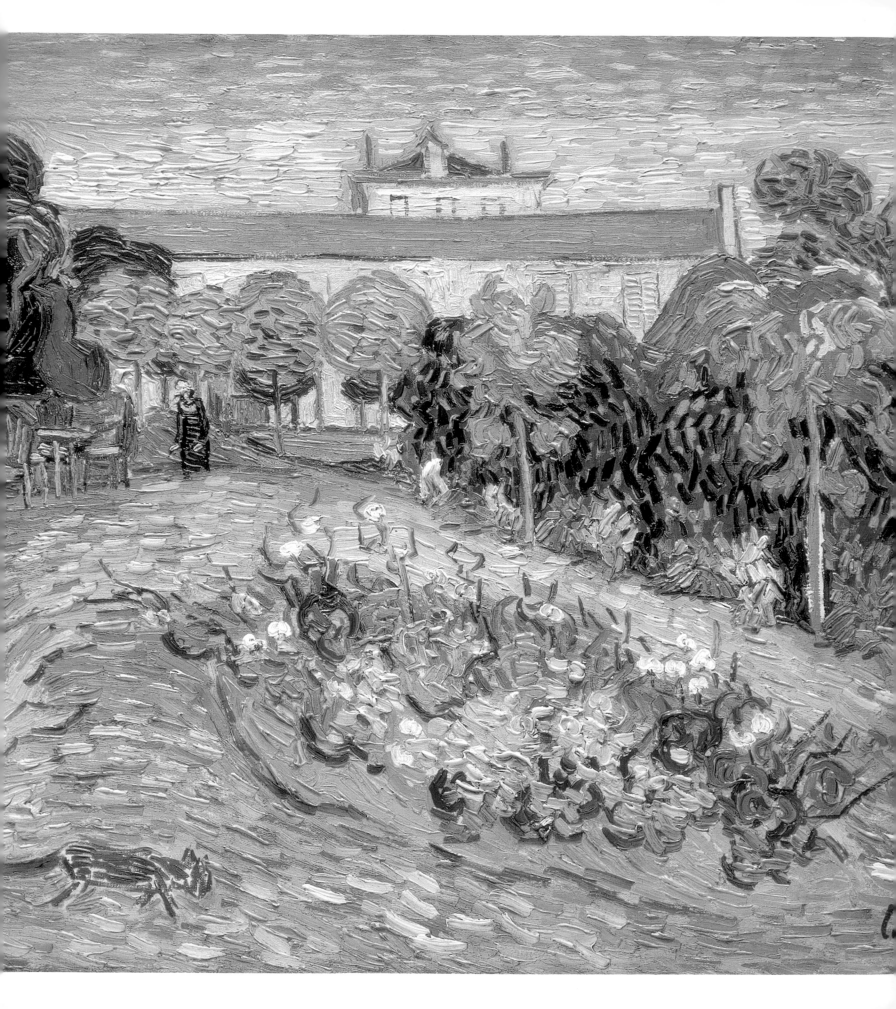

Contents

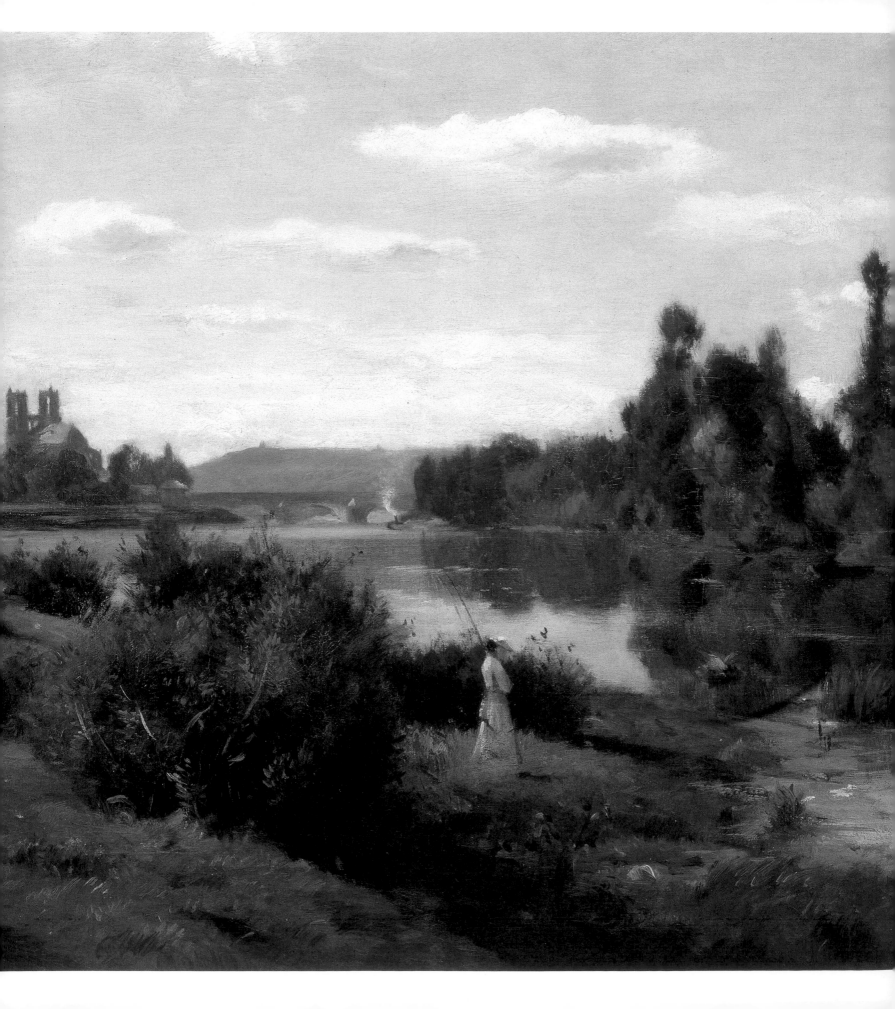

Foreword

This exhibition and its accompanying book are devoted to the achievements of the distinguished French landscape artist Charles François Daubigny (1817–1878). His practice of painting sketch-like landscapes in the open air anticipated the work of Monet and the Impressionists, while his house and studio at Auvers-sur-Oise became a pilgrimage site for numerous followers and admirers, not least Vincent van Gogh.

This long overdue exhibition is the result of a fruitful and rewarding partnership between three museums in the United States, Scotland and the Netherlands. We would like to extend our thanks to the curators, each of whom has contributed to the catalogue, and especially to Lynne Ambrosini, whose extensive research on Daubigny forms the basis of the current exhibition. We also gratefully acknowledge all the hard work put into the realisation of such an ambitious project by our colleagues at the Taft Museum of Art, the National Galleries of Scotland and the Van Gogh Museum.

The exhibition could not have taken place without very generous loans from many public and private collections. We offer our heartfelt thanks to all those who have lent us their works. For an exhibition of this kind financial support is of crucial importance and we are immensely grateful to the generous sponsors of the exhibition at each venue. ∎

Deborah Emont Scott
Director/CEO, Taft Museum of Art, Cincinnati

Sir John Leighton
Director-General, National Galleries of Scotland, Edinburgh

Michael Clarke
Director, Scottish National Gallery, Edinburgh

Axel Rüger
Director, Van Gogh Museum, Amsterdam and The Mesdag Collection, The Hague

DETAIL fig. 8
CHARLES FRANÇOIS DAUBIGNY
The River Seine at Mantes, c. 1856

Major Sponsors

The Taft Museum of Art gratefully acknowledges Mr and Mrs Randolph L. Wadsworth Jr for their significant support for the publication of this exhibition catalogue and for Lynne Ambrosini's scholarly research.

The exhibition has been generously funded by the following major sponsors: National Endowment for the Arts; The Carol Ann and Ralph V. Haile, Jr U.S. Bank Foundation; CFM International; The Thomas J. Emery Memorial; Stillson Foundation, Fifth Third Bank, Trustee; Fifth Third Bank; Whitney and Phillip Long; Debbie and Rich Oliver; The Daniel and Susan Pfau Foundation; and the William S. Rowe Foundation.

This exhibition is supported by an indemnity from the Federal Council on the Arts and the Humanities. Additional exhibition support is kindly provided by the Ellen and George Rieveschl Endowment, the Warrington Exhibition Endowment, and the Chellgren Family Endowment.

The Taft Museum of Art expresses gratitude for the operating support provided by ArtsWave and the Ohio Arts Council. ■

CLAUDE MONET
Sunset, 1880
Oil on canvas, 50 x 61.5 cm
Private collection

Acknowledgements

The exhibition organisers owe an enormous debt of gratitude to the lenders to the exhibition. Among them, we heartily thank the directors, curators, registrars and staff of the lending museums, which are listed opposite. We also wish to thank our generous private lenders The Phillips Family Collection, The Rudolf Staechelin Collection, the Vincent van Gogh Foundation, Sallie R. Wadsworth, and others who wish to remain anonymous.

At the Taft Museum of Art, we thank our accomplished colleagues at the Scottish National Gallery and the Van Gogh Museum for their enriching contributions to the exhibition and catalogue.

For their scholarly assistance and stimulating dialogue on Daubigny, I thank very warmly Anne and the late Daniel Raskin-Daubigny, Sir Jack Baer, Richard Brettell, Hans-Peter Bühler, France Daguet, Christophe Duvivier, Madeleine Fidell-Beaufort, Anne and the late Robert Hellebranth, Robert Herbert, Simon Kelly, Michael Marlais, Thomas Millette and Alexandra Murphy.

For assistance with research, I am grateful to Paul-Louis Durand-Ruel and Flavie Durand-Ruel of the Archives Durand-Ruel; Michèle Dupuis-Bogo, Archives des Musées Nationaux, Paris; and Dominique Lobstein, formerly of the Musée d'Orsay. Kind assistance was provided by the staffs of the Fondation Custodia, Paris; Documentation, Musée d'Orsay; Documentation and Département des Arts Graphiques, Musćc du Louvrc, Paris; thc Institut National d'Histoire de l'Art, Paris; the Getty Research Institute, Los Angeles; and the Frick Art Reference Library, New York.

Among the individuals who have aided with the preparation of this exhibition, I thank: Scott Allan, Dita Amory, Julie Aronson, Rich Aste, Frederick Bancroft, Sophie Barthélémy, Esther Bell, Séverine Berger, Claire Bernardi, Ken Bloom, Susan Bodo, Stephen Bonadies, David Brenneman, Jo Briggs, Anne Cappel, Thomas Colville, Sybil and John Eakin, Sarah Faunce, Gloria Groom, Vivien Hamilton, Jefferson Harrison, Sarah Herring, James Horns, Rosamond Hurrell, Larry Kanter, George Keyes, Ellen W. Lee, Louise Lippincott, Rebecca J. Long, David Marquis, Mary Morton, Linda Muehlig, Lawrence W. Nichols, Patrick Noon, Nancy Norwood, Véronique Notin, Stéphane Paccoud, Sylvie Patry, Jacques Pelpel, Isolde Pludermacher, Chris Riopelle, Joseph Rishel, Salvador Salort-Pons, Polly Sartori, Jane Satkowski, Lisa Schiller, George Shackelford, Kristin Spangenberg, Susan Stein, John Stomberg, Hans Vogels, Robert T. Wallace, Anthony Walsh, Wendy Watson, Fronia Wissman and Amanda Zehnder, with apologies to anyone inadvertently omitted.

For the small staff of the Taft Museum of Art, this was an ambitious and challenging project that set a new institutional bar. Deborah Emont Scott and the entire staff express deep gratitude to the Board of Directors of the Taft from 2005 to 2015 for their unflinching and generous support. They took a collective leap of faith and committed personal resources, making the project a reality.

Further, the Taft could never have undertaken the present exhibition and its accompanying catalogue without the unprecedented generosity of its funders. With profound gratitude, we thankfully acknowledge the munificent support of these individuals, foundations, corporations and agencies:

Mr and Mrs Randolph L. Wadsworth Jr
National Endowment for the Arts
The Carol Ann and Ralph V. Haile, Jr US Bank Foundation
CFM International
The Thomas J. Emery Memorial
Stillson Foundation, Fifth Third Bank, Trustee
Fifth Third Bank
Whitney and Phillip Long
Debbie and Rich Oliver
The Daniel and Susan Pfau Foundation
William S. Rowe Foundation

Exhibition support is generously provided by the Ellen and George Rieveschl Endowment, the Warrington Exhibition Endowment and the Chellgren Family Endowment.

This exhibition is supported by an indemnity from the Federal Council on the Arts and the Humanities.

We also thank the following for their generous financial support: Selz Foundation, Rosemary and Frank Bloom, Shannon and Lee Carter, Robert Contin, Linda and Harry Fath, Tim Goldsmith and Mindy Hastie, Lynne Meyers Gordon, Kate and Gerry Greene, Debbie and Bruce Long, Ellen Rieveschl; Betsy and Paul Sittenfield; Susan and Steve Black, Deborah and Paul Chellgren, Debra and David Hausrath, Kristin and Carl Kalnow, Robert Lehman Foundation, Inc., Susan and John Tew, Jane and Jon Votel, John Gunnison-Wiseman; Sylvia and Arnold Ambrosini, Certain Teed Gypsum, Docents of the Taft Museum of Art, Gerald T. and Ann Silvers; Thomas Colville, Barbara and Dr Kenneth Kreines, Schiller and Bodo European Paintings, Lynne and Steve Vollmer; Ann and Stephen Bjornson, Libby and Kevin Ott; Dr Diane Babcock, Diane and Bill Carney, Wm. Joel McCray, Andy and Deborah Emont Scott, Sotheby's, Carolyn and Lowell McCoy, Amy and Scot Perlman, Lynne Ambrosini and several supporters who wish to remain anonymous. Additional support came from numerous generous friends of the Taft.

One of the joys of this enterprise has been working with the Taft Museum of Art's talented staff, *all* of whom contributed in essential ways to its completion. I thank especially Katie G. Benedict, Timothy Brown, Emma Caro, Joan Hendricks, Cynthia Kearns, Tamera L. Muente, Lisa Morrisette, Lindsey Riehl, Mark Rohling and Beth K. Siler. I appreciate more than I can say the visionary support of the Taft's executive director, Deborah Emont Scott, and also thank former staff members who contributed to the project: the late David T. Johnson, Mary Ladrick, Phillip C. Long, Natalie Mathis, Christine Miller, Cate O'Hara, Kristi Reed, Abby Schwartz and Maggie Sears.

Finally, I am deeply grateful to my immediate family – surnamed Ambrosini, Contin and Stroshane – for their patience and loyalty during the long gestation of this project. ∎

Lynne Ambrosini
Director of Collections and Exhibitions
Taft Museum of Art

List of Lenders

AUSTRIA
Österreichische Galerie Belvedere, Vienna

CANADA
The Montreal Museum of Fine Arts

FRANCE
Musée des Beaux-Arts, Bordeaux
Musée des Beaux-Arts, Dijon
Musée des Beaux-Arts, Lyon
Musée d'Orsay, Paris
Musée du Louvre, Paris
Petit Palais, musée des Beaux-Arts de la Ville de Paris

HUNGARY
Museum of Fine Arts, Budapest

NETHERLANDS
Gemeentemuseum, The Hague
Kröller-Müller Museum, Otterlo
The Mesdag Collection, The Hague
Museum Boijmans Van Beuningen, Rotterdam
Museum de Fundatie, Zwolle and Heino / Wijhe
Museum Gouda
Rijksmuseum, Amsterdam
Van Gogh Museum, Amsterdam
Van Gogh Museum (Vincent van Gogh Foundation),
 Amsterdam

SWITZERLAND
Collection Rudolf Staechelin, Basel
Fondation Beyeler, Riehen / Basel
Galerie Jacques de la Béraudière, Geneva
Musée d'art et d'histoire, Neuchâtel

UNITED KINGDOM
Ashmolean Museum of Art and Archaeology,
 University of Oxford
The Barber Institute of Fine Arts,
 University of Birmingham
The British Museum, London
Glasgow Museums

The National Gallery, London
Amgueddfa Cymru – National Museum Wales
Scottish National Gallery, Edinburgh
Tate, London

UNITED STATES
Albright-Knox Art Gallery, Buffalo
The Art Institute of Chicago
Brooklyn Museum, New York
Carnegie Museum of Art, Pittsburgh
Chrysler Museum of Art, Norfolk
Cincinnati Art Museum
Dallas Museum of Art
Detroit Institute of Arts
The Fine Arts Museums of San Francisco
High Museum of Art, Atlanta
Indianapolis Museum of Art
Herbert F. Johnson Museum of Art,
 Cornell University, Ithaca
Kimbell Art Museum, Fort Worth
Memorial Art Gallery of the University
 of Rochester, NY
The Metropolitan Museum of Art, New York
Minneapolis Institute of Art
Minnesota Marine Art Museum
Mount Holyoke College Art Museum,
 South Hadley, MA
National Gallery of Art, Washington DC
Jill Newhouse Gallery, New York
Philadelphia Museum of Art
The Phillips Family Collection
Saint Louis Art Museum
Smith College Museum of Art, Northampton
Taft Museum of Art, Cincinnati
Toledo Museum of Art
Tweed Museum of Art, University of Minnesota,
 Duluth
Sallie R. Wadsworth
The Walters Art Museum, Baltimore
Yale University Art Gallery, New Haven

Preface

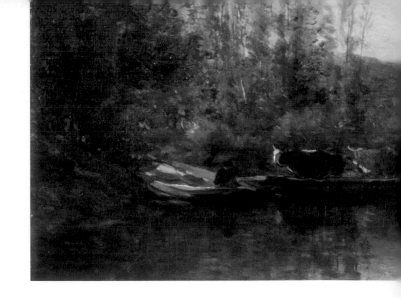

Charles François Daubigny was one of the most important French painters of the nineteenth century. From relatively humble beginnings, he rose over the course of a long and increasingly successful career to a position of eminence in the critical canon and achieved considerable commercial success. His landscapes, inspired in particular by the rural and river scenery of France, came to be widely discussed and admired when they were exhibited at the annual Salons, and his work was popular with collectors both in France and abroad. Together with other artists of his time, such as Camille Corot, Théodore Rousseau and Jean-François Millet, he helped to redefine French landscape painting and lead it towards a naturalism that replaced the hitherto dominant strain of neoclassicism, which had held sway since the late eighteenth century.[1] In his direct approach to nature and in his practice of painting in the open air Daubigny anticipated the art of his younger contemporaries, the Impressionists, a number of whom he supported and befriended early in their careers.

Today many of his major works can be found in the collections of the world's great museums and they have been included in exhibitions of recent decades dedicated to themes such as Impressionism and its origins.[2] Yet to the general public Daubigny remains relatively unknown. This is despite the prolific nature of his production, for like his great friend Corot he catered for the dealer-led Parisian market that satisfied the bourgeois taste for landscape paintings from mid-century onwards. But he fell victim to the dominant preference for Impressionism that gathered momentum from the late nineteenth century onwards among critics and collectors alike. Artists whose careers had coincided with those of the Impressionists came to be overlooked even if, as was the case with Daubigny, their work was closely studied by these younger painters and palpably influenced them. In order to redress this imbalance we have created this exhibition, which aims to do justice both to Daubigny's own great achievements as a landscape painter and to his influence on the next generation of artists. As a member of the Salon jury, he supported the budding Impressionists and in 1870 he introduced Claude Monet and Camille Pissarro to the influential art dealer Paul Durand-Ruel. In the 1860s and early 1870s Monet, Pissarro, Alfred Sisley and Berthe Morisot fruitfully exploited Daubigny's innovations: his new compositions such as riverbank views and flowering orchards, his invention of the studio boat, his emphasis on *plein-air* painting, and his preservation of sketchy effects even in finished pictures. No exhibition has previously illuminated the younger artists' debt to him or, reciprocally, their effects on his late style.

Three museums with fine collections of French nineteenth-century landscapes and superb examples by Daubigny have come together to trace his story in the context of the Impressionist movement. The Taft Museum of Art in Cincinnati holds three paintings by Daubigny along with many by his French contemporaries, who were beloved by American Gilded Age collectors such as Charles and Anna Sinton Taft. The Van Gogh Museum and its sister museum in The Hague, The Mesdag Collection, own twenty pictures by Daubigny from the collection formed by the Dutch painter, collector and banker Hendrik Willem Mesdag in the late nineteenth century. The Scottish National Gallery has five pictures by Daubigny, testament to the legacy of pioneering Scottish collectors who appreciated progressive

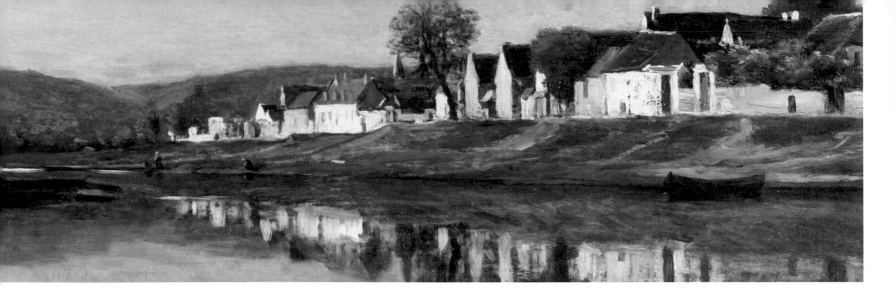

French art before it was widely accepted in the rest of the United Kingdom. As the curators of this exhibition came together to consider how to tell the story of Daubigny's importance, they realised that they could not do the subject justice without also telling two further, interlocking tales: the fascinating chronicle of his contacts and connections with the Impressionists, and the little-known account of Daubigny as touchstone and inspiration for Vincent van Gogh.

The texts in this book examine many different aspects of Daubigny's achievement and influence. The first essay summarises Daubigny's career, highlighting some of the major pictures he submitted to the Salon, and investigates the cultural context and contemporary responses to his pictures. Subsequent essays examine the interactions between Daubigny and the young Impressionists; Daubigny's and Monet's respective use of studio boats to paint their river views; the market for his paintings in an era that increasingly favoured landscape; the formation of an artists' colony in Auvers-sur-Oise, Daubigny's seasonal home after 1860; and the evolution of Daubigny's highly original technical processes. When Van Gogh, the subject of another essay in this book, arrived in Auvers in 1890 he had already referred with admiration in his correspondence to Daubigny's work. During his last few months in Auvers (where he was to die on 29 July) he adopted a distinctive canvas format strongly associated with Daubigny and, as an act of homage, painted several pictures of Daubigny's house and garden.

Had Daubigny never been born, not only would his own compelling work not have existed, but the history and creations of Impressionism, and very likely the pictures of Van Gogh, would also have manifested themselves in altered forms. In the end, Daubigny's impact was both richly nuanced and historically critical. In his inventive subjects, pioneering techniques and innovative attitudes toward the pictorial process, he ushered in new avenues for artistic exploration. Monet and Van Gogh, his greatest inheritors, would travel these paths audaciously. ∎

Lynne Ambrosini

DETAIL fig. 12
CHARLES FRANÇOIS DAUBIGNY
The Village of Gloton, 1857

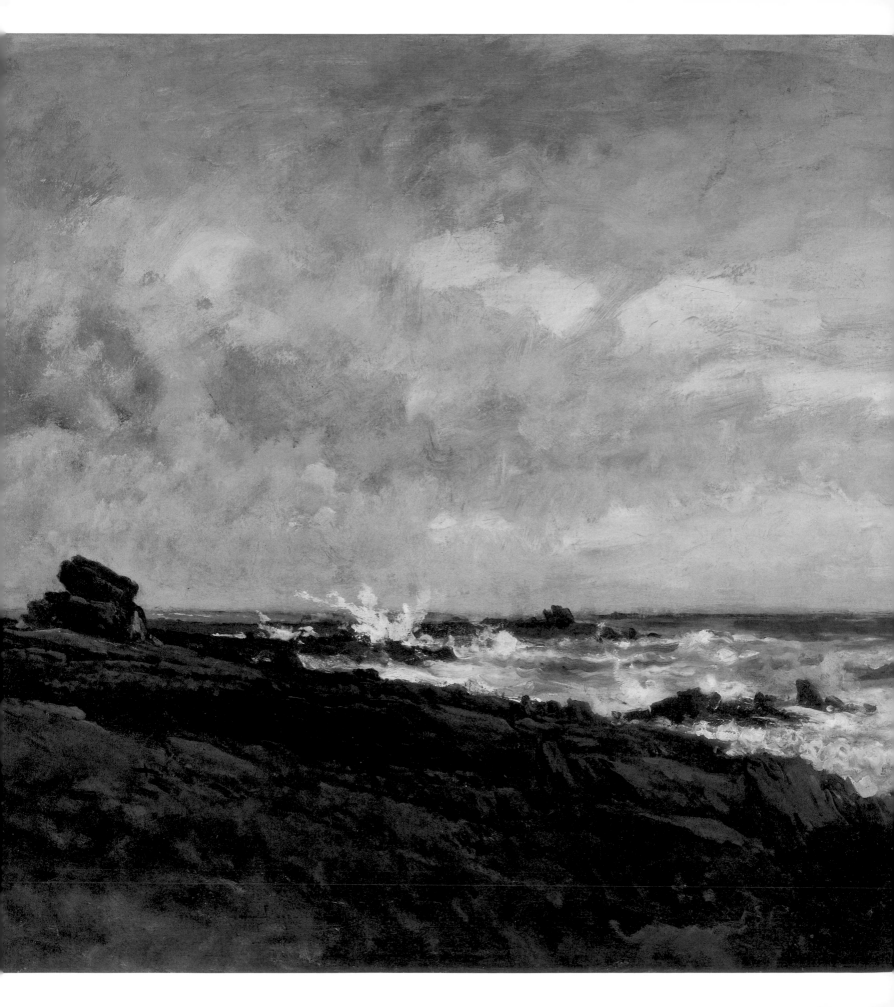

'Leader of the School of the Impression' Daubigny and his Legacy

Lynne Ambrosini

Charles François Daubigny (b. 1817) died in February 1878, about a year after his friend and contemporary Gustave Courbet (1819–1877).[1] That spring the republican politician and progressive critic Jules-Antoine Castagnary saluted the two artists, who 'shared first place in our universal admiration'. 'They were the last of the heroic generation. Since they have gone to rejoin Rousseau, Millet and Corot, landscape painting resembles an army that has lost its commanders. The great leaders no longer exist.'[2]

Castagnary places Daubigny in his rightful position as a pioneer along with other, now better-known artists. Generally remembered today only by specialists, Daubigny is arguably the most neglected nineteenth-century French pictorial innovator. In fact, in 1865, almost a decade before the famous group exhibition in 1874 that first elicited the label 'Impressionism', a journalist referred to the 'school of the impression and its leader, Monsieur Daubigny'. As will be shown, this was not an isolated comment.[3] Given his historical importance and the high quality of his best work, Daubigny deserves reconsideration.

This exhibition and catalogue re-examine Daubigny's contributions to French landscape painting, Impressionism and the art of Vincent van Gogh (1853–1890). The present essay offers a succinct summary of Daubigny's career and some relevant issues, including his early technique and practices; his intended content, based on surviving correspondence; contemporary responses to his pictures; and how his paintings were socially implicated.

Early Career and Recognition as a 'Realist': 1836–1856

After learning first from his father, Edme-François, a neoclassical landscapist, Daubigny studied with the history painter Pierre-Asthasie-Théodore Sentiès first in 1835 and again in 1837. In between, he spent a frugal year in Italy from February 1836 to November 1837, where he probably painted the study *Landscape in the Roman Campagna* (fig. 1) outdoors, in keeping with common academic practice. Its only truly distinctive quality, the wide horizontal format, would prove a life-long preference.[4] Returning to Paris in November 1837, Daubigny started exhibiting at the Paris Salons the following year. In 1840, he entered the atelier of Paul Delaroche (1797–1856). On track for a Rome prize, he made a careless error that eliminated him from the competition in 1841.

DETAIL fig. 21
CHARLES FRANÇOIS DAUBIGNY
Seascape, Saint-Guénolé,
Penmarc'h, Brittany, c. 1867

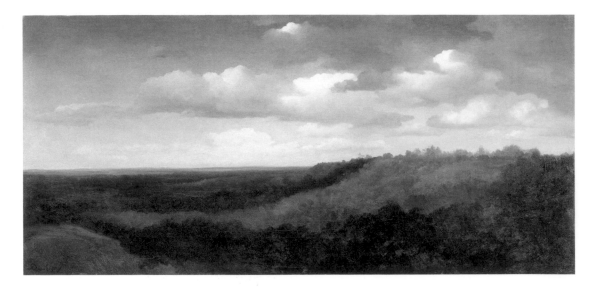

At that point, he renounced the academic path. Graphic work for books and magazines provided his livelihood during the next decade, while he continued to paint independently.[5]

In an unusual practice, Daubigny sometimes attempted to create exhibition canvases outdoors. In 1839, he tried to paint his Salon of 1840 picture, *Saint Jerome in the Desert* (Musée de Picardie, Amiens) from nature, working atop a mountain in the French Alps (Isère). A stiff wind thwarted this plan.[6] In 1843, he worked outside on another future Salon canvas, *The Crossroads of the Eagle's Nest, Forest of Fontainebleau* (fig. 2); it dates from his stay in Barbizon that autumn.[7] In a letter, Daubigny wrote of carrying this canvas and all his painting gear into the forest each day.[8] Completed in the studio later that winter, the picture displays a pronounced tonal structure of contrasting light and shadow, recalling his academic instruction, graphic practice and on-going study of Dutch seventeenth-century landscape painting.

Between 1849 and 1858, Daubigny made several trips to paint in the hills east of Lyon, above the Rhône valley, an area that inspired some twenty-five works.[9] The dramatic, ruin-crowned site in the Isère that appears in *Landscape near Crémieu* (fig. 3) first attracted Daubigny in November 1849.[10] In this picture, he created softer, more natural shadows than before and more effectively unified land and sky. In its composition, palette and touch, the painting recalls Camille Corot (1796–1875).[11] Indeed, Corot and Daubigny may have been working in Crémieu together in 1849; Daubigny reported later that Corot was bent on returning there in 1852.[12] Contrary to past assertions, then, the two artists' friendship probably dates from 1849 or earlier.[13]

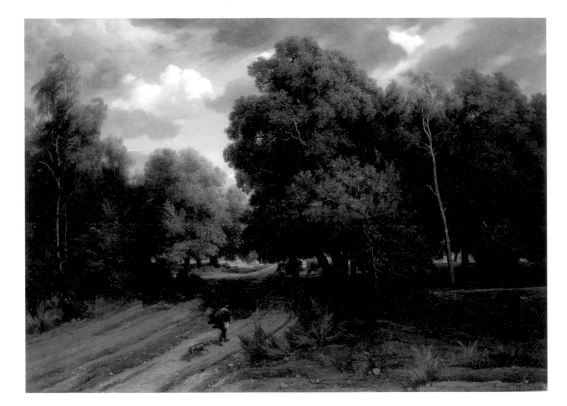

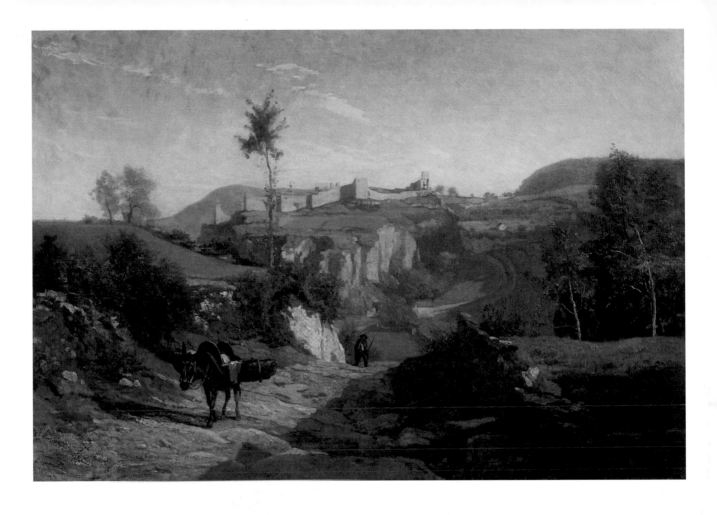

Daubigny achieved his first fame at the Salon of 1852 with *The Harvest* (figs 4 & 119).[14] Uncommon in the early nineteenth century, the theme harks back to traditional allegories of the seasons. Additionally, the childhood years that Daubigny spent in the village of Valmondois in the Oise valley endowed the French countryside with idyllic personal associations. In a letter written in 1852, he mentioned a desire to depict 'the active life of the countryside'.[15] Though categorised posthumously as a painter of rivers, Daubigny would render agricultural scenes throughout his career.

When composing the panoramic *Harvest*, Daubigny dispensed with classical framing elements. Perhaps he had looked at Dutch landscapes by the likes of Philips de Koninck (1619–1688). At least one oil sketch preceded the final picture, in which Daubigny ably evoked the diffuse light of summer shimmering through hazy humidity in central France.[16] The Goncourt brothers hailed the picture: 'No one has ever rendered the harvest better; wheat has never arrived on a canvas looking so bronzed, so crackling, so true, under the burnt atmosphere of the month of August; and Mr Daubigny's painting is a masterpiece.'[17]

Daubigny was adventurous in his handling and colour.[18] In *The Harvest*, he modelled the clouds and foreground path in pink and violet and indicated the distant fields with juxtaposed strokes of vivid turquoise, violet, blue-green and yellow (fig. 4), prefiguring Impressionism. Quite radically, he applied paint with a palette knife in the sky, the foreground and even at the horizon, breaking the rule that distant planes should be treated very delicately. The critics reacted: 'In Mr Daubigny's horizon, one sees only tones of rather garish blue and pink applied as if with a trowel.'[19] The conservative Maxime Du Camp sniped: 'The background is not finished and the front planes … are only sketched; with a few months of work, the thing could resemble a painting.'[20]

At the Salon of 1853, Daubigny's *The Pond at Gylieu* (fig. 5), another picture from the Isère, was acclaimed as a masterpiece. It sold to Emperor Napoleon III and earned Daubigny a first-class medal.[21]

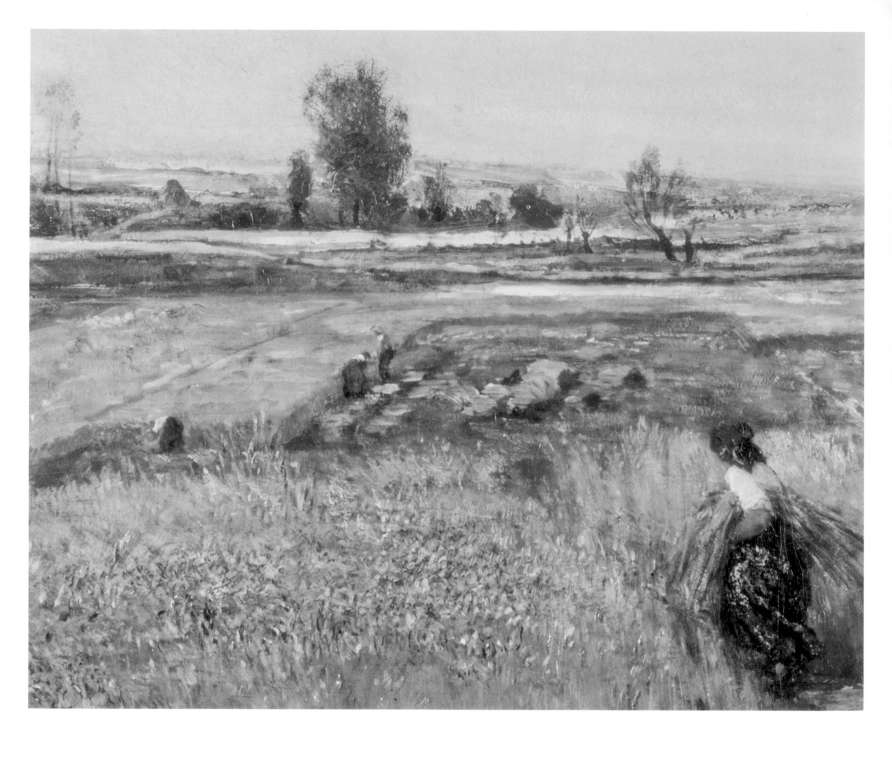

CHARLES FRANÇOIS DAUBIGNY
The Harvest, 1851
Detail of fig. 119

Clément de Ris marvelled: 'The clarity of the water, the limpidity and delicacy of the sky, the freshness of the air, are indescribable. This painting can be inhaled as well as looked at, and gives off some kind of aroma of wet leaves that ends up intoxicating you.'[22] The satirical cartoonist Bertall underscored Daubigny's verisimilitude (fig. 6). Holding a handkerchief, a visitor to the Salon exclaims: 'They are absolutely too humid, these paintings of Daubigny! I can't look at them without getting a head cold; it destroys your handkerchiefs.'[23]

His contemporaries thus read Daubigny's style as an arresting *réalisme*.[24] Théophile Gautier (1811–1872) even compared the painting to a daguerreotype in its 'exactitude' and 'living impression'. He added: 'Here art has completely disappeared to make way for nature – One would think this were a window open onto the countryside rather than a stretcher surrounded by a frame.'[25] Looking today, however, we see also the artifice of Daubigny's classically balanced composition and delicately stroked surfaces.

The label 'realism' sits even more easily on *The Water's Edge, Optevoz* (fig. 7), an Isère subject. It is autumn: the grasses bear seed heads and the foliage shows a characteristic colouration. The season and the weather emerge clearly from Daubigny's pictures, and some of his drawings also bear notations of the time of day.[26] Here, he abandoned the conventional

foreground, a strip of land, and projected the viewer immediately onto the brink of the still, secluded pond, a choice that anticipated his later river compositions. Moreover, the extraordinary specificity of the plants, rocks and water life depicted could only be the result of meticulous on-site observation. An ecologist has identified in the painting precise species of algae, sedge, reeds, bulrushes and other water plants, each shown in its own appropriate, pond-specific ecological zone, along with the 'grit and slime … of a small eutrophic pond'.[27]

The picture also exemplifies Daubigny's early process. He drew on the canvas, shaded the drawing with hatching and laid in preparatory earth colours before adding the later design layers.[28] Although *Water's Edge* is painted quite thinly, as is most of his early work, its brushwork involves a remarkable variety of sizes, directions and angles of strokes: flat patchy dabs for rocks, thin vertical slashes for grasses and tiny brush-tip dots for foliage. In the pond, colours are smudged and streaked to represent areas of reflection, while impastos scumbled over the surface mimic tendrils of aquatic plants.

Daubigny's rich range of colours enhanced specificity. The heads of the golden grasses glint with pale violet modelling touches; vivid turquoise defines the distant mountains. Above all, Daubigny's palette bore a wide range of blues, yellows and greens, some, like the recently invented viridian, applied directly.[29]

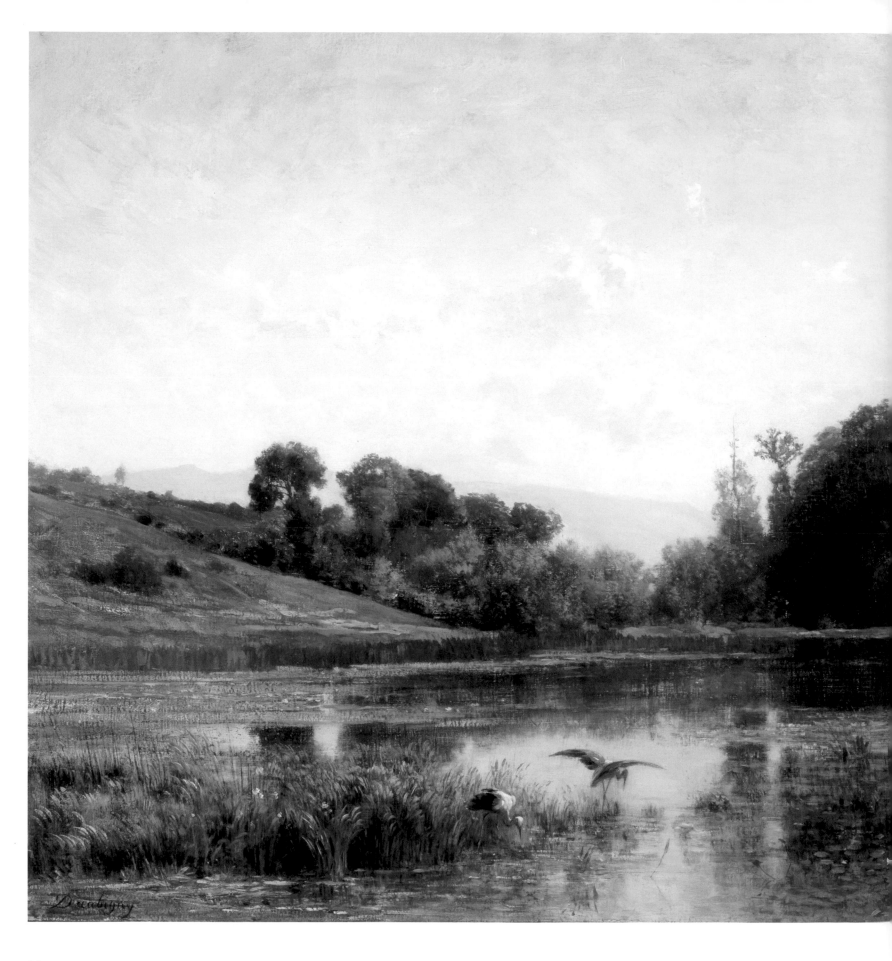

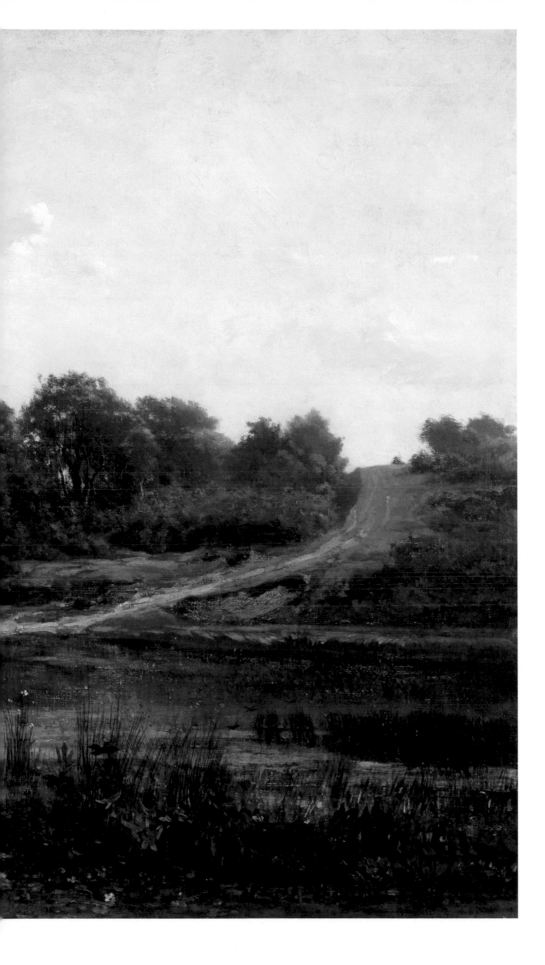

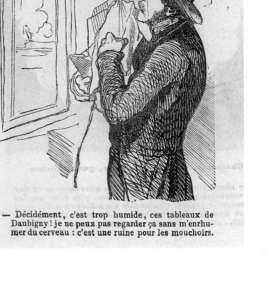

— Décidément, c'est trop humide, ces tableaux de Daubigny ! je ne peux pas regarder ça sans m'enrhumer du cerveau : c'est une ruine pour les mouchoirs.

5
CHARLES FRANÇOIS DAUBIGNY
The Pond at Gylieu, 1853
Oil on canvas, 62.2 × 99.7 cm
Cincinnati Art Museum, gift of Emilie L. Heine in memory of Mr and Mrs John Hauck, 1940.969

6
BERTALL (CHARLES-ALBERT D'ARNOUX)
'The Salon depicted and drawn by Bertall',
Le Journal pour rire, no. 95, 21 July 1853, p. 2
Bibliothèque nationale de France, Paris

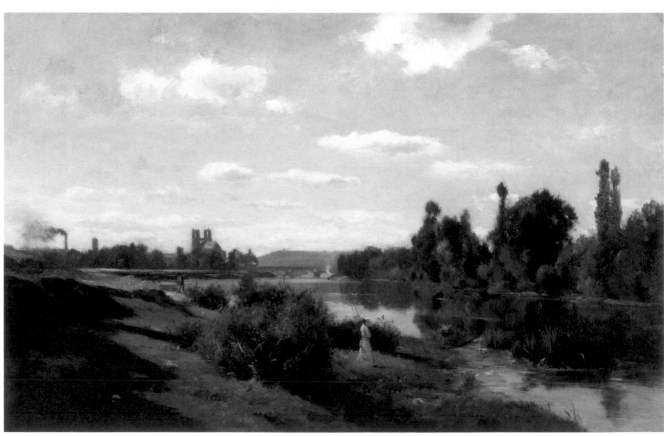

7

CHARLES FRANÇOIS DAUBIGNY
The Water's Edge, Optevoz, by 1856
Oil on canvas, 66.7 × 122.6 cm
Mount Holyoke College Art Museum, South Hadley,
Massachusetts, gift of anonymous donor in memory
of Mildred and Robert Warren, MH 1981.8

8

CHARLES FRANÇOIS DAUBIGNY
The River Seine at Mantes, c. 1856
Oil on canvas, 48.4 × 75.6 cm
Brooklyn Museum, New York, gift of Cornelia E.
and Jennie A. Donnellon, 33.271

9

CAMILLE PISSARRO
Banks of the Oise near Pontoise, 1873
Oil on canvas, 38.1 × 55.3 cm
Indianapolis Museum of Art, James E. Roberts
Fund, 40.252

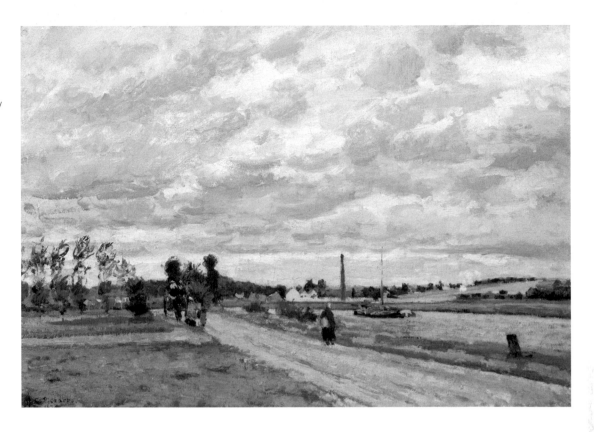

Conservators have singled Daubigny out for his exploratory use of new pigments.[30]

In June 1854, Daubigny discovered Villerville, a fishing village on the Normandy coast, having deliberately sought a relatively undiscovered, sparsely settled area.[31] His first experience of the sea elicited an ecstatic reaction: 'I see the ocean, and it is so beautiful that I don't want to go anywhere else, and I can't wait to work.'[32] In a double-square painting, *Villerville Seen from Le Ratier* of 1855 (fig. 75), he depicted a sweeping panorama of mussel banks at low tide. This is Daubigny's earliest known dated double-width canvas, which suggests that the challenge of painting the ocean strengthened his attraction to broad formats.[33]

In the 1850s, Daubigny also painted in the Ile de France. *The River Seine at Mantes* (fig. 8) represents the small city of Mantes seen from the south-east with the church of Notre Dame, the medieval tower of St Maclou and a factory chimney releasing black fumes in the distance.[34] On the river, a steam-powered boat issues a plume of smoke, while closer to us a middle-class woman carrying a fishing rod

approaches the river. Such contemporary details anticipate Impressionism. Daubigny's role as a precursor emerges clearly if we compare this painting to Camille Pissarro's (1830–1903) *Banks of the Oise near Pontoise* of 1873 (fig. 9), in which Pissarro adopted a similar perspective and, like Daubigny, optimistically integrated factories and barges within an agrarian landscape. Both attentively rendered the silvery reflected light of northern France.[35]

Daubigny had already represented industrial themes in his drawings: in 1844, he had contributed six drawings to an *Album-Revue de l'industrie parisienne* and had drawn factories, bridges and railways for other publications.[36] He saw industrialisation transforming northern France with the spread of the railways, dredging of rivers and digging of canals, as well as the construction of factories and urban expansion into former farmlands. The writer Frédéric Henriet (1826–1918), a friend of Daubigny's, expressed their shared anxiety: 'Every conquest of industry and material improvement essentially causes some sacrifice of the poetry of memories and the harmony of picturesque beauty.

… We would say to the followers of pure art … steep yourselves again and again in the life-giving contact with nature, the eternal source of truth, beauty, and power … where your inspiration will not bruise its wings against the factory chimney, the telegraph pole or the black stacks of the locomotive!'[37]

In his paintings of the 1850s, Daubigny included but distanced such urban elements, subordinating them to a scenic ensemble.[38] Hints of environmental awareness emerged in his letters then, too, and eventually he eliminated all signs of industry from his work.[39]

The Master of Realism: 1857–1863
At the 1857 Salon, Daubigny displayed the first of many pictures of blossoming orchards, *Spring* (fig. 73). On a diagonal path through flowering apple trees and fields of burgeoning grain, a young woman riding a donkey is followed by two young lovers, their heads barely visible. Gautier explained the picture's originality: 'Mr Daubigny has had this ingeniously simple idea that has never occurred to anyone else since painting began. … He is the first among all

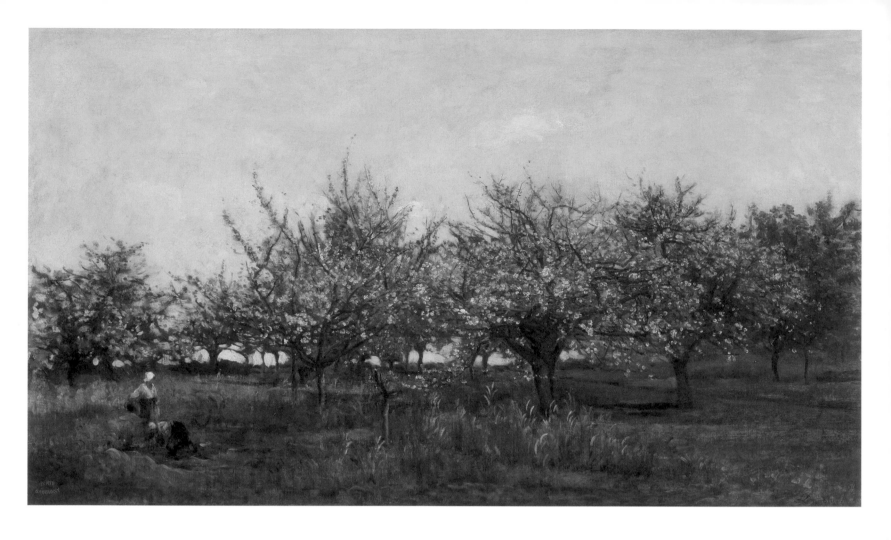

landscapists to notice that trees are covered with flowers in the spring … he has painted the little green leaves with pink and white flowers – voilà – it is called *Spring*, and it's a masterpiece. … This charming image has been around for some five or six thousand years by now and no one ever had the bright idea of bringing it to the city.'[40]

Castagnary found it 'an idyll of renewal in all its greenery and all its grace', while other reviewers praised Daubigny's realism; one called him the 'head of the Realist school'.[41] Daubigny's closest friend, the Parisian sculptor Adolphe-Victor Geoffroy-Dechaume (1816–1892), recalled: 'Well before the railways, around 1834 … we would go with our young friends several times a year on foot or by a coach to the charming village of Valmondois, where Daubigny had lived as a child with his wet nurse. … There were many, many fruit trees. … When all of that was in bloom, towards the month of June, and you and a friend took a walk in silence, we [sic] could listen

to the songs of the little birds, intoxicated by this harmony of the sweet fragrance of the haymaking, the flowering trees, our hopes, of everything in short – we were happy!!! We called this "getting re-energised". … Abundance seemed as if it would be eternal.'[42]

This passage eloquently voices the theme of Daubigny's orchard pictures, including *Spring*.

Implicit in these commentaries was a perceived duality between life in Paris – with its overcrowding, filth and vice – and the wholesome, restorative countryside. Nicholas Green has traced this dialectic in mid-nineteenth-century France.[43] The growing desire to immerse oneself in the natural world via day trips or vacations occurred in tandem with the surging popularity of landscape painting; both expressed the moneyed classes' visual consumption of nature. Daubigny participated in this phenomenon as both a producer of images and a city-dweller who sought his own release in experiencing nature. As he once said: 'Long live the countryside and nature

which serve as harmonic register for all good and beautiful things.'[44]

After the Salon, the French state purchased Daubigny's *Spring* and hung it in the Musée du Luxembourg where it remained on view for decades.[45] Claude Monet (1840–1926), Pissarro and Alfred Sisley (1839–1899) probably saw it and Daubigny's later orchard paintings at the Salons of 1859 and 1867–70.[46] They may also have noticed Daubigny's freely brushed studies of flowering trees at dealers' shops in the 1860s.[47] The lyrical *Apple Trees in Normandy* of about 1865–7 (fig. 10) affords an example of his increasingly colourful and vivacious spring scenes. Monet's *Apple Trees in Blossom* and Pissarro's *Orchard in Bloom, Louveciennes* (fig. 11), both of 1872, show them adopting Daubigny's subject.[48] Although Pissarro more candidly represented brown, freshly ploughed earth, he, like Daubigny, celebrated spring by planting his easel outdoors to capture the delicate colours of sky and blossoms.[49]

10
CHARLES FRANÇOIS DAUBIGNY
Apple Trees in Normandy, c. 1865–7
Oil on canvas, 56 × 97 cm
Calouste Gulbenkian Foundation, Lisbon

11
CAMILLE PISSARRO
Orchard in Bloom, Louveciennes, 1872
Oil on canvas, 45.1 × 54.9 cm
National Gallery of Art, Washington DC,
Ailsa Mellon Bruce Collection, 1970.17.51

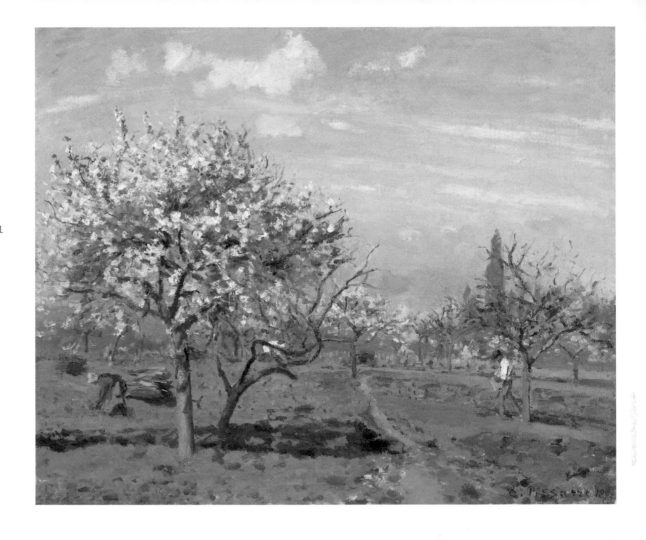

Commissioned by the minister of the interior, Daubigny's *Spring* brought him 3,000 francs, which must have seemed a small fortune.[50] He was now forty years old and had always struggled to make a living.[51] The large sum made possible an important purchase, a studio boat (the *Botin*), which would in turn enable another, equally influential series of paintings: his river views. That very autumn, in 1857, he launched his famous studio boat on the Seine, beginning a twenty-year practice of painting landscapes from mid-stream.[52]

An autumnal study dated 1857 of the village of Gloton on the Seine is one of the earliest known products of Daubigny's first river campaign (fig. 12).[53] It is likely that Daubigny painted the panel all at once, probably on his boat, using fresh, bright hues that were unusually vivid even for outdoor sketches at this time.[54] In the 1850s, the spontaneous manner of his *plein-air* work stood out clearly against the more deliberate studio execution of his Salon pictures.

One of Daubigny's great innovations – allowed by the floating atelier – was to replace terrestrial foregrounds with extensive passages of watery reflections. But without nearby land to set up perspective, how was he to create an illusion of recession? The 1857 panel shows his solution: gradually modulating colour and stroke to suggest distance. Writing that year, Henriet explained: 'Daubigny's daring … is to use his knowledge of the relative values of colours … in order to compensate for sacrificing the planes that are generally employed to conduct the eye of the viewer to a focal point.'[55] Graduating his tonal values and touch became paramount.

Perhaps proceeding by analogy, Daubigny created another novel compositional type while on the Normandy coast the following year. In *Sea with Overcast Sky* of 1858 (fig. 13) he eliminated the shoreline, suspending the viewer over the waves. He painted the blustery weather that he saw, rejecting

the picturesque, and rendered the sky with brisk, multidirectional jabs and the sea with rippling horizontal strokes. In subsequent years, he produced more of these frontal views of the sea composed only of sky and water.[56] Such seemingly unmediated encounters with the ocean set the stage for Courbet's equally elemental wave pictures, created in Normandy from 1865, particularly as the two artists were friendly during the intervening years.[57]

The painting that clinched Daubigny's reputation as a modern master was *Banks of the Oise* (fig. 54), a grand-scale canvas that was exhibited at the Salon of 1859. It depicted the Ile de Vaux, a small island in the River Oise, on a still day when reflections could play a large part in the picture's design.[58] The critic Emile Perrin announced, 'Among landscapists … Daubigny is now incontestably the best', while other writers classed him with Corot and Théodore Rousseau (1812–1867), calling them the three great forces in contemporary landscape.[59] Official

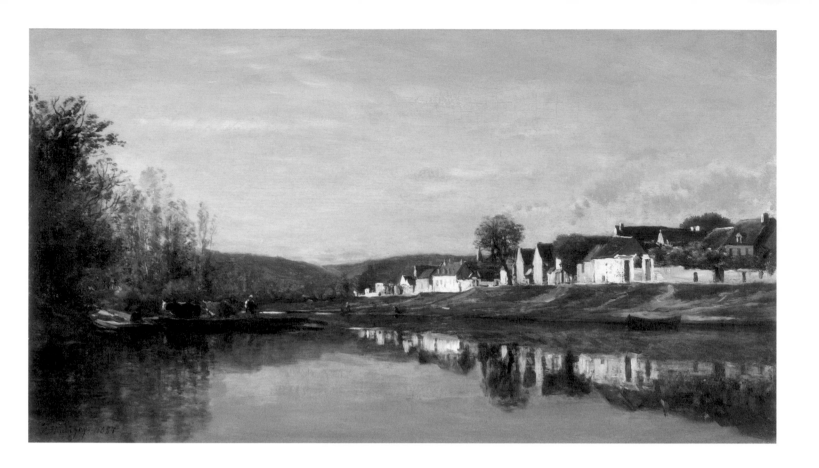

recognition soon followed in the form of a third gold medal and the Légion d'Honneur.

Some writers, like Daubigny's champion Castagnary, considered the painting a masterpiece of realism and objectivity.[60] Charles Perrier described Daubigny as 'the very model of the sincere realist; his paintings are the most literal translation of nature as it is, as the whole world sees it … his originality consists of fixing on canvas images that seem to have freed themselves from a mirror.'[61] Emile Zola later emphasised Daubigny's disinterested observation, too, saying that he 'had hastened the realist revolution': 'he painted what he saw, seeking no subjects beyond what reality offered him … Daubigny was a trailblazer, a master.'[62]

Surprisingly, however, others lauded the subjectivity of Daubigny's *Banks of the Oise*. Charles Baudelaire declared that Daubigny's landscapes 'immediately convey to the soul of the viewer the original feeling with which they are filled'.[63] Perrin agreed: 'He doesn't copy nature, he expresses it, and that with a feeling … which no other master can surpass.'[64] Indeed, a confusing dualism of objectivity/subjectivity

permeated discussions about 'realism', 'truth' and 'impressionism' in the nineteenth century and surfaced frequently in the early critical literature on Daubigny.[65] In 1859, only the perceptive Zacharie Astruc (1833–1907) encompassed this complexity, commenting that Daubigny was strong in both 'eyes' and 'heart': on the one hand, he had an objective eye, 'such a delicious naiveté – as simple as a child before his subject, neither adding nor subtracting anything'; on the other, he had a powerful 'feeling' and 'ardour' that made possible his 'remarkable individuality'.[66] Daubigny's early style represented a compromise between exactitude and interpretation.

In 1860, Daubigny's purchase of land and construction of a studio in Auvers-sur-Oise, a village close to Valmondois, marked a milestone.[67] Keen on painting 'rustic landscapes with figures', he chose an area characterised by small farms 'where the ploughs are not yet steam-powered'.[68] Following his earlier *Harvest*, Daubigny had been making outdoor studies of farmworkers labouring in the fields of the Vexin, an area often referred to as the breadbasket of France. This was the large fertile plain just over the ridge that

runs parallel to the Oise, north of Auvers. In 1856, Daubigny depicted Vexinois peasants, equipped with horse-drawn carts and traditional tools, building a haystack (fig. 14). He painted workers raking hay in 1858 and carting it in 1860.[69] Having been hired in 1860 to illustrate a new threshing machine, however, Daubigny was alert to the mechanised future.[70] In choosing Auvers, 'a village where one still sees thatched roofs', he (like Pissarro a decade later) knowingly embraced the old rural France.[71] Daubigny still lived in Paris, and this opposition mattered: like the city-dwellers who bought his pictures, he wanted 'in the middle of the artificial and walled-in life of the city, to go back to nature'.[72] Ironically, industrial agriculture reached the Vexin in Daubigny's lifetime, accelerating after 1873, although you would never guess it from his pictures of Auvers.[73]

Landscape along a Country Road (fig. 15) includes the medieval village church of Notre-Dame-de-l'Assomption d'Auvers, with its distinctive tall, square tower. Probably painted in the open air in the 1860s, this small oil panel captures a view towards the village from the north-east. The high stands of golden

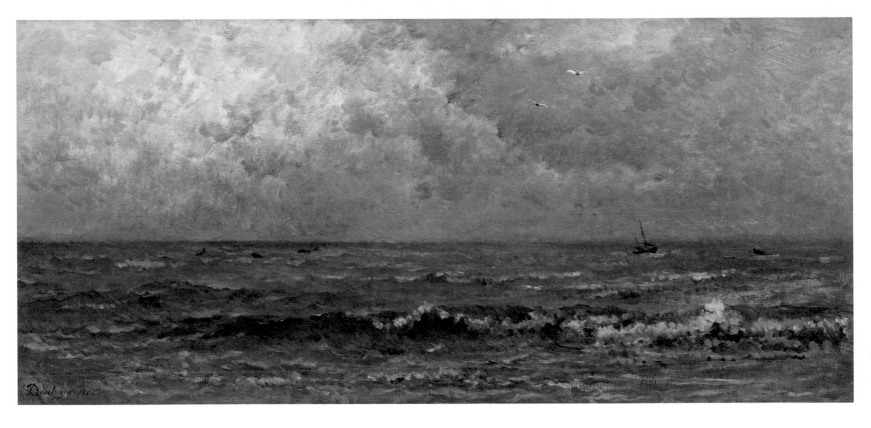

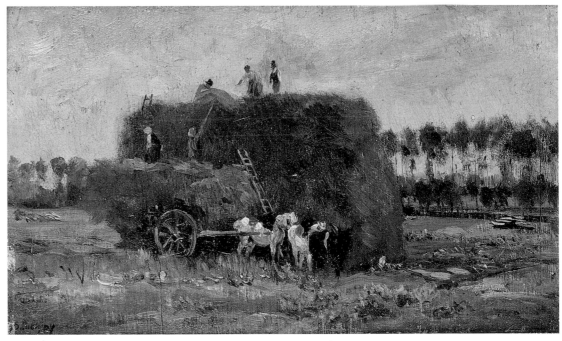

12

CHARLES FRANÇOIS DAUBIGNY
The Village of Gloton, 1857
Oil on panel, 29.8 × 53.7 cm
The Fine Arts Museums of San Francisco,
Mildred Anna Williams Collection, 1940.4

13

CHARLES FRANÇOIS DAUBIGNY
Sea with Overcast Sky, 1858
Oil on canvas, 44 × 90 cm
Groninger Museum, Groningen

14

CHARLES FRANÇOIS DAUBIGNY
The Haystack, 1856
Oil on panel, 14.4 × 25.3 cm
Musée Tavet-Delacour, Pontoise

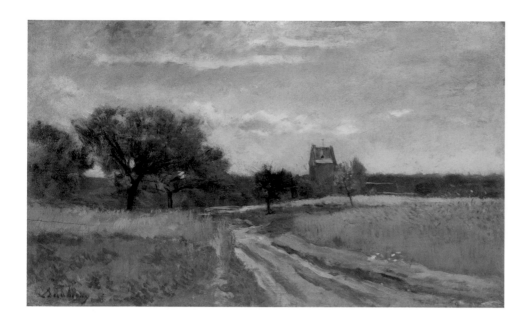

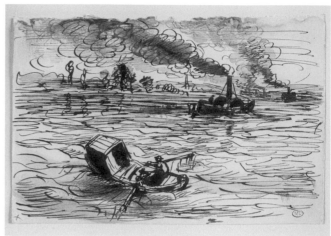

grain and hazy summer sky epitomise the fertility and tranquillity of the French countryside. Daubigny depicted this familiar spot on at least five other occasions.[74] 'There is nothing like [working in] the nature in which one lives every day, where one truly enjoys being. Then the paintings show the effects of one's inner life and the sweet sensations one feels there', he wrote.[75] Daubigny's presence in Auvers, and the friends attracted there by his hospitality, good humour and occasional instruction, helped establish the village as a small artists' colony.[76]

In the 1860s, Daubigny continued to exhibit river landscapes such as *Banks of the Oise at Auvers*, Salon of 1863 (fig. 77), an image unified by the cool light of an overcast sky. Though at every Salon some conservative critics chided him for 'having sent only sketches', other writers honoured him for his conscientious realism.[77] In fact, just the year before, Daubigny had subtly declared his artistic allegiance on an etched self-portrait by delicately inscribing the word 'réalisme' (fig. 63).[78] This quiet manifesto alluded to the fact that since the early 1840s he had devoted himself to painting real places factually. He certainly agreed with Courbet's statement that; 'Art in painting should consist only of the representation of things that are visible and tangible to the artist.'[79]

Seen today, however, Daubigny's realism appears selective. In paintings like the 1863 *Banks of the Oise at Auvers*, he left out a common sight on the river: barges loaded with freight. By the 1850s, a connection to the Canal Saint-Martin in north-eastern France established the Oise, with its deep channel, as the major conduit to Paris from coal mines in Belgium and northern France.[80] When painting there, Daubigny must have waited patiently for these long carriers to pass. Art should only depict real things, he would have said, but it did not have to depict *everything*.

The striking, unfinished *Flood at Billancourt* (fig. 17) shows a grounded boat, perhaps the *Botin*, beside a dislodged, battered tree with tangled roots, a sign of the wreckage caused by a flood on the western outskirts of Paris.[81] It reveals Daubigny's technique for his highly finished pictures. Despite the availability of commercially primed canvases, he often prepared his own grounds. Here he primed the sky with a grey-white layer; he also sometimes used tones of tan, grey or pinkish beige.[82] Daubigny carried the sky to a relatively high degree of completion before turning to the land, so that he could key it to the colour and light above. Visible in the lower register are accomplished underdrawing, then dark, transparent paint over a toned brown ground and finally touches of colour applied to the tree and boat's hull.

Middle Career and Daubigny's Role in Early Impressionism: 1864–1869

Daubigny's pictures are inextricably entangled with the contemporary development of French tourism. Take, for example, his *Evening at Andrésy, Twilight* (Walters Art Museum, Baltimore).[83] From the 1830s to the 1880s, passenger steamboat itineraries signalled Andrésy as a beauty spot on the Seine.[84] In fact, comparing Daubigny's favourite sites on the Seine to those recommended in French travel literature yields striking overlap. The steamboat guide lists (among others) La Frette, Herblay, Conflans, Andrésy, Triel, Meulan, Rangiport, Limay, Mantes, Vétheuil, La Roche-Guyon, Bonnières, Giverny, Vernon, Les Andelys, Portejoie and Pont de l'Arche. Daubigny painted all of them.[85] Is this simply because they were the most scenic spots when viewed from the water, or was Daubigny capitalising on their popularity? Both propositions must be true. As a former illustrator for travel guides in the region, he was certainly familiar with its attractions.[86]

Just as important as what Daubigny included when painting the Seine is what he left out: steam-powered freighters, tugboats, motorised barges, riverside towing towers, locks and canalised river sections. Beginning in the mid-1830s, the Seine gradually lost

15

CHARLES FRANÇOIS DAUBIGNY
Landscape along a Country Road, 1860
Oil on panel, 20.2 × 33.8 cm
Yale University Art Gallery, New Haven, gift of Miss
Jessie M. Tilney, in memory of her grandparents,
John William and Hannah M. Mason, 1938.23

16

CHARLES FRANÇOIS DAUBIGNY
Steamboats (recto), *c.* 1857?
Pen, pencil and brown ink on paper, 10.9 × 16.2 cm
Musée d'Orsay, Paris

17

CHARLES FRANÇOIS DAUBIGNY
Flood at Billancourt, 1866
Oil on canvas, 50 × 65 cm
The Phillips Family Collection

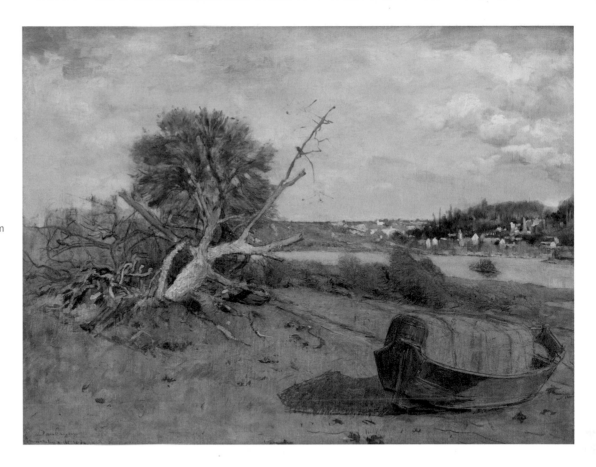

its rural appearance as it was widened, deepened and transformed into a major route serving industrial needs. Between 1850 and 1870, traffic on the Seine increased, transporting most of the raw materials and heavy goods essential to industry in the Paris basin.[87] Increasing numbers of factories, warehouses, tanneries, paper mills and foundries dotted the banks of the river.[88]

Daubigny was well aware of these developments. During his first trip on the *Botin* in 1857, he remarked: 'We are only bothered by the steamboats, and there are a lot of them going back and forth.'[89] Occasionally he sketched the challenges they posed to the little studio boat. In *The Botin Steering Clear of the Steamboat*, he showed his craft near a port on the Seine, where a steamer emits dark smoke.[90] In *Steamboats*, he sketched the struggle to keep the *Botin* afloat between the wakes of two large vessels (fig. 16).[91] Obviously Daubigny did not deem such incidents – or the Seine's commercial or industrial activities – suitable for pictures. He painted its most unspoiled sites: picturesque stone houses, medieval monuments and unchanged bucolic areas.[92] In fact,

the Seine's greater industrialisation must explain his preference for the Oise.

In *Sunset on the Oise* of about 1865 (fig. 18), Daubigny rendered the flush of twilight colour reflected in the river. Such extemporaneous studies served as memory aids for later, larger studio paintings.[93] Pierced at its corners, this panel may have been among the many oil sketches that Daubigny tacked to his atelier wall for reference.[94] Eugène Boudin (1824–1898) said of them: 'In his studies there is a boldness, an abandon, that I wish to have in my own.'[95] With their economy of touch and direct notation of ephemeral conditions, such oil studies anticipated Impressionism. In *The Seine at Bougival, Evening* (fig. 19) Monet similarly depicted a sunset sky from a low vantage point across a reflecting river and, with varied, dashed strokes, produced an image also marked by its immediacy.[96] Both artists were thinking in patches – though Monet's are larger – and privileging colour and light over detail and outline. Moreover, in 1869 Monet probably conceived of this summary work as an *esquisse* (sketch), too.[97] Within the next few years, Monet would follow Daubigny

in equipping a boat as a floating studio from which to paint reflecting views from mid-river, as in his delicately stroked and shimmering *Autumn on the Seine, Argenteuil* (fig. 157).

Sunset on the Oise illustrates Daubigny's increasingly intuitive approach to painting. He referred to his works as transcriptions of 'sensations' experienced before the landscape.[98] Castagnary alluded to this in 1859: 'What a fortunate man … who has only to depict his sensations to reveal himself as a poet!'[99] Henriet, who took lessons from Daubigny, observed: 'Everything in his art derives from sensation.' Daubigny described his own process as spontaneously and rapidly rendering his feelings outdoors.[100] Indeed, Castagnary's famous definition of Impressionism, 'They are impressionists in the sense that they render not the landscape, but the sensation produced by the landscape', summarised his and others' earlier writings on Daubigny.[101] Appropriately, the word 'sensation' unites opposing ideas: it recalls a sensor that mechanically registers facts (objectivity) while implying a sentient person who senses or feels (subjectivity). This dualism underlies the tension in

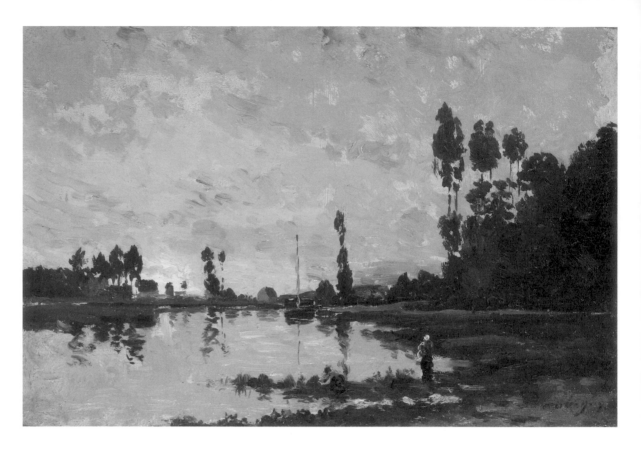

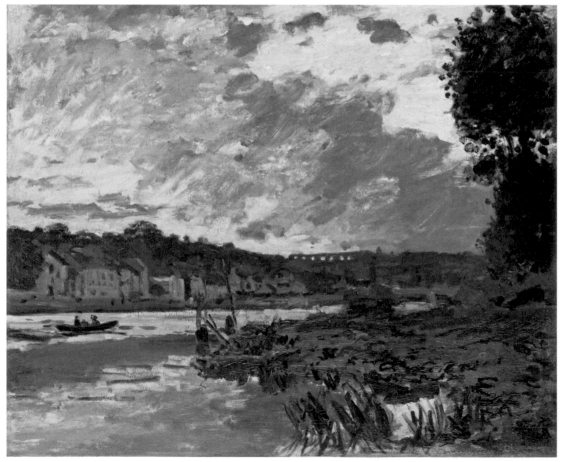

18
CHARLES FRANÇOIS DAUBIGNY
Sunset on the Oise, c. 1865
Oil on panel, 23 × 33 cm
Musée des Beaux-Arts, Dijon

19
CLAUDE MONET
The Seine at Bougival, Evening, 1869
Oil on canvas, 60 × 73.3 cm
Smith College Museum of Art, Northampton,
Massachusetts, purchased, SC 1946:4

20
CHARLES FRANÇOIS DAUBIGNY
French Coastal Scene, 1867–71
Oil on canvas, 46.5 × 81.2 cm
Tweed Museum of Art, University of Minnesota,
Duluth, gift of Mrs George P. (Alice) Tweed, D53.x22

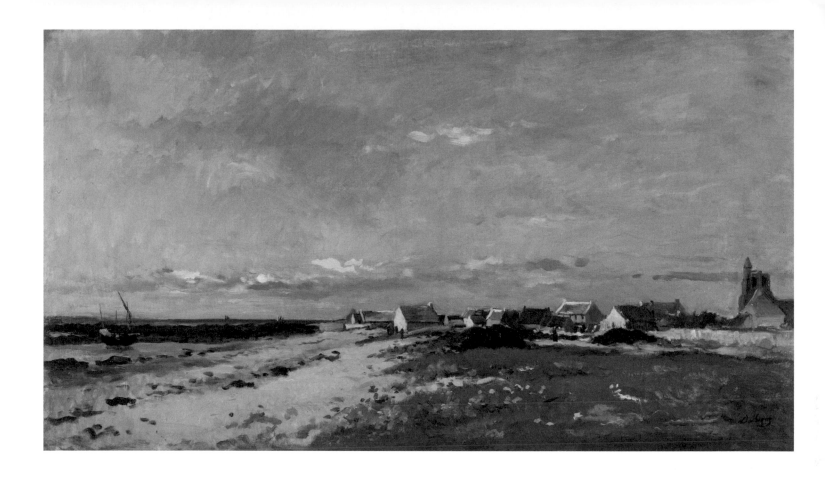

Daubigny's work between precise description and an increasing preference for brushing more generalised, feeling-based 'sensations' before nature.[102]

In the 1860s, Daubigny wrestled with how to preserve the freshness of his outdoor sensations in larger, more elaborate canvases, such as the monumental *Cliffs near Villerville* (fig. 131), which he sent to the Salon of 1864. Henriet said he painted it outdoors. Daubigny had stayed at Villerville the previous October, when he must have begun the painting.[103] Henriet also stated that Daubigny's works were 'generally at least sketched on the spot if not actually finished there'.[104] As we have seen, he had been practising this from as early as 1839; whether he kept it up continuously is unknown, but there is evidence from later years as well to support it.[105] Furthermore, a writer who visited Daubigny's studio in 1868 also reported that some of his important paintings – not just studies – had been executed in the open air.[106]

However, Henriet also claimed that Daubigny actually *completed* work on the Villerville painting outdoors, certainly an overstatement: most artists – even the Impressionists – usually altered pictures

back in the studio.[107] Further complicating the image of Daubigny as a pioneer of outdoor work is the fact that he also created many small pictures, often variants of past Salon paintings, in his studio at the request of dealers.[108] Nonetheless, Henriet provided enough details to be convincing about Daubigny working on at least some phase of *Cliffs near Villerville* outside: 'Daubigny had fastened his canvas to stakes firmly planted in the ground, and there it remained, exposed to such risks as the horns of goat and cattle and the mischief of little scamps, until it was completely finished. The painter had carefully chosen a stormy grey sky, with large clouds blown angrily by the wind. He would wait for the right moment and then run to work on the painting as soon as the weather showed the impression he wanted.'[109] This concern with momentary conditions foretold Monet's process in his series of the 1890s.[110]

For *Villerville*, Daubigny had again chosen a barren stretch of the coast, peopling it with two mussel gatherers in traditional garb. Sunlight breaks through storm clouds in the distance, turning the sea a milky jade. At the Salon of 1864, Castagnary admired the

'dramatic and desolate impression; the effect is irresistible'.[111] As Daubigny attempted to retain the spontaneity of his on-site observations in larger-scale formats, reviewers saw his style becoming more powerful and energetic.[112] Such efforts incensed other critics, however, who warned: 'We see only *ébauches*, broadly brushed studies done with a coarse, careless touch.'[113]

In 1864, many writers applied the term 'impression' – positively and negatively alike – to Daubigny's sketch-like effects.[114] De la Fizelière commended him for finding the relationships among elements 'under a given light' and capturing 'aspects of colour, effects of light, transparency of air … to call forth in the viewer the impression that he himself felt before nature'.[115] On the other hand, Léon Lagrange felt that in *Villerville*, Daubigny rendered only a 'brutal impression of reality' and was 'a slave to his impression'.[116] A year later, Lagrange labelled Daubigny's *Moonrise* 'the manifesto of this school of the impression and of its leader, Monsieur Daubigny'.[117] Such comments continued through the 1860s – about both Daubigny and the

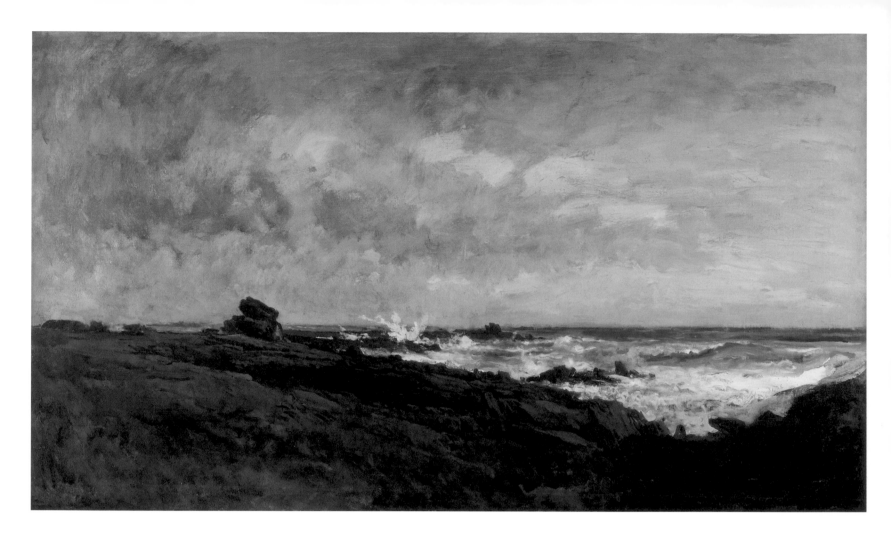

young Impressionists – so that by the time of the latter's first independent exhibition in 1874, the word 'impression' came easily to mind.

Probably dating from Daubigny's stay in Brittany in 1867 is the *French Coastal Scene* (fig. 20), which represents the village of Kérity in Finistère.[118] Deploying high-keyed colour and brisk strokes, applied with the loose vigour of an open-air sketch, Daubigny portrayed bright afternoon light and gusty weather at the coast.[119] Short strokes of paint replaced the precisely drawn forms of Daubigny's early work in a manner that was in many respects Impressionist.

Brittany and the turbulent power of the sea striking its dark, rocky coast also inspired *Seascape, Saint-Guénolé, Penmarc'h, Brittany* (fig. 21).[120] To generate this energy, Daubigny enlarged the scale of his sketch style to fit the five-foot canvas. He used the palette knife extensively in the sky, dashing on impastos with slashing movements that suggest the wind and the foaming surf.[121] Castagnary erroneously stated

that Daubigny first employed the palette knife in 1868, whereas he had actually begun wielding it in exhibition pieces early in his career, as in *The Harvest* of 1851 (fig. 119).[122]

At the Salon of 1868, Daubigny exhibited a grand-scale, broadly treated agricultural scene, *Moonrise* (fig. 79).[123] Most critics blasted it, calling Daubigny 'the firstborn of this whole young school' in 'yielding to the fad of the palette knife', and caricaturists mocked its impastoed moon, which they represented as a coin, a metallic disc, a clock or a whole round cheese.[124] But the young artist Odilon Redon (1840–1916) admired Daubigny as the painter 'of a moment, of an impression. He takes possession of it, alive and powerful', while another writer noted that Daubigny had greatly influenced younger landscapists.[125]

The Late Style: 1870–1878

Daubigny and his family spent the period of the Franco-Prussian War and Commune (1870–1) in

London, where he had acquaintances from two previous trips.[126] Returning to Paris, he stopped on the Normandy coast at Etaples in May 1871. There he painted one of his most captivating open-air canvases, *The Dunes at Camiers* (fig. 22).[127] Perhaps its brio expressed his relief at returning to France, or revealed his recent contact with Monet and Pissarro, which may have encouraged the loose, more experimental direction he had recently been taking. To evoke the coastal atmosphere, Daubigny freely brushed and virtually smeared together paints while wet, and – in the sky – applied generous swathes of impasto with a knife. He also used the white ground as a colour to attain an effect of brilliant outdoor light. This Impressionist picture exemplifies his late style when painting for friends, progressive collectors and his own pleasure.

Once back home, Daubigny continued his habit of alternating frequent trips by boat or land to favourite parts of France – and even Holland, the Pyrenees

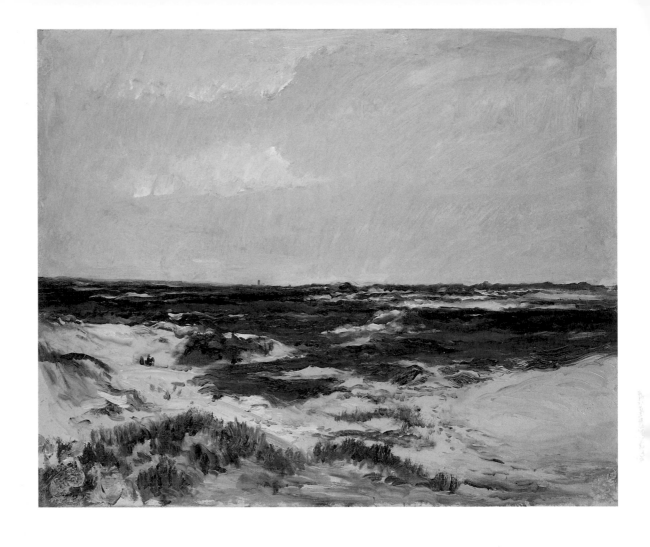

21
CHARLES FRANÇOIS DAUBIGNY
Seascape, Saint-Guénolé, Penmarc'h, Brittany,
c. 1867
Oil on canvas, 84 × 146.5 cm
The Barber Institute of Fine Arts, University
of Birmingham

22
CHARLES FRANÇOIS DAUBIGNY
The Dunes at Camiers, 1871
Oil on canvas, 57.2 × 65.4 cm
Minneapolis Institute of Art, gift of Wheelock
Whitney, Wheelock Whitney III, Pennell Whitney
Ballentine, Joseph Hixon Whitney, and Benson
Kelley Whitney in memory of Irene Hixon Whitney,
86.90

and Spain – with periods of painting in Auvers and
Paris. In *The Coming Storm, Early Spring* of 1874
(fig. 23), he depicted the farming activities within
a panoramic sweep of the Vexin, dominated by a
cumulous-laden sky.[128] As darker storm clouds blow in
from the west, three small figures on the path at the
right rush towards shelter. Daubigny evidently worked
quickly and energetically to capture the transitory
meteorological effect before the downpour.[129] Brusque
sweeps of paint provide shorthand for clouds,
crops and wind in this 'impression' or *effet* – that
crystallisation of time, place, light and atmosphere –
captured in a welter of strokes outdoors.

In his late style of the 1870s, Daubigny worked
boldly and broadly. *Seascape* (fig. 25) recapitulates
with bolder handling the frontal, bipartite format
he had invented by 1858: sky above, sea below,
comprising the whole picture.[130] Villerville is probably
the site represented, but the subject is really the
brooding weather over the infinite sea.[131] The grey-

green water and leaden sky demonstrate Daubigny's
refusal to beautify the prospect. Except for a tiny
ship far out to sea to establish scale, the painting
at first appears empty, until variations of touch and
pigment create an illusion of drifting fog, cool, filtered
illumination and churning waves. Daubigny created
space by reducing the size of the waves and the relief
of his paint towards the horizon. Deft swipes of heavy
white impasto made by a palette knife represent the
nearest wave crests.

Although the elemental *Seascape* lacks
both picturesque elements and Impressionist
contemporaneity,[132] in other seaside views
Daubigny's aesthetic intersected with the culture
of tourism. For example, in *The Beach at Villerville
at Sunset* of 1873 (fig. 26) a fisherman with a net
and women carrying baskets of fish climb a curving
footpath up the slope.[133] This glimpse of 'authentic'
regional occupations met travellers' expectations
about Normandy. Indeed, the on-going increase in

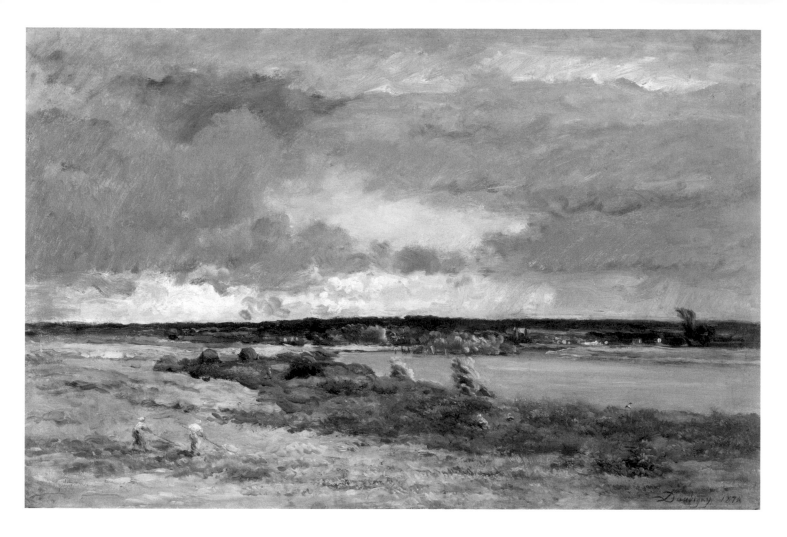

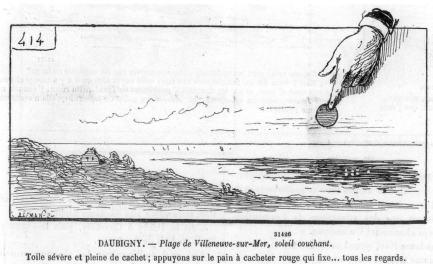

DAUBIGNY. — *Plage de Villeneuve-sur-Mer, soleil couchant.*

Toile sévère et pleine de cachet ; appuyons sur le pain à cacheter rouge qui fixe... tous les regards.

23
CHARLES FRANÇOIS DAUBIGNY
The Coming Storm, Early Spring, 1874
Oil on panel, 44.4 × 69.4 cm
The Walters Art Museum, Baltimore, acquired
by Henry Walters, 1887–1895, 37.163

24
STOP (LOUIS MOREL-RETZ)
'The Salon of 1873; Daubigny. – The Beach
at Villeneuve-sur-Mer [Villerville] at Sunset',
Le Journal amusant, no. 872, 17 May 1873, p. 5
Bibliothèque nationale de France, Paris

25
CHARLES FRANÇOIS DAUBIGNY
Seascape, c. 1874
Oil on canvas, 47 × 81.9 cm
Private collection

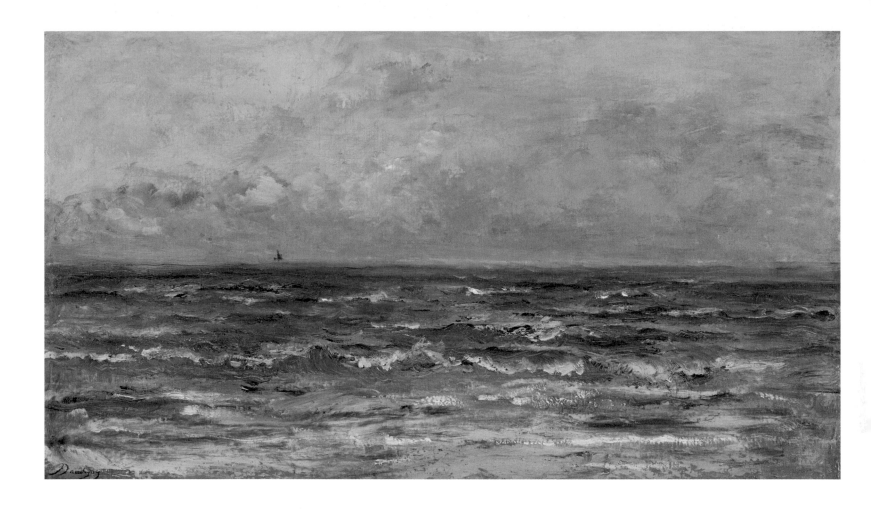

French bourgeois travel focused particularly on the accessible Channel coast. After the initial Romantic interest in Normandy's monuments and history, later tourist literature emphasised 'nature tourism' there as compensatory relief from Parisian life.[134] Daubigny's Norman views provided an ideal response to this need.

Having earlier contributed illustrations to travel guides, Daubigny had evidently internalised the traveller's perspective.[135] On first discovering Villerville in 1854, he had enthused about the sights: 'and then women gathering mussels, and shrimp fishermen, too, all in cotton bonnets, which you know I like!'[136] Initially, he could rent a room there for only ten francs a month, but later complained that more people were discovering the village: 'If that continues in Villerville, you would need to buy property to afford to stay here. The bathers are arriving in crowds.'[137] Once discovered by Parisian vacationers, Villerville acquired a boardwalk and bathing cabins.[138] In fact, when

painting the *The Beach at Villerville at Sunset* in 1873, Daubigny must have turned his back on these newly built amenities to view the old Normandy, looking down the coast to the south-west. He had been – and probably still conceived of himself – as a discoverer of unspoiled France. Paradoxically, though, he was fully implicated in tourist culture through his own visual consumption of such sites and his 'packaging' of them in works of art sold to well-to-do buyers.

Even the portrayal of an alluring destination did not shield the *The Beach at Villerville* from the usual condemnations at the Salon, where the painting featured prominently as one of fourteen pictures hung in the central hall.[139] Reviewers who liked clear outlines and polished details complained that Daubigny 'had gone astray, making rough, weak sketches'.[140] They found fault with the impastoed sun, 'too visibly deposited on the canvas with a palette knife'.[141] A cartoonist ridiculed this (fig. 24) with a punning caption: 'An austere canvas, full of character (*cachet*);

let's press on the red sealing wax (*pain à cacheter*) which fastens … all eyes on it.'[142] Castagnary defended the painting.[143] Seen now, it stands out for its precocious colourism: Daubigny rendered the glittering light reflected in the rock pools with daubs of bright lavender, salmon pink and acid yellow.

His fondness for this vantage point led him to depict the scene on multiple occasions under varying weather and light conditions. Two other such renditions include *Villerville* of 1872 (fig. 27), which captures dramatic crepuscular colour in a cloudy sky and *Sunset at Villerville* of 1874 (fig. 130), an image of twilight on a serene evening. Although not specifically interrelated in the manner of Monet's serial paintings of the 1890s, these variations reveal Daubigny's interest in registering temporal and meteorological alterations in a landscape.

Landscape with a Sunlit Stream (fig. 28), which depicts the Ru de Valmondois, dates from 1876 or earlier.[144] This brook was probably a favourite

26
CHARLES FRANÇOIS DAUBIGNY
The Beach at Villerville at Sunset, 1873
Oil on canvas, 76.8 × 141 cm
Chrysler Museum of Art, Norfolk, Virginia,
gift of Walter P. Chrysler, Jr, 71.635

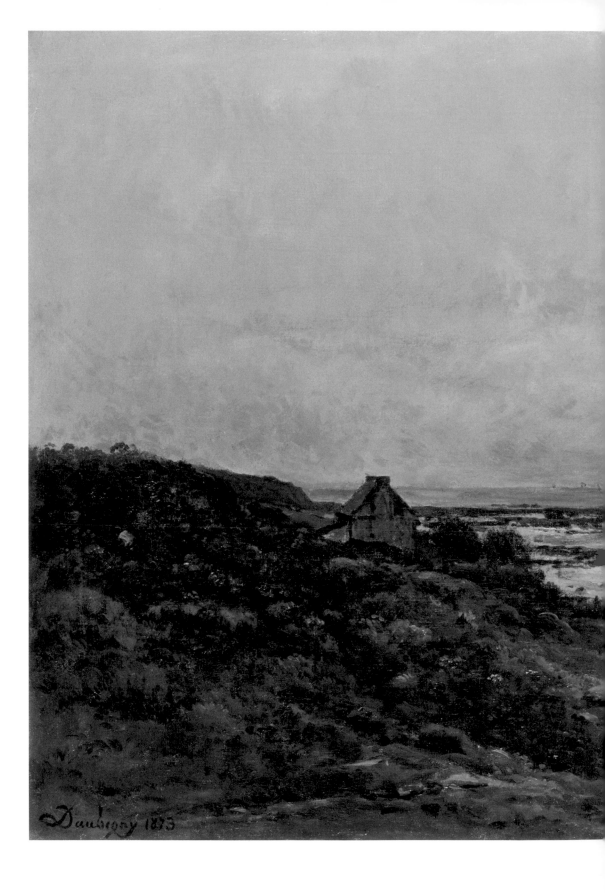

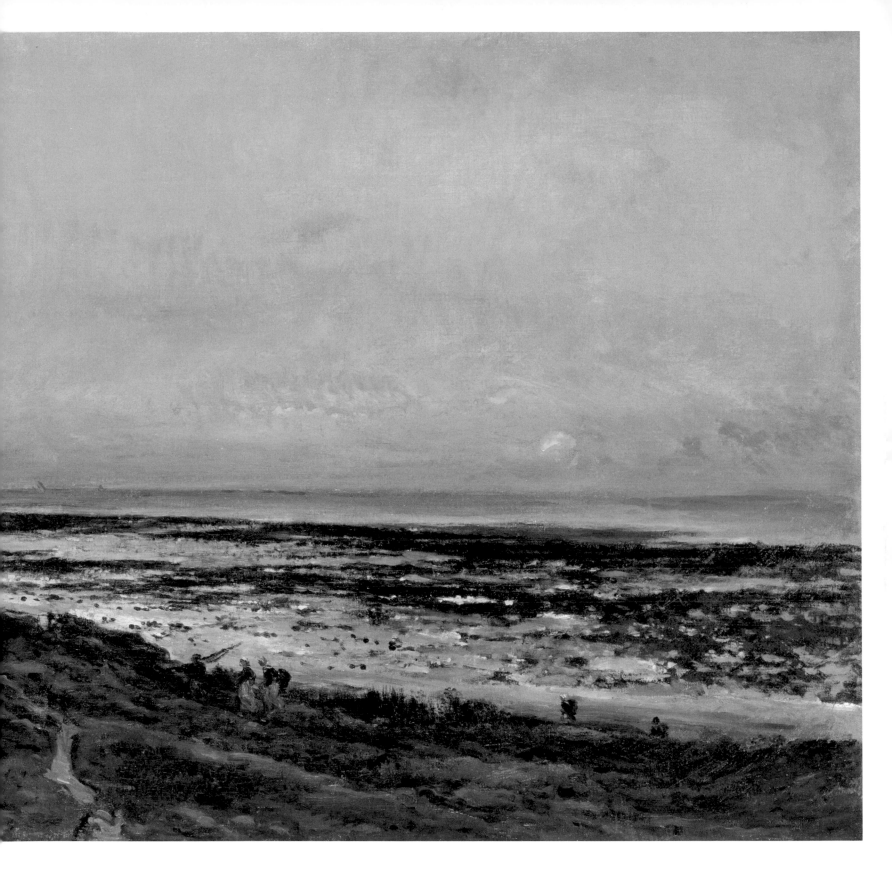

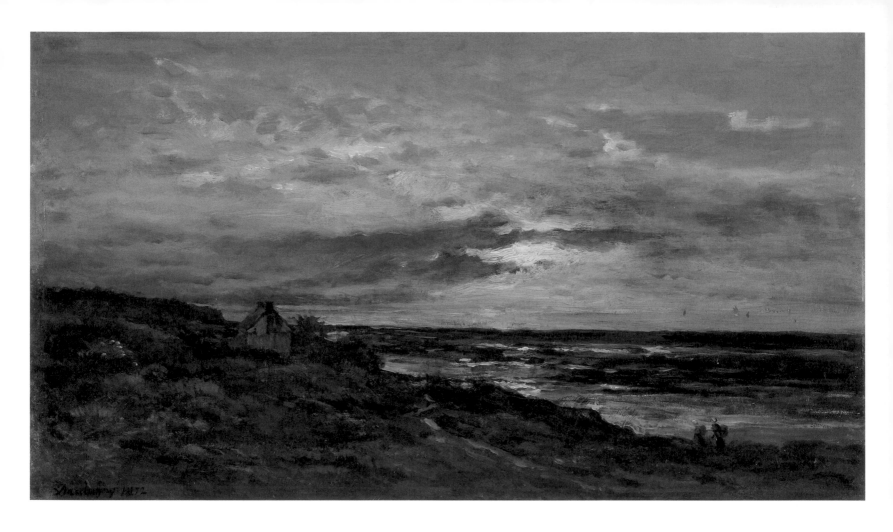

childhood haunt, for Daubigny painted it as early as 1835 and returned to the theme many times in later years.[145] He usually framed it as a vertical composition to capture the arching trees in this wooded area. Extending his vocabulary of touch and colour in his late period, Daubigny applied blue to shadows and dashes of yellow and pale green to simulate light striking foliage.

In addition to his Impressionist essays of the 1870s, with their specificity of place, Daubigny simultaneously explored an antithetical vein of painting: simplified evening and nocturnal scenes that emphasised mood. He had already exhibited moonlit landscapes at the Salons of 1859, 1861, 1865 and 1868, but he created more than twenty-five of them in the decade before his death.[146] In *Landscape by Moonlight* (fig. 29), he rendered the evening hour when the sky turns an inky blue. Taking advantage of the wood panel's warm brown colour as a foil for cool evening tones, he painted with wide brushes,

wet-into-wet, apparently all in one session. A yellow moon casts rosy reflections on the clouds around it, and both yellow and pink notes are mirrored in the water below. A single long rippling mark defines the riverbanks at left. Daubigny probably painted quickly and economically to capture the effect while it lasted. Because the thinly brushed paint floats in pools of colour, the surface receives emphasis and space appears flattened. A dreamy image that conjures up the mystery of night, this tonalist picture reminds us of Daubigny's friendship with James Abbott McNeill Whistler (1834–1903).[147]

In *Moonrise* (fig. 30), a low full moon also shines on uninhabited and indistinct terrain. Here, however, Daubigny applied a pale ground to the panel.[148] This allowed him to suffuse the entire composition with the luminous glow of early evening and achieve a high chromatic range of pale, smoky blues and greens.

In such pictures, specific features of a site no longer mattered to Daubigny; he seemed interested

only in expressing 'the languor and melancholy of evening'.[149] As the critic Paul Mantz recognised, Daubigny was 'sacrificing the rendition of detail to the striking aspect of the larger whole'.[150] Henriet expanded: Daubigny wanted, he said, 'to summarise his impressions instead of painting corners and details, to replace local colours with modified and relative hues, to sacrifice a bit of literal truth to allow more space for interpretation.'[151] This stress on 'interpretation' applies particularly to Daubigny's late style, when the pendulum swung decisively towards the subjective. In the large *Moonrise at Auvers*, also known as *The Return of the Flock* (fig. 31), Daubigny depicted the fields of the Vexin on a misty evening with fog rising from the dark Oise below. He set the river's opposite shore back along the horizon. A shepherd, two dogs and a flock of sheep head back to Auvers through fields containing three grainstacks.[152] The painting is about mood: the end of a long day spent outside, anticipation of homecoming and the

27

CHARLES FRANÇOIS DAUBIGNY
Villerville, 1872
Oil on panel, 39 × 66 cm
Private collection

28

CHARLES FRANÇOIS DAUBIGNY
Landscape with a Sunlit Stream, 1876
Oil on canvas, 63.8 × 47.9 cm
The Metropolitan Museum of Art, New York, bequest
of Martha T. Fiske Collord, in memory of her first
husband, Josiah M. Fiske, 1908, 08.136.4

29

CHARLES FRANÇOIS DAUBIGNY
Landscape by Moonlight, c. 1875
Oil on panel, 34 × 55.5 cm
Museum de Fundatie, Zwolle and Heino / Wijhe

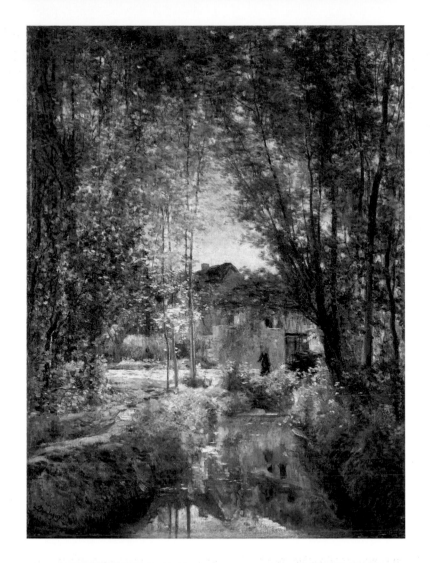

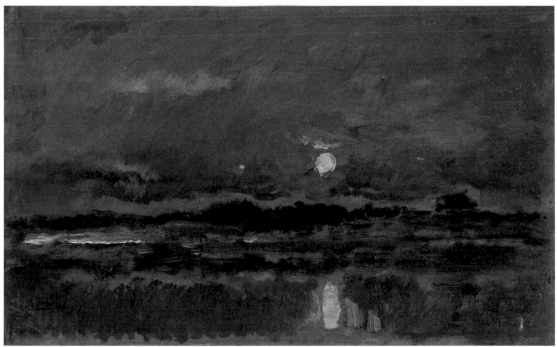

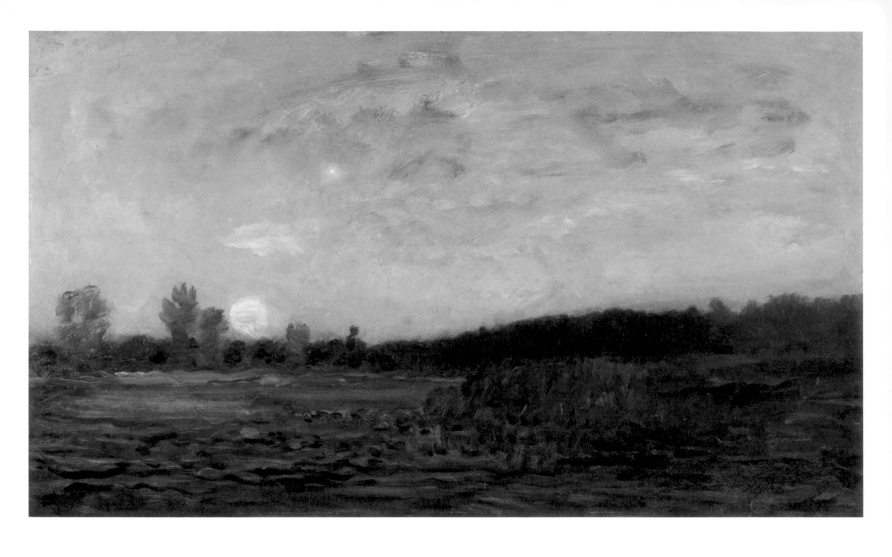

30
CHARLES FRANÇOIS DAUBIGNY
Moonrise, 1874–6
Oil on panel, 37.1 × 64.1 cm
Tweed Museum of Art, University of Minnesota,
Duluth, gift of Howard Lyon, D57.x12

31
CHARLES FRANÇOIS DAUBIGNY
Moonrise at Auvers, also known as *The Return
of the Flock*, 1877
Oil on canvas, 106.5 × 188 cm
The Montreal Museum of Fine Arts,
gift of Lady Drummond in memory of her husband,
Sir George A. Drummond

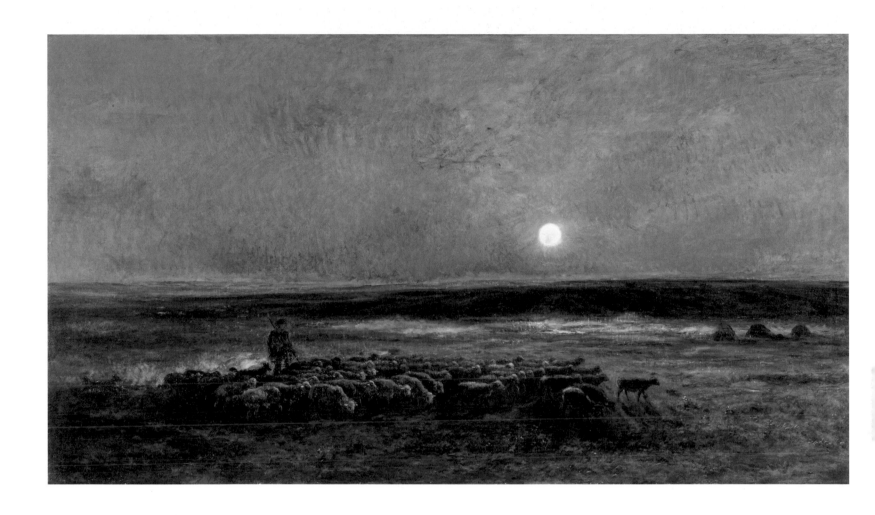

revelation of beauty in the hushed landscape with its mysterious lunar glow.

Moonrise at Auvers stands out for its remarkable chromatic effects. The sky is rendered with deep blues and violets, and the reflected light of the moon with complementaries of yellow and orange. The far bank of the Oise glimmers with pale cool greens and touches of crimson. The fog, reflecting pale pink, pastel blue and lemon yellow, creeps over pastures modelled in teal, orange and violet. Even the soft grey fleeces of the sheep receive touches of sky blue, rose and paler yellow. Ample glazes accentuate these effects; Daubigny knew how to trap light within layers of paint. Fittingly, Odilon Redon recognised Daubigny's colouristic innovations. Among his generation, he said, only Daubigny had this 'piercing and highly expressive colourism, and this precious quality gives him an important role in contemporary art'.[153]

Daubigny scarcely had time to finish this painting before his death in February 1878. Later that year nine of his best works, including this one, appeared at the Exposition Universelle in Paris, where more than one critic labelled them 'true masterpieces'.[154] Zola singled out *Moonrise at Auvers* as 'a magnificent painting'. 'It is the soul of nature that speaks to you. … Night has just fallen and transparent shadows veil the fields, while the full moon rises in a clear sky. You can feel the silent quivering of evening and the last sounds of the fields as they fall asleep. [The painting] gives the impression of a limpid grandeur, of tranquillity rich with life. … We are far from the classical style … which lacks anything personal and in which rhetoric stifles life.'[155] Zola, who famously defined naturalism – and by extension, Impressionism – as 'a corner of nature seen through a temperament', acknowledged the ardent response to the natural world that permeates Daubigny's late landscapes.

Whether we label these nocturnes pre-symbolist or simply late Romantic, Daubigny's work as a whole belonged to a specific historical moment. In it, he expressed an adulation of the countryside and sympathy for its peasants, values characteristic of his coming of age as an early socialist of 1848.[156] Geoffroy-Dechaume wrote of a dinner for friends and family that took place in the apple orchard in Valmondois in 1877: 'During dessert, our old friend Daubigny sang, as in his youth, 'Haymaking' by Pierre Dupont. Under this immense, leafy canopy, our friend Daumier and all of us were happy to hear his melodiously resounding voice. It charmed us before rising and disappearing into the starry vastness; there he was truly at home.'[157]

Dupont's 'Song of Haymaking', like the songwriter's other anthems of the 1840s and 1850s, summoned up the grinding toil and earthy joys of traditional agricultural labours: 'Bring your scythe … Reaper! For it's in June that we harvest the hay.'[158] This anecdote grounds Daubigny in his formative era.

Among Daubigny's contributions, his invention of

new landscape subjects in the 1850s comes first: the farm landscapes, windswept coastal scenes, spring orchards and mid-river views. His riparian subjects presented an optimistic image of France as pristine and lushly verdant, and his agricultural scenes reminded city-dwellers of seemingly timeless rural traditions, the foundation of French prosperity. Daubigny pioneered the frontal seascape as a direct encounter with the ocean's power and the flowering orchard as a joyous salute to spring. His images offered up these places as he himself experienced them – as healing and harmonious – although he left a few intrusive modern details out of the frame. Nonetheless his contemporaries saw him as a realist, in part because of the novelty of his everyday motifs.

Daubigny also acquired the reputation of a realist through his technical innovations: the crisply detailed observation of his early work and his expansion of *plein-air* painting, invention of a studio boat, early adoption of new pigments and attention to mutable properties of landscape. This was a more palatable realism than Courbet's provocative art, to be sure, but Daubigny's procedures made his landscapes appear startlingly factual, freshly composed, intensely coloured and strikingly mimetic in their atmospheric effects. The artist Adolphe Appian (1818–1898) explained in 1857 why he respected Daubigny: 'He paints not just the objects in front of him, but the air that surrounds them and the light that colours them; he paints what is important.'[159] Tempering the myth of abrupt revolution, Impressionist art grew organically from the progressive work of predecessors like Daubigny.

In the 1860s, Daubigny's evolving technique earned him blame for exhibiting 'impressions'. In trying to capture changeable effects, he came to value immediacy over careful drawing and increasingly left the edges of forms undefined. The painter Robert Wickenden (1861–1931) said, 'he brought into landscape art greater freshness and spontaneity than had yet been seen … with palette-knife and brush he dashed in effects instantaneously'.[160] In essence, Daubigny's development recapitulated nineteenth-century painting as a whole: he progressed from a reliance on distinct stages of pencil drawing, underpainting and, finally, local colours to a reconception of painting itself as a form of drawing in thick, patchy strokes that denoted both colour and light.

That may be what Frank Stella (b. 1936) found fascinating about Daubigny in the twentieth century. Stella has recounted that on his first trip to the Frick Collection in New York, Daubigny's quiet 1877 masterpiece *Dieppe* (fig. 32) claimed his entire attention for its paint handling, 'so fluid and precise'. He continued, 'I was taken in and taken over, perhaps, by the ability of artists to convert impressions into pigment, and nearly vice-versa, paint into feeling. … There is in Daubigny's landscape a modest, compelling wholeness created by brushstrokes that seem to read as a single gesture – somehow the moment is captured, arrested, by moving pigment.' Speaking of Daubigny and Manet together, Stella concluded: 'I suppose the idea here is to bring the processes of drawing and painting as close together as possible in order to bring a paint-inflected gesture to life.'[161]

Finally, although the trio of Daubigny, Monet and Van Gogh may initially seem odd, they participated in a shared enterprise. In their mature work, all three embraced the natural world as their primary motif and their passionate responses to it as their subject. They all came to avoid industrial elements as antithetical to their projects.[162] All three were able to channel their emotions before a site into an outpouring of spontaneous and sensuous brushwork. A contemporary recalled that Daubigny 'was a wonderful improviser, and his most beautiful canvases … were dashed off this way in the heat of the initial passion'.[163] Daubigny described this as a special madness: 'It's in the memory [of nature], or the sight of it, that we sometimes become crazy and it's then that we make good paintings.'[164] Monet's and Van Gogh's spates of spontaneous mark-making were correspondingly expressive.[165] In sum, all three of the artists highlighted here found in the French countryside the models they needed for brilliant and enduring improvisations.

32

CHARLES FRANÇOIS DAUBIGNY
Dieppe, 1877
Oil on canvas, 67 × 101 cm
The Frick Collection, New York, 1904.1.31

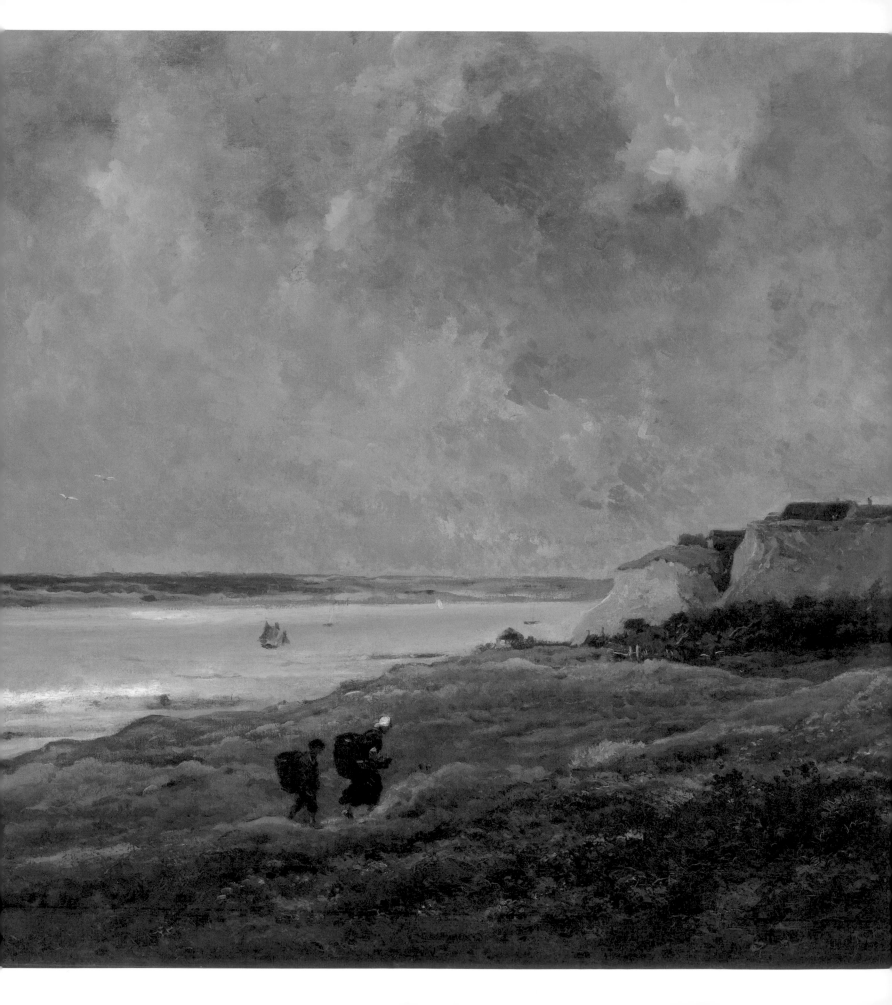

Daubigny and the Impressionists in the 1860s

Maite van Dijk

Nowadays it is impossible to consider Daubigny's work without placing it in the context of Impressionism. Since the publication of John Rewald's groundbreaking *The History of Impressionism* in 1946, Daubigny has been seen as one of the most important forerunners and sources of inspiration for the Impressionists.[1] Daubigny defended these young artists in the 1860s and paved the way for their success – in particular at the 1868 Salon. However, Daubigny's role as a pioneer and promoter of Impressionism is not a logical account of cause and effect; it is a nuanced story of reciprocal influences, of chance encounters and pivotal moments, of tradition and innovation, and of the conscious and unconscious creation of a public image. In an endeavour to get a better grasp of this tangled narrative that typifies the relationship between Daubigny and the Impressionists, this essay will focus on the developments, relations, ambitions and interests of Daubigny in the crucial 1860s – the decade when Impressionism was born.

Daubigny's Reputation around 1860

In the view of many critics, the Paris Salon of 1859 ushered in a new era. History painting, traditionally held to be the highest and most respected form, had made way for a new genre: landscape. At that year's Salon there were many large, impressive landscapes, of a size that, in the words of the writer Maxime Du Camp, had previously been the preserve of historical subjects or 'la grande peinture'.[2] There was talk of a 'new revolution' and of landscape as 'the most important branch of the art of our day'.[3] Daubigny was almost unanimously regarded as the leading representative of this new field. One of his entries that year, *Banks of the Oise* (fig. 54), was praised for the realism, sincerity and directness of its depiction of nature. In the words of Charles Baudelaire, who would write his last review of a Salon that year, Daubigny's landscapes 'instantly convey to the viewer's soul the original emotion with which they are imbued'.[4] Théophile Gautier also referred to the realistic effect of Daubigny's art: 'His paintings are fragments of nature cut out and framed in gold.'[5]

In his choice of everyday, unpicturesque landscapes, in conjunction with a direct, sketchy technique, Daubigny was seen as the most authentic and immediate translator of nature. More emotion and grandeur was observed in his contemporary Théodore Rousseau's landscapes, so that they were viewed as romantic, while Camille Corot's art was regarded as idealising and classical. Daubigny had

DETAIL fig. 131
CHARLES FRANÇOIS DAUBIGNY
Cliffs near Villerville, 1864–72

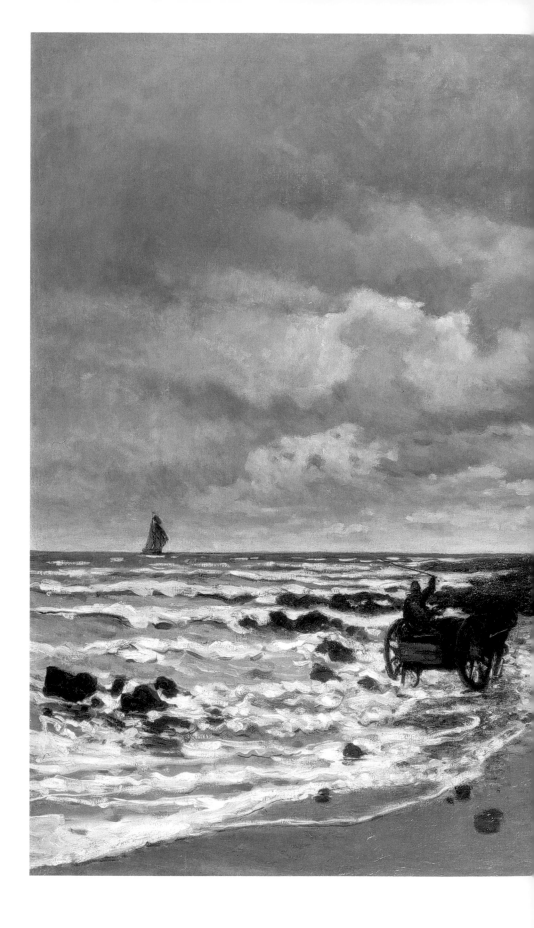

33
CLAUDE MONET
La Pointe de la Hève at Low Tide, 1865
Oil on canvas, 90.2 × 150.5 cm
Kimbell Art Museum, Fort Worth, Texas, AP 1968.07

exchanged both the Romantic ideal of almighty, unspoilt nature and the academic predilection for the Italianate landscape as manifested in the prestigious Prix de Rome competition that enabled promising artists to travel to Rome, for a more realistic depiction of the French countryside around Paris and in Normandy with its farms, its rural activities and its people.[6] Towards the end of the 1850s Daubigny had firmly established his image as an unaffected painter of the unembellished landscape, attracting comments in which words like 'sincerity', 'the everyday' and 'impression' frequently recur.[7]

Daubigny can therefore be viewed as an important link in the development of nineteenth-century landscape art and he had a direct impact on various young artists who appeared at the Salon for the first time in 1859 – as exhibitors or visitors. Camille Pissarro was the only one actually represented with a painting (*Paysage à Montmorency*); the judges had rejected Edouard Manet's (1832–1883) submission, and Edgar Degas (1834–1917) and Claude Monet were just visiting. Daubigny's canvases made a particularly strong impression on Monet, as his letters to Eugène Boudin on 19 May and 3 June 1859 attest: 'Daubigny's paintings are really beautiful in my opinion. One of Honfleur in particular is sublime', and 'Daubigny, the man I told you about, is a wonderful artist. It would be very unfortunate if you were not able to see his work.'[8] As would rapidly become clear, these artists admired Daubigny's spontaneous rendition of the changeable effects of the seasons and the weather, and shared his interest in the French countryside and riverscapes, and his liking for the large, panoramic format. The combination of the landscape and everyday life that they found in Daubigny's view of the commonplace

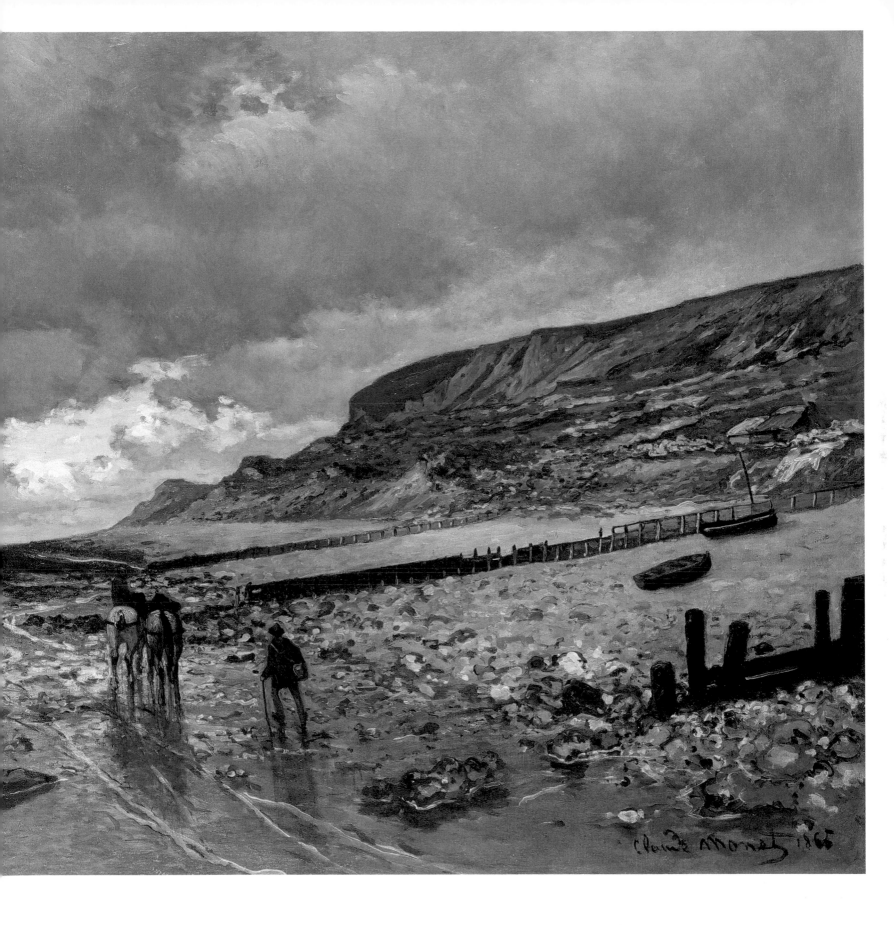

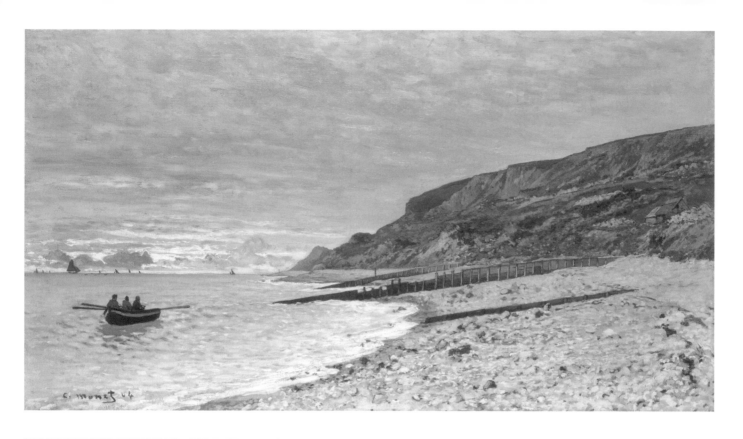

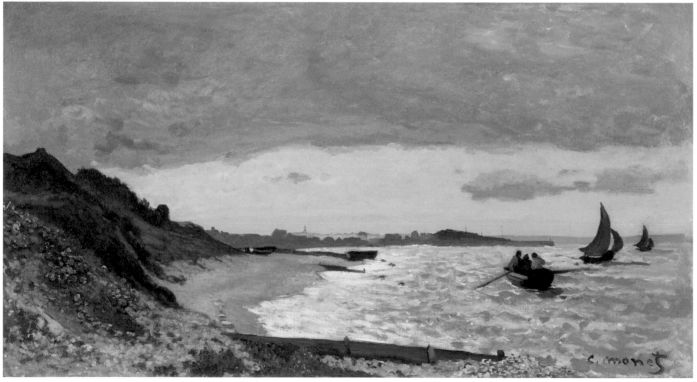

34
CLAUDE MONET
La Pointe de la Hève, Sainte-Adresse, 1864
Oil on canvas, 41 × 73 cm
The National Gallery, London

35
CLAUDE MONET
The Shore at Sainte-Adresse, 1864
Oil on canvas, 40 × 73 cm
Minneapolis Institute of Art, gift of Mr and Mrs
Theodore Bennett, 53.13

36
CLAUDE MONET
Towing a Boat, Honfleur, 1864
Oil on canvas, 55.2 × 82.1 cm
Memorial Art Gallery of the University of Rochester,
gift of Marie C. and Joseph C. Wilson, 91.35

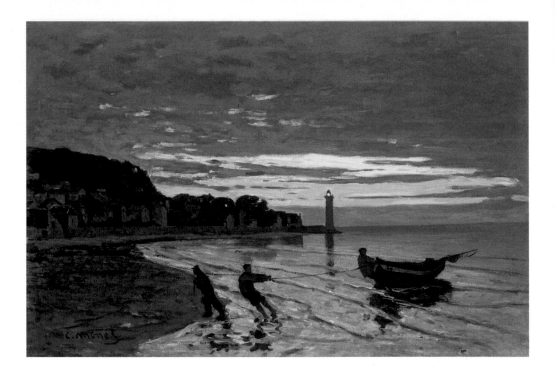

rural scene was to become one of the most important characteristics of the Impressionist movement.[9]

The Modern Landscape

Despite the almost unanimous praise for Daubigny's entries at the 1859 Salon, his star did not rise unchecked. There was also criticism of his technique and of the fact that his submissions for the Salon looked sketchy or unfinished. According to these critics Daubigny should refine his painting technique to elevate the motif, precisely because the subjects he chose were so mundane. They thought it unforgivable that he should paint huge canvases of uninteresting tracts of land with grand gestures and little attention to detail. Daubigny did this quite deliberately, though, to suggest that he was giving a sincere, almost naive interpretation of nature, as some contemporaries perceptively observed. The critic Théodore Pelloquet, for instance, wrote in 1858: 'Mr Daubigny's paintings have been criticised for too often resembling studies. Sometimes this reproach is justified, suggesting that when he portrays nature the painter occasionally leaves certain parts of his work incomplete as to execution, fearing, and rightly so, that by finishing them this bloom of innocence, this sincerity of expression which is so important to him would be lost.'[10]

In 1861, he also had to endure a great deal of criticism at the Salon. Reviewers wrote that he was going in the wrong direction because of his lack of attention to detail and sketch-like handling. His paintings were seen as *ébauches*: preparatory works used for reference in the studio, but not worthy of the Salon. The critics had particular difficulty with the limited level of detail, which meant that his work offered only an 'impression', with too great an emphasis on strokes of colour.[11] Gautier, who had been so full of praise in 1859, wrote that Daubigny 'contents himself with an *impression* and so neglects the details. His *tableaux* are only *ébauches* and *ébauches* which have not been taken far … they offer only juxtaposed patches of colour.'[12] This free technique of loose touches was seen as an important characteristic of anti-academic painting, and Daubigny's 'système de touche' would become a significant recurring element in the reviews. Daubigny's biographer and friend Frédéric Henriet was to stand up for this technique and would later write, in his 1875 biography of the artist, that 1861 marked the start of a new development in Daubigny's talent.[13] The critic Jules-Antoine Castagnary, too, appreciated Daubigny's technique and even took the trouble to defend it in his review. His paintings, the critic believed, had 'at the same time the merit of a finished work and the charm of a newly started piece', precisely because the artist finished the canvas first, and then worked over it again with a few dabs of colour.[14] In Castagnary's view, Daubigny achieved an outcome reminiscent of the great classical French landscape painter Nicolas Poussin (1841–1895), but with a deeper colour effect and more sentiment. It is hard to conceive of higher praise than this.

As the 1860s progressed Daubigny started to make even less distinction between his impressionistic studies (*ébauches*) and finished paintings (*tableaux*), and this brought him closer to the new generation of landscape painters – Monet, Pissarro, Alfred Sisley and Berthe Morisot – who were achieving their first successes at around this time. Zacharie Astruc, for instance, devoted two laudatory pages to Pissarro's debut at the 1859 Salon, though without mentioning him by name.[15] Although the young artists took Daubigny's art as an example, as we shall see, Daubigny was not only a forerunner, but was also in tune with the Impressionists. His working methods and painting style were still evolving. The 1860s were to be a period of transition and innovation in which Daubigny and the younger artists were developing their new landscape painting at the same time. They tackled similar motifs – the rivers and the French countryside in the immediate environs of Paris and Normandy – and they experimented with brighter colours, greater luminosity and a forceful brushstroke in order to record their 'pure' impressions of nature.

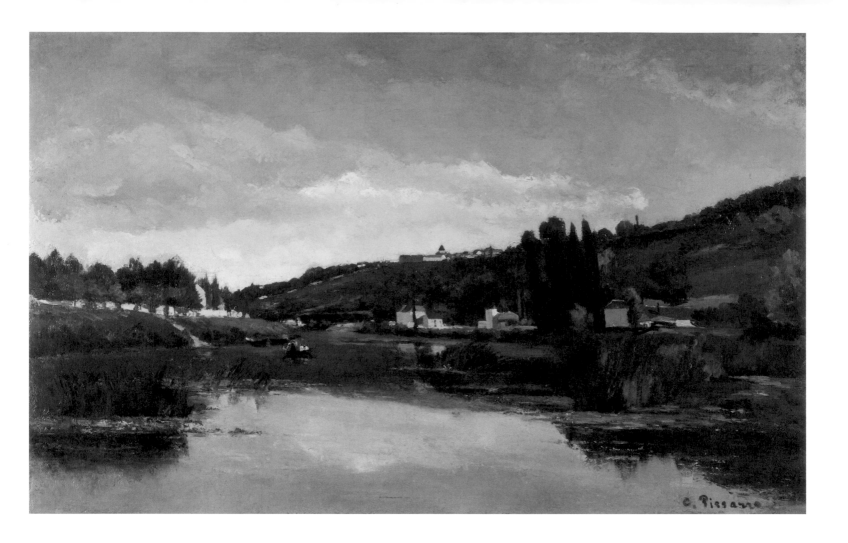

They found a common champion in the writer Emile Zola. He wrote of the 1866 Salon: 'I regret one thing: that more space could not be given over to three landscape artists I like: Messrs. Corot, Daubigny and Pissarro.'[16]

This shared vision of landscape and painting clearly emerged at the 1865 Salon. That year it included paintings by Monet and Pissarro which were very close to Daubigny's work in terms of subject, mood, effect, palette, size and handling. In painting *La Pointe de la Hève at Low Tide* (fig. 33), Monet must have had Daubigny's submission to the previous year's Salon in mind (fig. 131). It was probably not by chance that Monet chose a spot directly opposite Daubigny's *Cliffs near Villerville* as the setting for his painting. Their paintings were made on either side of the mouth of the Seine and the distance between the two locations is a mere six and a half nautical miles.

It is not clear whether the artists already knew one another at that time, but they certainly met later on the Normandy coast.

Monet had already made several paintings at Sainte-Adresse and Honfleur in 1864, probably as studies for his Salon work of 1865 (figs 34, 35 & 36). Like Daubigny's *Cliffs near Villerville*, Monet's Salon painting is dominated by a view of the chalk cliffs and the beach in stormy weather. Both painters put in the sky with louring clouds, using coarse, broad brushstrokes and focusing on capturing the effect of the light.[17] Monet's touch is rougher and slightly looser, and his sea is more turbulent than Daubigny's. In both paintings there are signs of human activity, such as the figures, boat and houses. Daubigny was widely praised for his painting, particularly for the melancholy sentiment it conveyed. Monet's work was also a success – even greater, according to his artist friend

Frédéric Bazille (1841–1870), than he had expected.[18] The critic Gonzague Privat wrote: 'Mr Monet's two seascapes are undeniably the best in the exhibition; the tone is candid, the breeze feels as if it is straight off the sea, the technique naive and youthful.'[19] Louis Gallet described Monet as a 'young realist', who was 'very concerned with the accuracy of the effect'.[20]

Daubigny's rendition of the effects of weather and light was not his only influence on the art of the new generation; his original compositions were also emulated. At the same Salon of 1865, for instance, Pissarro was represented by his *The Marne at Chennevières* (fig. 37), which has rightly been described as a homage to Daubigny's larger version of his *Ferryboat near Bonnières-sur-Seine* (fig. 38) shown at the 1861 Salon (now in a private collection).[21] Daubigny was known as the supreme painter of the river landscape and Pissarro deliberately followed in

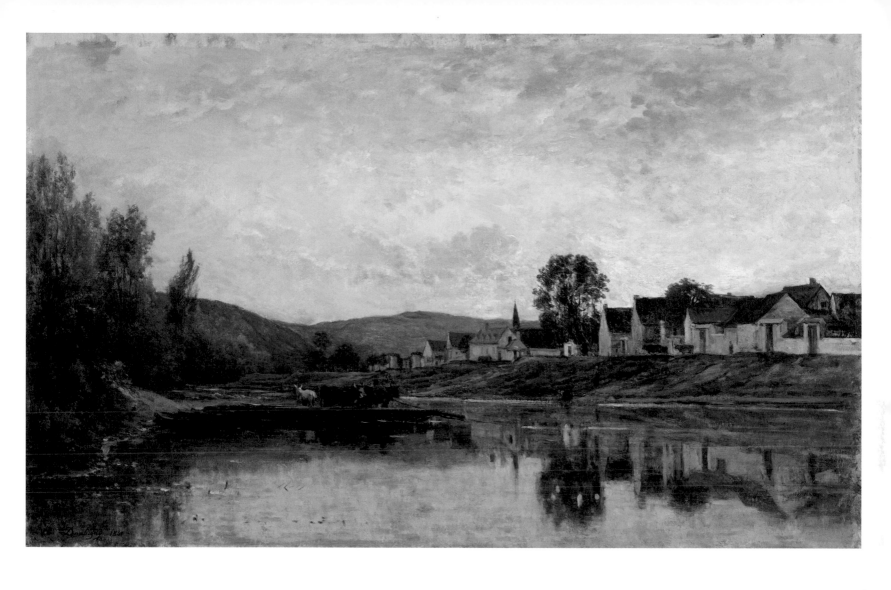

37
CAMILLE PISSARRO
The Marne at Chennevières, 1864–5
Oil on canvas, 91.5 × 145.5 cm
Scottish National Gallery, Edinburgh

38
CHARLES FRANÇOIS DAUBIGNY
Ferryboat near Bonnières-sur-Seine, 1861
Oil on canvas, 57.2 × 93.3 cm
Taft Museum of Art, Cincinnati, 1931.463

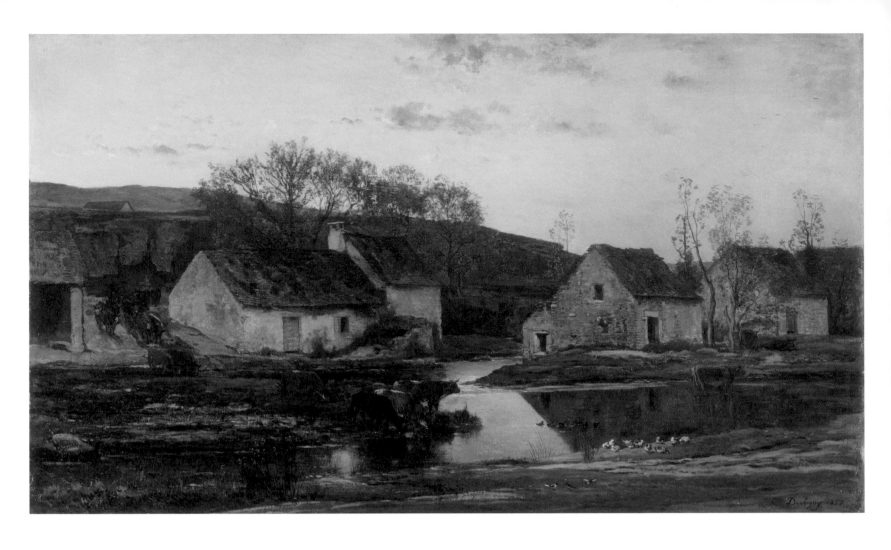

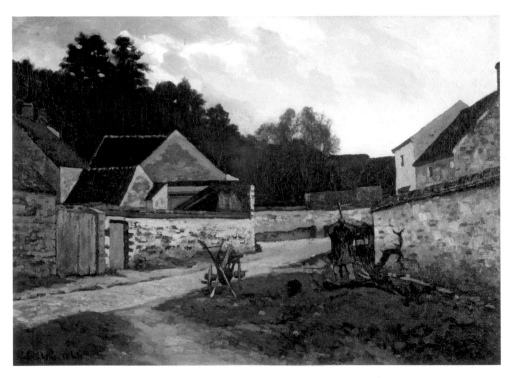

39

CHARLES FRANÇOIS DAUBIGNY
The Mill, 1857
Oil on canvas, 86.7 × 150.5 cm
Philadelphia Museum of Art, The William L. Elkins
Collection, 1924, E1924-3-4

40

ALFRED SISLEY
Village Street in Marlotte, 1866
Oil on canvas, 84.8 × 111.1 cm
Albright-Knox Art Gallery, Buffalo, 1956:1

his footsteps. With an almost identical vantage point – from the middle of the river – he painted the reflections in the water and the buildings along the banks. But where Daubigny added a narrative element to an otherwise unremarkable riverscape – a farmer moving his cattle at the end of the day – Pissarro focused more on composition and form.[22] Both artists used a fairly broad, loose touch, although Pissarro's brushstrokes are even rougher and he used a palette knife for the central section – a technique inspired by Gustave Courbet's paintings, and thus further removed from the academic conventions of refinement and finish.

At the 1866 Salon Alfred Sisley showed a view of the village of Marlotte (fig. 40). He worked in this hamlet on the southern edge of the Forest of Fontainebleau in company with Pierre-Auguste Renoir (1841–1919). The simplification of forms has much in common with a work that Daubigny had painted in Optevoz in the Isère, almost ten years earlier (fig. 39). Both paintings depict unpretentious spots; they concentrate on 'the natural, the unassuming, the real',[23] but the subdued palette infuses them with a sombre mood. Both artists, moreover, manipulated reality and arranged the forms so as to create balanced compositions. The lack of detail and finish in these painting was, of course, problematic for the conservative critics.

Daubigny and the Impressionists also had contacts outside of the annual Salons. In addition to Monet, Daubigny had met Berthe Morisot who, in the summer of 1863, had been to lunch with him in Auvers, a village on the banks of the Oise some eighteen miles to the north of Paris; they had been introduced by their mutual friend, the painter Achille-François Oudinot (1820–1891). Through him Daubigny also met Antoine Guillemet,

and the two landscape painters became close friends. The younger Guillemet often went out with Daubigny on his boat, which he had converted into a studio.[24] In around 1864 Guillemet met the young Impressionists at both the Café Guerbois and in the Atelier Suisse in Paris. Pissarro became one of his closest friends, and in 1866 he accompanied Paul Cézanne (1839–1906) to paint in Aix-en-Provence.[25] Guillemet was therefore an important link between Daubigny and the younger generation of artists in Paris. When Bazille in 1867, frustrated at yet another rejection by the Salon, decided to circulate a petition seeking permission for a Salon des Refusés similar to that which had been staged in 1863, this petition was signed by Daubigny, Guillemet, Manet, Monet, Pissarro, Renoir and Sisley. It emerges from a letter to his mother that Bazille's idea of hiring a space himself and mounting an exhibition there was also supported by some of the same artists: 'Courbet, Corot, Diaz, Daubigny and many others … have promised to send work and heartily support our idea. With these people, and Monet, the best of all of them, we are certain of success. You will see how much attention we will get.'[26] Although this exhibition did not take place, the petition did have a positive effect: the rules for electing the panel of judges for the Salon the following year were relaxed. This proved to work very much to the advantage of the young landscape painters.

The 1868 Salon
According to the new regulation any artist who had previously exhibited at the Salon was entitled to vote. For the Salon of 1868 Daubigny received the most votes. Under his direction the judges accepted a very large number of works (4,213 in total) and almost

all the future Impressionists (Bazille, Degas, Manet, Monet, Morisot, Pissarro, Renoir and Sisley) were admitted, marking a triumph for realistic landscape art. In his review Castagnary made his now legendary comment: 'The 1868 Salon is the Salon of Youth. There has been a revolution!'[27] This development caused Count Emilien de Nieuwerkerke considerable concern; as the director of all the museums in France he was also responsible for the Salon and for national art policy. According to Castagnary, Nieuwerkerke held Daubigny directly responsible: 'Mr de Nieuwerkerke blames Daubigny. If the Salon this year is what it is, a Salon of newcomers, if the doors were opened to almost everyone who applied, if the Salon had 1,378 items more than the previous year; if, in this explosion of free painting, State painting cuts a rather pathetic figure, then it is Daubigny's fault.'[28]

This was not the first time that Daubigny, as a member of the judging panel, had pushed for the acceptance of progressive entries. In 1866 he unsuccessfully defended the work of Renoir, Courbet, Pissarro and Cézanne, whose daring he preferred to the 'nullities which appear at every Salon'.[29] But in 1868 Daubigny was able to allow almost all the Impressionists to exhibit at the Salon, and he took the trouble to write to the artists himself to tell them of their success. The critics, particularly Castagnary, also stressed the decisive role Daubigny had played in this, for which history has judged him kindly. Although Daubigny influenced the Salon's tolerant policy in 1868, it should be noted the Impressionists had all had works accepted on previous occasions. In 1859 Pissarro became the first of this later group of artists to show at the Salon. Manet, whose work was an inspiration to the Impressionists, followed the year after, and went on to provoke the Parisian art

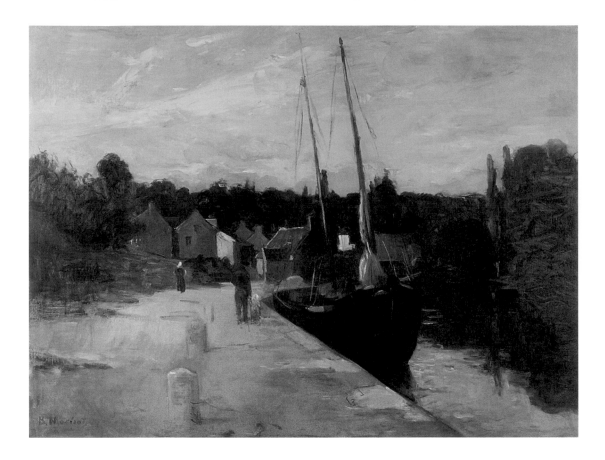

41
BERTHE MORISOT
Rosbras, 1866–7
Oil on canvas, 55 × 73 cm
Private collection, on loan to the Minnesota Marine
Art Museum, Winona

world on several occasions with his entries, among them the infamous *Olympia* in 1865. Morisot and Renoir made their debuts in 1864; Monet and Degas followed in 1865, and Sisley and Bazille in 1866. It is therefore only partly true to say that these artists owed their success to Daubigny. It is even possible to reverse this assertion: might it be conceivable that Daubigny wanted to associate himself with the growing appreciation of these new, progressive landscape artists, who had a similar vision of art and nature but were successfully taking it even further? That he wanted to be part – or even the foreman – of this new, young movement, which according to Castagnary unleashed a revolution and was embraced by the public as 'the spirit of the new age' and as 'the industrious youth of contemporary society'?[30] In any event, Nieuwerkerke had his doubts about the sincerity of Daubigny's intentions, as Castagnary's paraphrase of his words reveals: 'Daubigny has tried to fabricate popularity; he is ambitious, a liberal and a free thinker; one step further and he would be a materialist, and would have been invited to the famous Sainte-Beuve dinner.'[31] Nieuwerkerke was

clearly not charmed by Daubigny's free spirit, accusing him in passing of being out for personal gain. This was in stark contrast to Zola's praise of Daubigny in 1866, when he described him as the only one of the judges who would act in the 'name of truth and justice'. And Daubigny himself also expressed an idealistic standpoint in a letter he wrote to Henriet in 1875, in which he said that he had become one of the judges to combat the intolerance and dogmatism of the prevailing order.[32]

Be this as it may, both Daubigny and the Impressionists benefited from the situation and their landscapes triumphed at the Salon. Daubigny was praised for his impressions of nature: 'It is the portrayal of a moment or an impression. It is something he possesses very keenly and strongly, and he has never sought anything else.'[33] Daubigny's influence on the younger generation of landscape painters was remarked on in the press,[34] but there were also references to the impact these young artists were having on the older master: 'perhaps Mr Daubigny would be like one of these young artists who puts something together which he would be

unable to finish …?'[35] The young generation also achieved success with the public and various critics. Morisot's painting (fig. 41) was commended by Zola, who also described Pissarro as 'one of our era's greatest and most important talents' (fig. 42).[36]

Abroad with Daubigny
The outbreak of the Franco-Prussian War in July 1870 saw many French people flee abroad. Several artists moved to London, among them Daubigny and some of the Impressionists, although Daubigny and Monet spent the summer of 1870 on the Normandy coast: Daubigny painted in his beloved Villerville and Monet worked in nearby Trouville. The spring had been tumultuous. After stormy elections for the Salon judges, with opposing lists openly circulating in the newspapers, Daubigny and Corot were again elected with the greatest number of votes. This time, though, Daubigny was unable to prevent the rejection of Monet's submission. 'From the moment that I liked this picture, I wouldn't allow my opinion to be contradicted', Daubigny proclaimed. 'You might as well say I don't know my trade.' He decided to

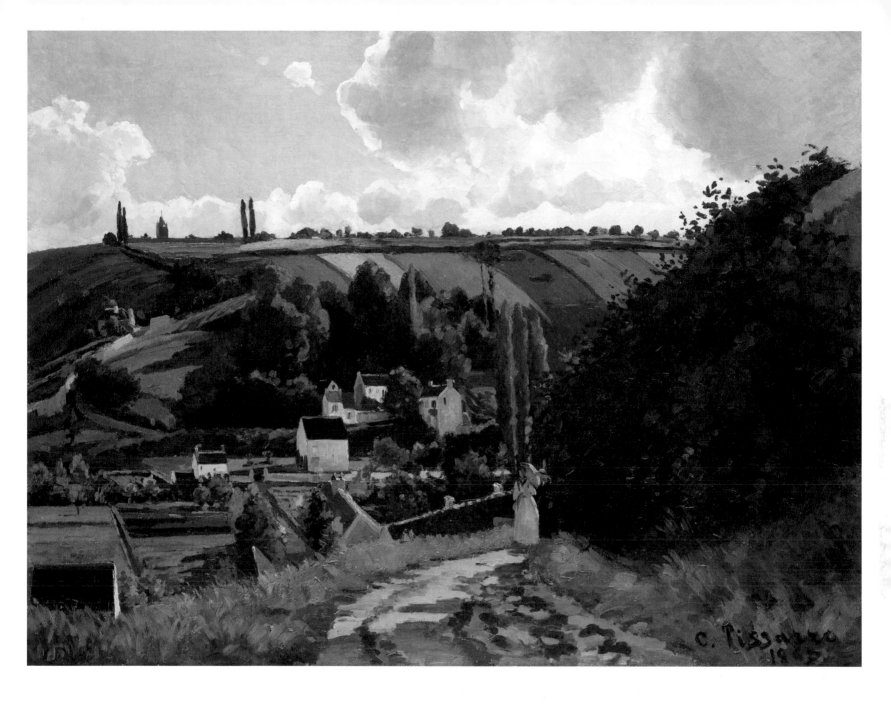

42

CAMILLE PISSARRO

Côte du Jallais, Pontoise, 1867

Oil on canvas, 87 × 114.9 cm

The Metropolitan Museum of Art, New York, bequest
of William Church Osborn, 1951, 51.30

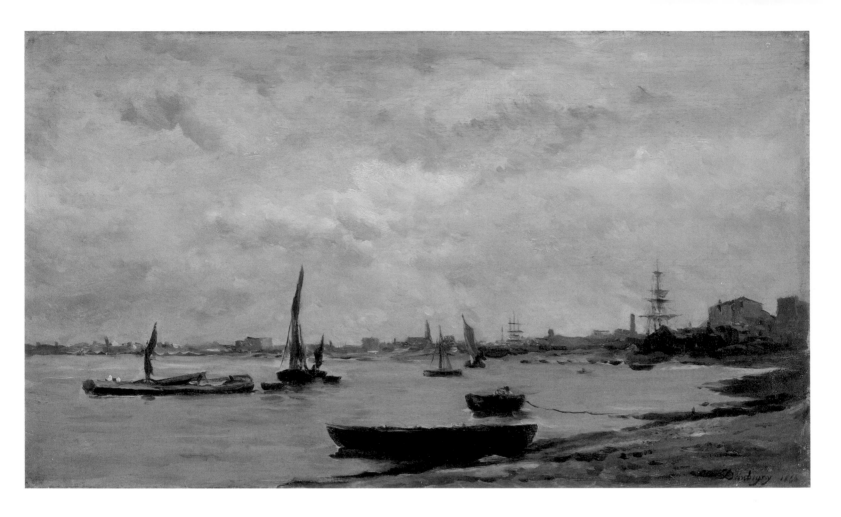

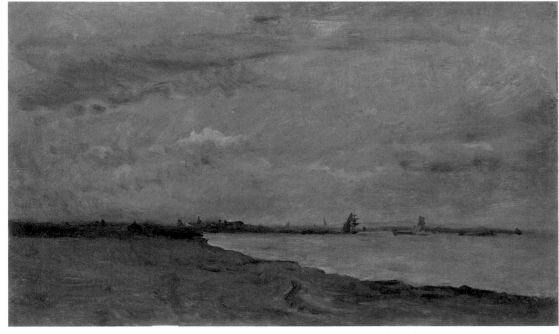

43

CHARLES FRANÇOIS DAUBIGNY
Scene on the Thames, 1866
Oil on panel, 26.7 × 45.5 cm
Museum of Fine Arts of Lyon

44

CHARLES FRANÇOIS DAUBIGNY
Bank of the Thames, c. 1868
Oil on canvas, 31.7 × 54 cm
The Mesdag Collection, The Hague

45

CHARLES FRANÇOIS DAUBIGNY
St Paul's from the Surrey Side, 1871–3
Oil on canvas, 44.5 × 81 cm
The National Gallery, London

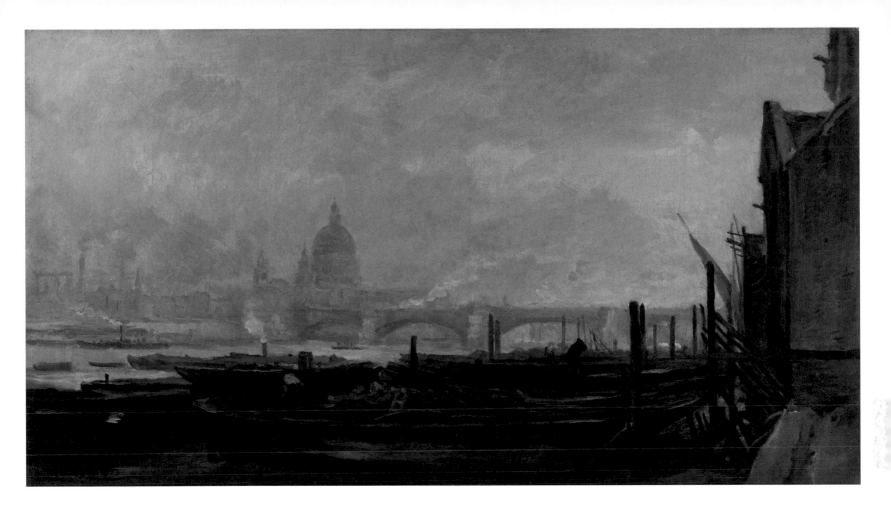

step down.[37] At the end of the year, Daubigny was able to right this wrong by including Monet's work in an exhibition in London, which he co-organised, for the 'distressed peasantry' in France. Monet had only just arrived in London – the exhibition opened on 17 December 1870. Daubigny had been in the city since October and had already built up a sizeable network of contacts, as evidenced by a list of names and addresses that he kept.[38] It was not Daubigny's first visit to London, of course; he had spent some time there in 1866 and made a number of riverscapes (figs 43, 44 & 155). Daubigny's circle of acquaintances included collectors, other artists – James Abbott McNeill Whistler among them – and, most importantly, the dealer Paul Durand-Ruel.

Faced with the Prussian threat, this French art dealer had also gone to London, where he had established a gallery. Ironically, it was called the German Gallery because Durand-Ruel had

been obliged to take over the name of the gallery previously located in the premises.[39] Possibly to take the sting out of the name, but also to strengthen his reputation, Durand-Ruel set up the Society of French Artists – a number of well-known French artists who would be associated with his gallery. The artists – including Courbet, Corot, Millet and Daubigny – were unaware of their involvement, but nevertheless this imaginary committee staged no fewer than eleven successful exhibitions in the space of five years. At these shows, organised by Durand-Ruel, there were works both by these more established masters and by the next generation. At the 1874 exhibition of this group – the same year as the first Impressionist exhibition in Paris – Daubigny's St Paul's from the Surrey Side (fig. 45) hung along with four works by Pissarro, three Monets (fig. 49), three Sisleys (fig. 48), a Morisot and a Manet.[40] When Monet was asked years later about his relationship with

Daubigny, he said the introduction to Durand-Ruel was the most important outcome. He wrote: 'He put me in touch with Mr Durand-Ruel, thanks to whom I and several of my friends did not starve to death. It is something I will not forget.'[41] Durand-Ruel also had vivid memories of this meeting; he noted that Daubigny introduced the young painter as someone who 'will be more important than all the rest of us'.[42] Monet was not the only artist Daubigny introduced to Durand-Ruel; he also brought Pissarro to his notice, as we read in another of Monet's letters: 'And here he is [Daubigny], all fired up and carried away, promising to come to our rescue, me and Pissarro. "I am going to send you a dealer," he said. And sure enough, old father Durand turned up soon after.'[43] Monet and Pissarro spent a lot of time working together in this period, painting in the parks (fig. 46), visiting the museums and discovering English art. It is clear that the young Impressionists

46

CLAUDE MONET

Green Park, London, 1870/1
Oil on canvas, 34.3 × 72.5 cm
Philadelphia Museum of Art, purchased with
the W. P. Wilstach Fund, 1921 W1921-1-17

47

CLAUDE MONET

The Zaan at Zaandam, 1871
Oil on canvas, 42 × 73 cm
Private collection

48

ALFRED SISLEY

View of the Thames: Charing Cross Bridge, 1874
Oil on canvas, 33 × 46 cm
Private collection, on loan to the National Gallery,
London

49

CLAUDE MONET

The Thames at London, 1871
Oil on canvas, 48.5 × 74.5 cm
Amgueddfa Cymru – National Museum Wales

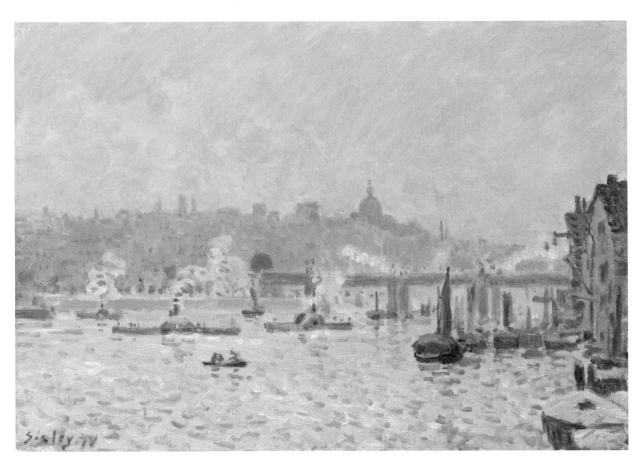

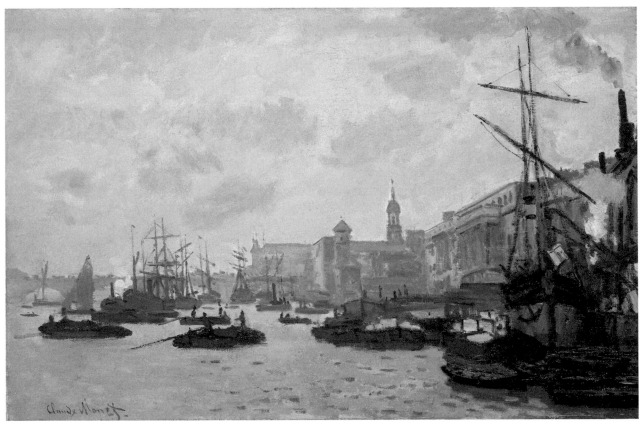

59

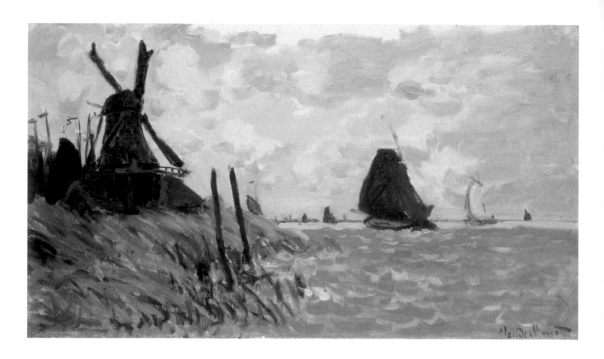

50
CLAUDE MONET
A Mill near Zaandam, 1871
Oil on canvas, 42 × 73.5 cm
Ashmolean Museum, Oxford

51
CHARLES FRANÇOIS DAUBIGNY
Mills at Dordrecht, Salon of 1872
Oil on canvas, 84.5 × 146 cm
Detroit Institute of Arts, gift of
Mr and Mrs E. Raymond Field, 32.85

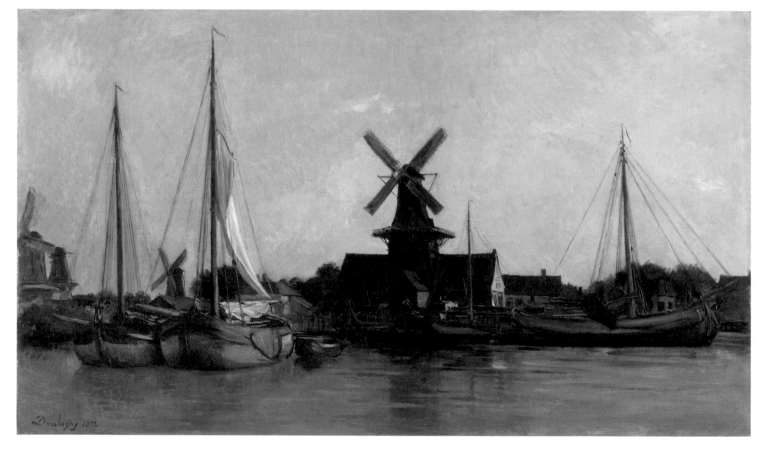

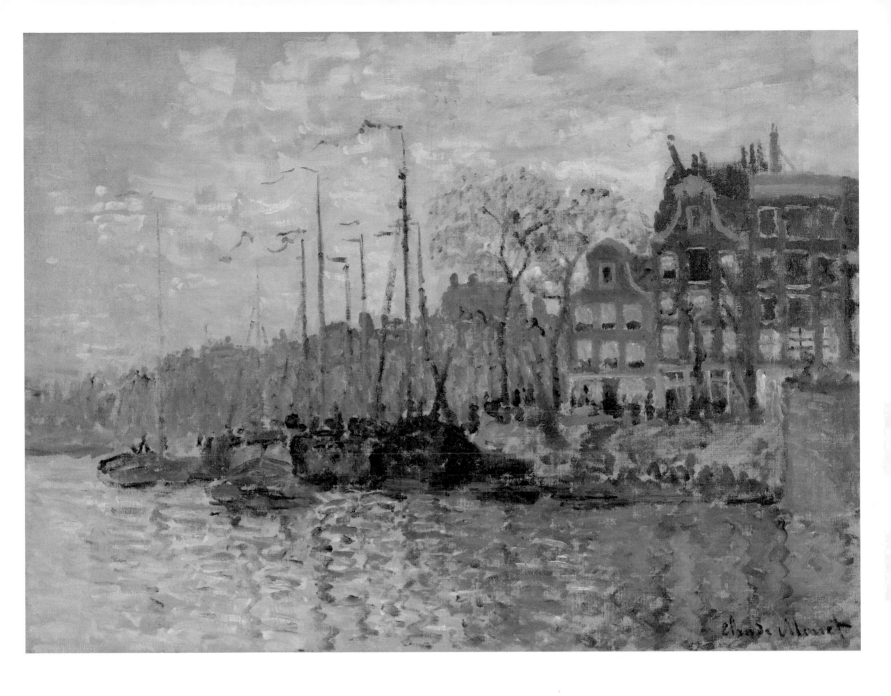

52

CLAUDE MONET
View of Amsterdam, 1874
Oil on canvas, 50.3 × 68.5 cm
Van Gogh Museum, Amsterdam, purchased with
support from the BankGiro Lottery, Stichting
Nationaal Fonds Kunstbezit, the Ministry of
Education, Culture and Science, the Mondriaan
Fund, Rembrandt Association, the VSB Foundation
and the Vincent van Gogh Foundation

53

CLAUDE MONET

Windmills near Zaandam, 1871
Oil on canvas, 48.3 × 74.2 cm
Van Gogh Museum, Amsterdam, purchased with
support from the BankGiro Lottery, Stichting
Nationaal Fonds Kunstbezit, the Ministry of
Education, Culture and Science, the Mondriaan
Fund, Rembrandt Association, the VSB Foundation
and the Vincent van Gogh Foundation

could still count on Daubigny's help in England.
He even told Durand-Ruel that he was prepared to
exchange unsold works by Monet for his own work.
This does not appear to have been necessary, but
Daubigny did buy one of Monet's paintings, *The Zaan
at Zaandam*, through Durand-Ruel (fig. 47).[44] Monet
had painted it while he was staying in Zaandam
in the summer of 1871 (from June to October).
Daubigny was also in the Netherlands in September
1871 and made several paintings of Dutch rivers.
He does not appear to have made all of these
works *en plein air*, however, for he wrote to Henriet:
'I am rushing back to Paris so I can try to apply to
canvas the excellent lessons learned in Holland.'[45]
The Dutch river scenes of Monet and Daubigny are
very different. Monet's rivers are built up with large
areas of colour and rhythmic brushstrokes that
suggest the movement of the water and changes
in wind and weather (figs 50, 52 & 53). Daubigny's
rivers, by contrast, are calm streams executed in
more muted, silvery tones (fig. 51). In their choice of
motif, approach to composition and vantage point on
the water, however, Monet and Daubigny are closely
comparable.

Daubigny continued to paint impressions of
nature in the 1870s, taking his inspiration from
the new painting techniques, materials and stylistic
developments of the Impressionists.[46] The connection
between the different generations of landscape
painters was considerable and the relations and
influences among them were strong. As the critic
Victor Fournel concluded: 'The Impressionists rubbed
their hands with delight before his [Daubigny's] latest
works, saying: he's one of ours.'[47]

Tales of the Riverbank: Daubigny's River Scenes

Michael Clarke

'... for it's very much on the banks of rivers that one sees the most beautiful landscapes.'[1]

Daubigny, letter of 27 September 1867

Daubigny's fascination with river scenery is nowhere better expressed than in this letter to his friend and champion, the writer and landscape painter Frédéric Henriet. In this correspondence Daubigny also announced his intention of commissioning a new studio boat (the *Botin*) for the following spring in order to work on the rivers Loire and Marne. His original floating atelier, in which he had first set sail in 1857, needed replacing, such had been the extensive use to which he had subjected it as he portrayed the major rivers of northern France.

In his exploration of this particular genre Daubigny was consciously making use of one of France's greatest visual assets. Rivers had played a crucial role in French history and the country is blessed with some of the most beautiful and distinctive waterways on the European mainland.[2] As early as the first century BC the Greek geographer Strabo had remarked how well served Gaul was by its rivers, and how cargoes could be transported to most places by water as opposed to land. Sixty-one of the original eighty-three *départements* of France would be named after its rivers. By the end of the nineteenth century France could boast over 4,000 miles of navigable river and over 3,000 miles of canal. Travel by water was slow, however, and if speed was of the essence,

then the rapidly expanding railway network provided an increasingly attractive alternative. River-borne journeys, by contrast, afforded the opportunity to view the passing landscape at leisure. Thus Gustave Flaubert, in the first chapter of his great novel *Sentimental Education* (1869), the opening of which is set in the politically tumultuous year of 1848, had his young protagonist Frédéric Moreau set out from Paris on the paddle-steamer to Nogent-sur-Seine: 'The river was lined with sand-banks. The boat kept coming across timber rafts which rocked in its wash, or a man sitting fishing in a dinghy. Then the drifting mists melted away, the sun came out, and the hill which followed the course of the Seine on the right gradually grew lower, giving place to another hill, nearer the water, on the opposite bank … The novel pleasure of a trip on the river banished any feelings of shyness and reserve. The practical jokers started getting up to their tricks. A good many began singing. Spirits rose. Glasses were brought out and filled.'[3]

The beauties of river scenery and the relaxed behaviour it could engender are both encapsulated in this passage. They were qualities which very much stimulated and were illustrated by Daubigny in his affectionate volume of etchings, *Le Voyage en bateau*,

DETAIL fig. 67
CLAUDE MONET
The Studio Boat, 1876

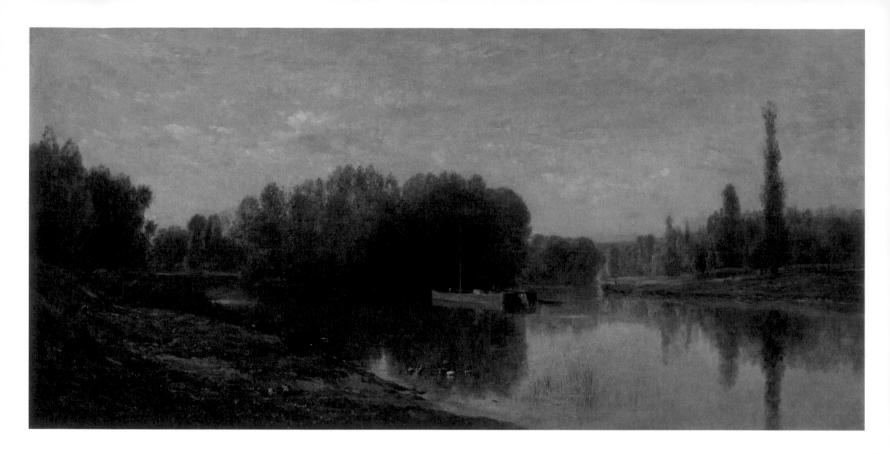

published in 1862, and which will be examined in detail in the course of this essay.

By the 1860s Daubigny had, after decades of solid endeavour, gained widespread critical recognition in the public realm, though he was criticised in some quarters for the apparent lack of 'finish' in his exhibited pictures. However, his carefully composed river scenes such as *Banks of the Oise* (fig. 54), shown at the 1859 Salon, were generally well regarded.[4] The picture was bought by the photographer Nadar (1820–1910) straight from the artist's studio (before it had been shown at the Salon) and presented to the museum in Bordeaux. Daubigny could rightly claim, by that date, to have become the master of this particular genre and had gradually developed a formula of broad-formatted views, sometimes taken from the riverbank, at others from mid-stream (from his studio boat), in which nature predominates and human presence is limited in the main to rural stereotypes. Intriguingly, one of his early etchings, an illustration to the Saint-Simonian *Fables* (1851) of Pierre Lachambeaudie, had been entitled *Two Riverbanks* (fig. 55),[5] illustrating on the left bank the ugliness of industrialisation and on the opposite

side the Edenic virtues of unspoilt countryside. Daubigny would pitch his artistic tent firmly on the right bank.[6]

Although reaction to Daubigny's 1859 Salon submissions had been generally favourable, he frequently had to endure a fairly bumpy ride from the critics, and it is often surprising to present-day readers to find that Daubigny's seemingly uncontroversial art could attract some of the same sort of opprobrium that would later be directed towards the young Impressionists. For example, his placid and carefully composed *View of Gloton, near Bonnières* (fig. 56), shown at the 1861 Salon, was thought to be nothing more than an *ébauche* (lay-in sketch) by Olivier Merson,[7] and Théophile Gautier considered it 'a beautiful study and nothing more'.[8] Théophile Thoré even wondered if the village of Gloton was made 'of cardboard or of tin'![9] It was not the subject matter which irked these commentators but Daubigny's bold and seemingly rough and 'unfinished' technique. However, his originality in this respect must surely have inspired artists such as Camille Pissarro, and in particular his submission to the 1865 Salon, *The Marne at Chennevières*

54
CHARLES FRANÇOIS DAUBIGNY
Banks of the Oise, 1859
Oil on canvas, 88.5 × 182 cm
Musée des Beaux-Arts, Bordeaux

55
CHARLES FRANÇOIS DAUBIGNY
Two Riverbanks, engraving for Pierre Lachambeaudie's *Fables*, 1851

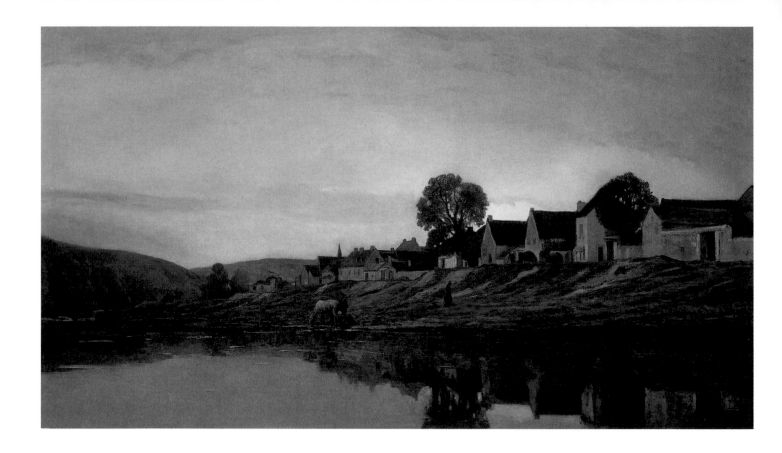

56

CHARLES FRANÇOIS DAUBIGNY
View of Gloton, near Bonnières, 1861
Oil on canvas, 85 × 150 cm
Private collection

(fig. 37), with its broad panoramic sweep indicating a viewpoint taken from mid-stream. The technique is even bolder than Daubigny's with its strident use of the palette knife, a device doubtless inspired by Gustave Courbet. Pissarro must have deliberately chosen this picturesque locale in consideration of its widespread popularity at the time. A pictorial guide to the River Marne, published in the same year as Pissarro exhibited this painting at the Salon, extolled its attractions. According to its author, Emile de La Bedolière, the scenery there was cherished by artists and canoeists who were '… the undoubted masters of a charming river, strewn with islands whose vegetation rivalled that of the tropics, lined with cheerful villas and dominated by hillsides from where the views encompassed a vast horizon. Great trees reflected in the waters that bathe their feet, forests of plumed reeds, multitudes of aquatic plants, give to the banks of the Marne, spared from having towpaths, the appearance of unspoilt nature, few examples of which have been left by civilisation, especially on the outskirts of great cities.'[10]

Another of Pissarro's Salon pictures of the mid-1860s, *Banks of the Marne* (fig. 57), exhibited in 1864, was formerly identified as depicting the towpath on the Marne but this was evidently incorrect.[11] It may well depict the Marne but, as La Bedolière indicated, the river had no towpaths and the path depicted in the painting is high up and away from the water.

The virtues of such scenery as extolled by La Bedolière held equally true for Daubigny. The riverside beauties of the Oise, Seine and Marne lay within easy reach of an increasingly industrialised Paris; for both artist and public they represented a welcome escape from the pressure and ugliness of urban life, and for the latter offered an attractive option for weekend tourism.

Life on the river was celebrated, albeit in more robust and personalised fashion, by Daubigny in his anecdotal, and initially private and familial, series of etchings, *Le Voyage en bateau*, published in 1862. In 1857 he had purchased a boat from his friend Baillet in Asnières. Originally built as a ferry, Daubigny had it converted into a floating studio (fig. 62).[12] It measured twenty-eight feet long by six feet abeam and provided rudimentary living quarters, storage space and an 'area from which to paint *en plein air*'. It served as the floating platform from which Daubigny

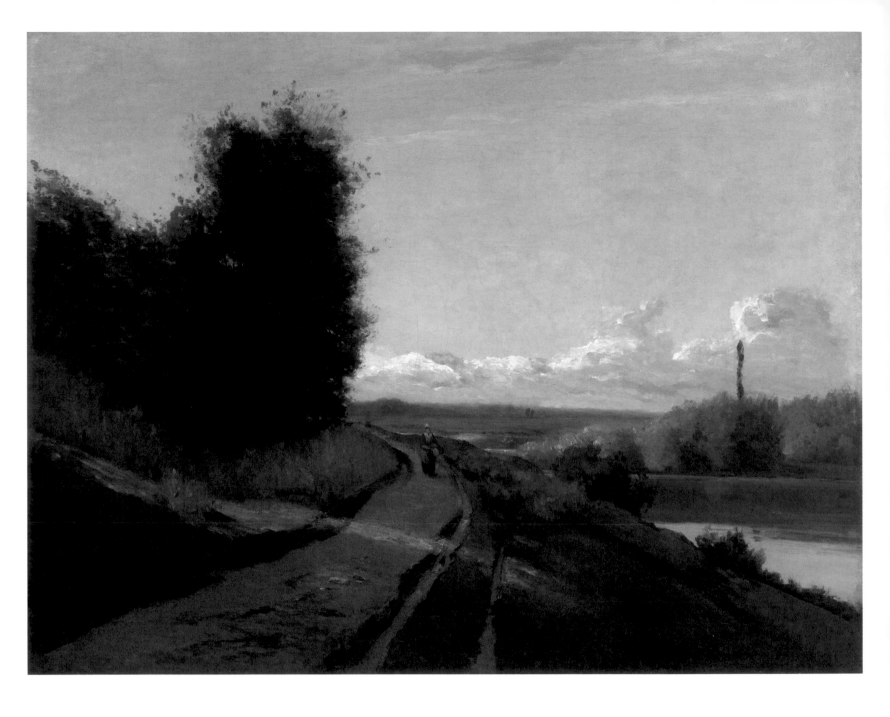

57
CAMILLE PISSARRO
Banks of the Marne, 1864
Oil on canvas, 81.9 × 107.9 cm
Kelvingrove Art Gallery and Museum, Glasgow

58
CHARLES FRANÇOIS DAUBIGNY
Tugboat near Le Havre, c. 1860
Oil on board, 21.2 × 45.4 cm
The Art Institute of Chicago, bequest of
Dr John J. Ireland, 1968.89

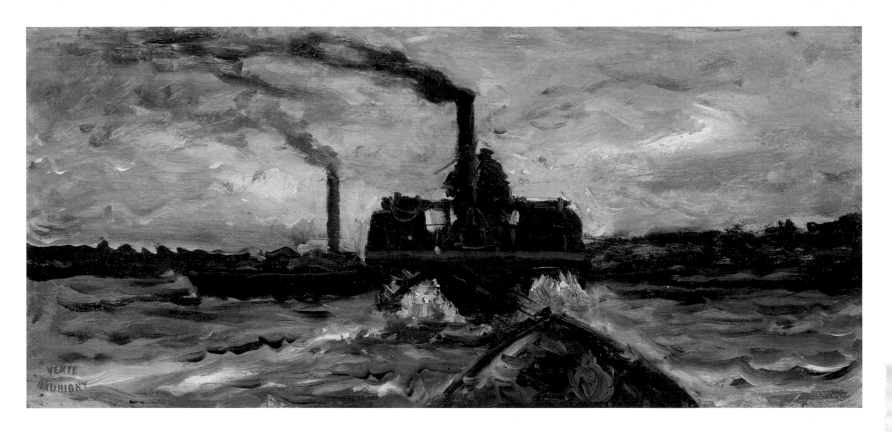

could observe life on the river and on the riverbank.[13] Of necessity it provided a low viewpoint for the artist, thereby heightening the sense of realism with which he was able to record passing scenery. This created an immediacy that was missing from Daubigny's most obvious forebears in this respect, namely the majority of Dutch seventeenth-century river paintings in which the viewpoint was nearly always raised, and therefore imaginary.[14]

The earliest reference by Daubigny to the *Botin* is found in a letter from Mantes, dated 28 October 1857, in which he made it clear that it was already in use and had been to many places, including La Frette and Herblay,[15] both of them situated on the Seine just under fifteen miles to the north-west of Paris. The origins of the word *botin* are not entirely clear. According to Henriet, it derived from the box-like (*boîte*) shape of the modified craft,[16] though spelling varied according to author. Daubigny, for example, always preferred *bottin*. The houseboat could function with three or six oars or, on occasion, with a sail. It could also be towed by a tug, as is made clear by the dramatic oil sketch *Tugboat near Le Havre* (fig. 58) painted from the prow of the boat as it was being

pulled through the choppy waters of the mouth of the Seine near Le Havre. Indeed Henriet, who provided the introductory text to the *Voyage en bateau*, noted the difficulties of coping with river traffic, particularly on the large and commercially busy Seine, where the wash of passing steamers had frequently to be avoided. The challenge of working from a small boat was later described by the painter Berthe Morisot when staying on the Isle of Wight in 1875: 'Everything sways, there is an infernal lapping of water; one has the sun and wind to cope with, the boats change position every minute…'[17]

There can be no doubt that Daubigny enormously enjoyed the experience of working from the *Botin* and he wished to convey that pleasure to his family and close friends. To that end he compiled an anecdotal *carnet* of forty-seven drawings illustrating his voyages on the studio boat.[18] Given the lush vegetation which features in many of these drawings it is reasonable to assume they were executed in the spring or summer of 1858, or perhaps the following year. Although they were intended for private viewing, they were seen by the dealer and publisher Alfred Cadart (1828–1875) who, in 1862, founded the Société des aquafortistes

('Etching Society'). At Cadart's behest, fifteen of the drawings were chosen and illustrated as etchings in the *Voyage en bateau*, which included Henriet's four-page introductory text and was printed by Delâtre in Paris. Daubigny was a very experienced printmaker having earned his living for many years as a graphic artist, illustrating books, magazines and travel guides.[19] His graphic style was steeped in a profound knowledge of the great Dutch seventeenth-century printmakers, many of whom he had consciously imitated in his own works.

In the case of the *Voyage*, as was usual practice, he transferred the original drawings selected for publication to the etching plates by tracing their designs onto sheets of semi-transparent *papier calque*. These new drawings were visible from both sides of the paper and could be placed face down on the copper printing plates, but in reverse to the original drawing. The result was that, when printed from, the plates delivered the designs in the same orientation as the original drawings. Remarkably, Daubigny's transfer drawings for the *Voyage* have survived and recently came to light in an exhibition organised by the Jill Newhouse Gallery in New York.

59

CHARLES FRANÇOIS DAUBIGNY
'Moving into "Le Bottin"', from *Le Voyage en bateau*,
1862
Etching, 10.2 × 16 cm
Bibliothèque nationale de France, Paris

60

CHARLES FRANÇOIS DAUBIGNY
'Lunch on the Boat', from *Le Voyage en bateau*,
1862
Etching, 10.6 × 16 cm
Bibliothèque nationale de France, Paris

61

CHARLES FRANÇOIS DAUBIGNY
'Open-air Lunch', from *Le Voyage en bateau*, 1862
Etching, 10.3 × 15.5 cm
Bibliothèque nationale de France, Paris

62

CHARLES FRANÇOIS DAUBIGNY
River Scene with Ducks, 1859
Oil on panel, 20.4 × 40 cm
The National Gallery, London

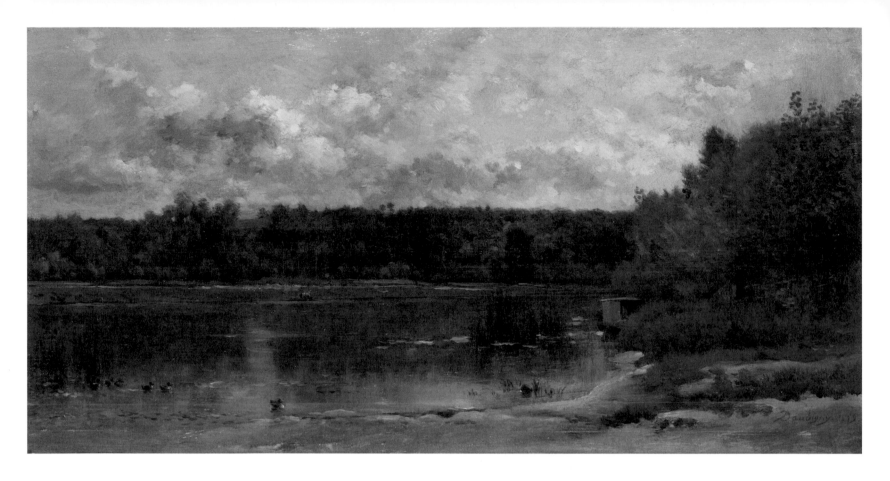

They came from an album of Daubigny drawings previously owned since the nineteenth century by the family of Maurice LeGarrec, partner in the Sagot LeGarrec gallery in Paris.[20]

The 'story' as it unfolds in the *Voyage* is one of good-humoured bonhomie. There is an open-air lunch before departure from Asnières (fig. 61).[21] The *Botin* can be seen moored on the right. At the extreme left sits Daubigny's son Karl, born in 1846, who would accompany his father on the trip as cabin boy or *mousse*. To his right is Daubigny himself, smoking a pipe. The other three figures remain unidentified. Though it would be tempting to suggest one of them was Daubigny's great friend and fellow artist Camille Corot, this cannot be adduced with any certainty as none of the figures bears a marked resemblance to him. It was Corot who had encouraged Daubigny to move to Auvers-sur-Oise in 1860 and to build a house there, and it became very much Daubigny's base of operations for the rest of his career. In Daubigny's accounts of his trips in the *Botin* Corot is referred to as the Honorary Admiral and he is known to have attended departures and return feasts. In 'Moving into "Le Bottin"' (fig. 59)[22] Karl is shown pulling a wagon loaded with a mattress, assisted enthusiastically by children from the village. The woman carrying the two toddlers could possibly be Madame Daubigny. There is something of the noble/heroic peasant imagery of Jean-François Millet (1814–1875) about her, while the notion of children helping with tasks such as this recalls the Rococo visual trope of children performing adult work as found in the compositions of François Boucher (1703–1770) and his contemporaries. Just visible on the left is the waiting *Botin* with its sail raised. The craft belonged to the category of boats known as *gabares* (from the occitan *gabarra*), which had flat bottoms and drew very little water. They could be rowed, sailed or, as is the case in 'Hauling by Rope',[23] they could be towed. In this instance it is Karl who is pulling the boat along while his father works in the *Botin*. 'Lunch on the Boat' (fig. 60)[24] is a rustic affair with a coffee pot and frying pan in the stern of the boat generating a great deal of smoke as father and son both sit astride a wooden bench in the boat and consume their meal, eagerly watched by caricatured fish who, half out of the water, await any morsels of food which may be thrown into the river. Nights were sometimes spent on board though, according to Henriet, Daubigny could be disturbed by the nocturnal frolicking of the fish, or by the discomfort of sharing his mattress with unwelcome guests such as amphibious rodents. The greater comfort afforded by inns was therefore sought on occasion, though the happenstance nature by which such accommodation was found is demonstrated in 'The Search for an Inn'[25] in which father and son, aided by the light of a lantern, approach a group of houses in the gathering gloom of evening. Night fishing from the *Botin* was also portrayed, using a lantern to attract and blind the fish, though strictly speaking this was illegal.

Perhaps the key image in the whole series is 'The Studio on the Boat' (fig. 63),[26] which serves as a manifesto for Daubigny's art. Daubigny depicts himself seated and painting directly from nature looking out of the window-like opening at the front of the cabin.[27] He would appear to be using the lid of his paint box as an easel to support the small picture on which he is working. This was the main purpose of these voyages in the *Botin*, namely the gathering of raw material in the form of *pochades* (oil sketches), some of which would later be used in

the preparation of larger, more composed pictures. Daubigny had already acknowledged this activity in his October 1857 letter to his sculptor friend Adolphe-Victor Geoffroy-Dechaume in which he described the first forays in the *Botin*: 'We travel, as you see, in short days; the days are so brief now, especially if you want to make pochades en route. You should see the grrreat pandemonium of pochades on board the Botin as that is carried out…'[28] Some of these must have been intended for sale as works of art in their own right, their relatively unfinished state notwithstanding. Daubigny's pupil Dwight W. Tryon (1849–1925) later recalled: 'The number of sketches which he brought back after a few days' journey was surprising, and many of the smaller paintings which are today found in various collections are the results of a few hours work, and were rarely touched the second time.'[29] These would have accorded well with the smaller, less finished landscapes that Daubigny's great contemporaries, Corot and Théodore Rousseau, were also being encouraged to produce from mid-century onwards in response to a growing 'dealer'-inspired taste for such works.

Humour is ever-present in the *Voyage*. In 'Watch Out for the Steamers' (fig. 65)[30] the little craft is tossed sideways by the wash of passing steamboats leaving Daubigny father and son manfully rowing hard to right the vessel. Fish, no longer at peril from the fishing rod or net, literally jump for joy in 'Rejoicing of the Fish at the Departure of the Cabin Boy'[31] as the *Botin* is towed off towards the horizon. In the final print, 'The Departure' (fig. 64),[32] modern transport triumphs as the travellers, father and son, leave by train, waving out of the carriage window, while the *Botin* can be seen on the river to the left. Drawings that were not used for the print series included depictions of the perils of breaking oars, and of the *Botin* being towed back to Paris with several large fish greedily eyeing a vulnerable frog and two eels spectating with glee.

The Impressionist painter Claude Monet would be profoundly influenced by Daubigny's river scenes, both by their subject matter and by the financial success they enjoyed, and he followed Daubigny's example by acquiring his own studio boat. Monet was reputedly

63

CHARLES FRANÇOIS DAUBIGNY

'The Studio on the Boat', from *Le Voyage en batcau*,
1862

Etching, 10 × 13 cm

Bibliothèque nationale de France, Paris

64

CHARLES FRANÇOIS DAUBIGNY

'The Departure', from *Le Voyage en bateau*, 1862

Etching, 10.2 × 15.8 cm

Bibliothèque nationale de France, Paris

65

CHARLES FRANÇOIS DAUBIGNY

'Watch Out for the Steamers', from *Le Voyage en
bateau*, 1862

Etching, 11 × 15.5 cm

Bibliothèque nationale de France, Paris

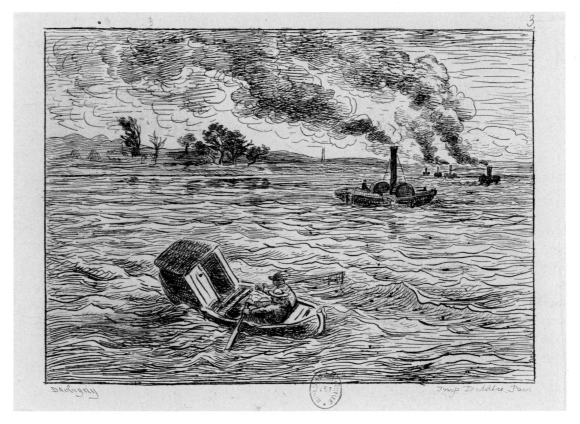

dubbed 'the Raphael of water' by his fellow painter
Edouard Manet,[33] such was his interest throughout
his career in the shimmering, ever-changing surfaces
of pond, river and sea.

Daubigny had supported Monet's early
submissions to the Salon and had offered help,
including an introduction to the dealer Durand-Ruel,
when the two artists were in temporary exile in
London during the Franco-Prussian War (1870–1).
On his return to France Monet settled at Argenteuil,
a small riverside town on the Seine twelve miles
north-west of Paris.[34] River scenery increasingly
preoccupied him and, probably in 1873, he followed
Daubigny's example and acquired his own studio
boat, the better to observe and paint the rich variety

66
CLAUDE MONET
The Studio Boat, 1874
Oil on canvas, 50.2 × 65.5 cm
Kröller-Müller Museum, Otterlo

67
CLAUDE MONET
The Studio Boat, 1876
Oil on canvas, 54.5 × 65 cm
Musée d'art et d'histoire, Neuchâtel

68
CLAUDE MONET
The Village of Lavacourt, 1878?
Oil on canvas, 35.5 × 73 cm
Private collection

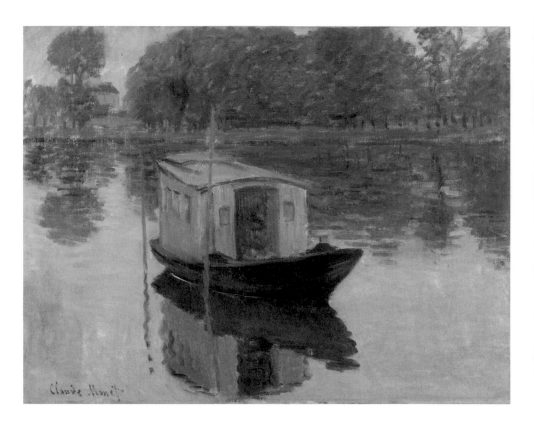

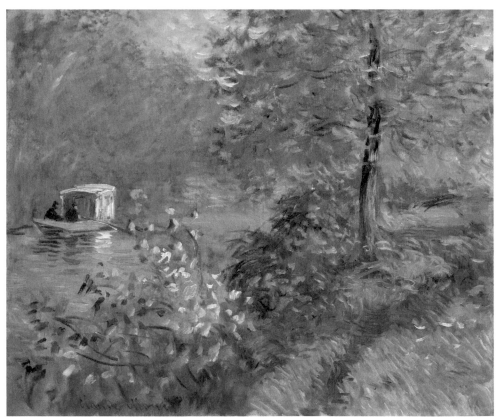

of riverine scenery that Argenteuil and its environs afforded him. However, as many commentators have pointed out, there was a fundamental difference of approach to subject matter between the two artists. Whereas, with a few exceptions such as the factory chimney visible in the far distance of his *The River Seine at Mantes* (fig. 8), Daubigny deliberately excluded most references to modern life and continued to regard the river and riverbank as essentially a rural and escapist idyll, Monet included factories, railway bridges, leisure craft and plentiful evidence of the growing suburbanisation of Argenteuil.

Monet's boat was probably financed by the results of 'a fruitful sale'. In shape it was almost identical to Daubigny's but was relatively cramped as far as space was concerned. Monet described it as having 'a cabin made out of planks where I had just enough room to set up my easel'.[35] Its appearance can be gauged from Manet's 1874 picture of Monet painting on the boat (Neue Pinakothek, Munich), his palette resting between his knees and his small portable easel directly in front of him, on which is visible a canvas probably identifiable with his *Sailboats in the Rental Area, Argenteuil* (California Palace of the Legion of

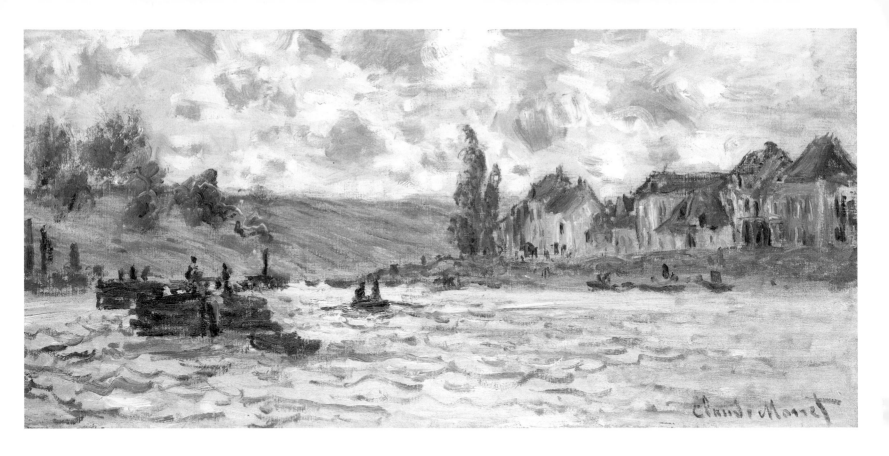

Honor, San Francisco). Monet depicted his studio boat on a number of occasions and two of these paintings, both made during his stay at Argenteuil, arc included here (figs 66 & 67).

Monet and Daubigny also differed in the manner in which they used their boats. Daubigny, as he illustrated in his *Voyage en bateau*, was relatively ambitious in the journeys he undertook on the Seine and the Oise, and was often away from home for several days, sometimes weeks, at a time. Monet, on the other hand, was rather more circumscribed, seldom ventured far, and moored his boat close to home. Like Daubigny, though, he became an accomplished oarsman. In all likelihood he would have been increasingly aware, also, of the commercial success the older artist was enjoying in the 1870s. As Simon Kelly has demonstrated, Daubigny probably accumulated significant wealth during this period, based on his successful sales, particularly of his river scenes.[36] Somewhat ironically, by this date he was losing interest in river scenery.[37] His surviving account books reveal spectacular rises in the prices he achieved in the early 1870s. By then he was occupying studios in

Paris and Auvers. At the end of the 1860s, on the advice of his dealer, he had relocated his Parisian studio to a fashionable area on the Right Bank near the auctions of the Hôtel Drouot and the dealers and commercial galleries situated round the rue Laffitte. The studio was lavishly decorated by the dealer Brame with draperies, oriental carpets and fine Louis XIV chairs. Monet, despite his frequent complaints of impecunity in his correspondence of this period, annually earned the equivalent of a reasonably successful lawyer or doctor but his outgoings exceeded his income. Later in his career, of course, he would become very wealthy indeed. However, this in no way measured up to Daubigny's earning power.

At Argenteuil Monet essayed a wide range of subjects, and the river played a consistent role in this. It would assume even more importance from 1878 onwards with his move downstream to the unconsidered little town of Vétheuil, opposite which lay the little village of Lavacourt. Monet depicted it in an impressive painting, compositionally indebted to Daubigny, which he successfully submitted to the 1880 Salon (fig. 69).[38] This relocation was driven, in

part, by reduced financial circumstances on Monet's part, coupled with the sad fact that his wife Camille was in deteriorating health. The Monet household combined with that of the bankrupt store magnate Ernest Hoschedé and jointly rented a relatively modest property on the outskirts of the town on the road leading to La Roche-Guyon.

Using his studio boat Monet immediately began exploring the reaches of the river in the vicinity of his new home. He travelled downstream and painted a series of canvases round the islands of Moisson and Mousseaux. These were untouched places where water, vegetation-covered riverbanks and the sky above were the key elements. There can be no doubt that the relative isolation of Vétheuil stimulated Monet in this quest for 'pure' landscape imagery which he captured using his high-keyed Impressionist palette. But the guiding example was surely Daubigny who, from the 1850s had painted seemingly countless such views, similarly composed. And Monet, at a time of financial pressure, found a ready market for his riverscapes. He would have been particularly aware of Daubigny at the time for the older artist died in 1878, the year of Monet's

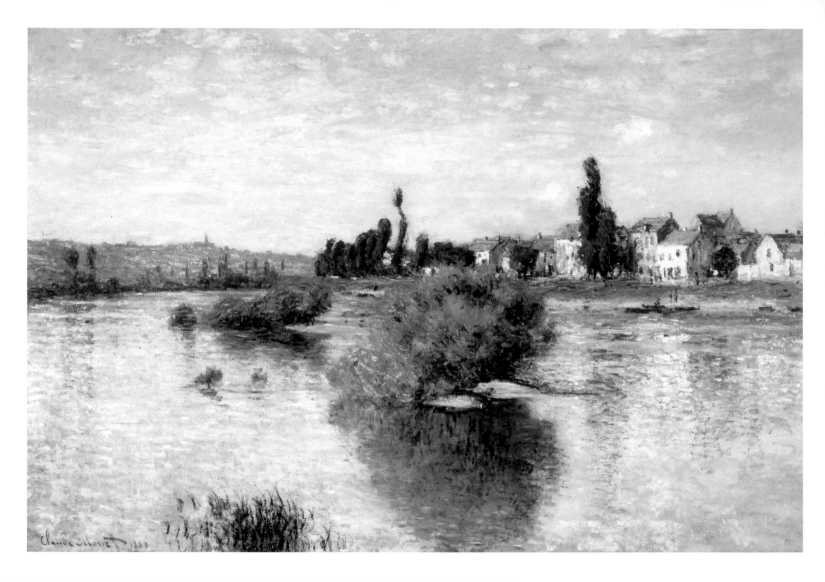

69

CLAUDE MONET
The Seine at Lavacourt, 1880
Oil on canvas, 98.4 × 149.2 cm
Dallas Museum of Art, Munger Fund, 1938.4.M

70

CLAUDE MONET
The Flood, 1881
Oil on canvas, 60 × 100 cm
Rau Collection for UNICEF, Cologne

71

CLAUDE MONET
Morning on the Seine near Giverny, 1897
Oil on canvas, 81.6 × 93 cm
The Metropolitan Museum of Art, New York,
bequest of Julia W. Emmons, 1956, 56.135.4

move to Vétheuil, and his work featured prominently in a major show organised in Paris by the dealer Paul Durand-Ruel of French paintings 1830–70, timed to coincide with the great Exposition Universelle held the same year.[39]

The Seine was a very busy river, with heavy commercial traffic from Paris all the way through to the mouth of the river at Le Havre. The immediacy of this is well conveyed in Monet's *The Village of Lavacourt* (fig. 68), which must have been painted quickly from his studio boat in mid-stream. Even more dramatic was his *Seine at Port Villez (A Gust of Wind)* of 1883 (Columbus Museum of Art), sketched by Monet from his studio boat looking out at a landscape in almost violent motion and painted wet-on-wet in a rush of paint. It would have required considerable skill to maintain position while he was

doing this. By then Monet had become a capable river man and owned, in addition to the studio boat, a number of other small boats that he kept moored at 'Port Monet'. He was also confident enough to venture out into the river at a time of heavy flooding, as is demonstrated in his 1881 canvas *The Flood* (fig. 70), as well as to navigate the breaking ice in the harsh winter of 1879–80. Crucially, the studio boat gave him access to viewpoints that were simply unachievable from the riverbank, and the resulting pictures made from mid-stream give the viewer the sensation of being 'in' nature rather than observing it from afar (fig. 72).

That Monet continued to use his original boat for some time after moving on from Vétheuil is evidenced by John Singer Sargent's (1856–1925) well-known *Monet Painting in his Bateau-Atelier* of about 1885–90

(National Gallery of Art, Washington) in which the boat appears unchanged. However, in 1891 Monet asked his fellow-painter and expert *canotier* Gustave Caillebotte (1848–1894) for the loan of a boat to use while he worked on a series of canvases on the River Epte, presumably the *Poplars* series. He stated he felt very uncomfortable working in a *norvégienne* (a type of round-stemmed rowing boat), implying he was no longer using his original studio boat.[40]

In Impressionist and related circles the artist who, apart from Monet, most admired Daubigny was Vincent van Gogh, but the older artist's river scenes held no fascination for the young Dutchman. Instead Van Gogh was particularly taken with Daubigny's orchard scenes, his use of bright colour, and the crows that were found in some of his pictures. All these features would come together in Vincent's art

72
CLAUDE MONET
Sunset on the River Seine at Lavacourt,
Winter Effect, 1880
Oil on canvas, 100 × 150 cm
Petit Palais, Musée des Beaux-Arts
de la Ville de Paris

when he spent his final months in 1890 in Auvers-sur-Oise watched over, at Camille Pissarro's suggestion, by the kindly Dr Gachet. His homage to Daubigny would take its most explicit form in his fascination with, and depictions of, Daubigny's house and studio there (fig. 123), and in the threatening and troubled views of the surrounding wheatfields.

Van Gogh, therefore, does not provide a suitable coda to the theme of this essay. Instead one must turn again to Monet, to his last great waterborne series of paintings, the *Early Mornings on the Seine* of 1896–7. In these ethereal visions (fig. 71) the most obvious inspiration from the previous generation was primarily that of Corot, in particular the sylvan trees of his late pictures such as the *Souvenir of Mortefontaine* of 1864 (Louvre, Paris). The *Early Mornings* were painted, however, from a broad-bottomed boat fitted with grooves to hold a number of canvases. Monet described it as 'quite a large sort of barge-cabin; one could sleep there',[41] and in that respect it resembled Daubigny's *Botin*, the most famous of all artists' floating studios, which also offered limited sleeping accommodation. Monet was in late middle age when he painted these pictures and they represented his last extensive series of excursions on the water. Thereafter, apart from specific travels to London and Venice, he confined himself in the main to the magical world he had constructed for himself at his house and garden at Giverny. Although his style, in its lyrical semi-abstraction, had moved far beyond anything essayed decades earlier by Daubigny, the example of exploration set by the older artist had remained of paramount importance throughout in stimulating Monet's own examination of the hidden and unsuspected beauties of river scenery.

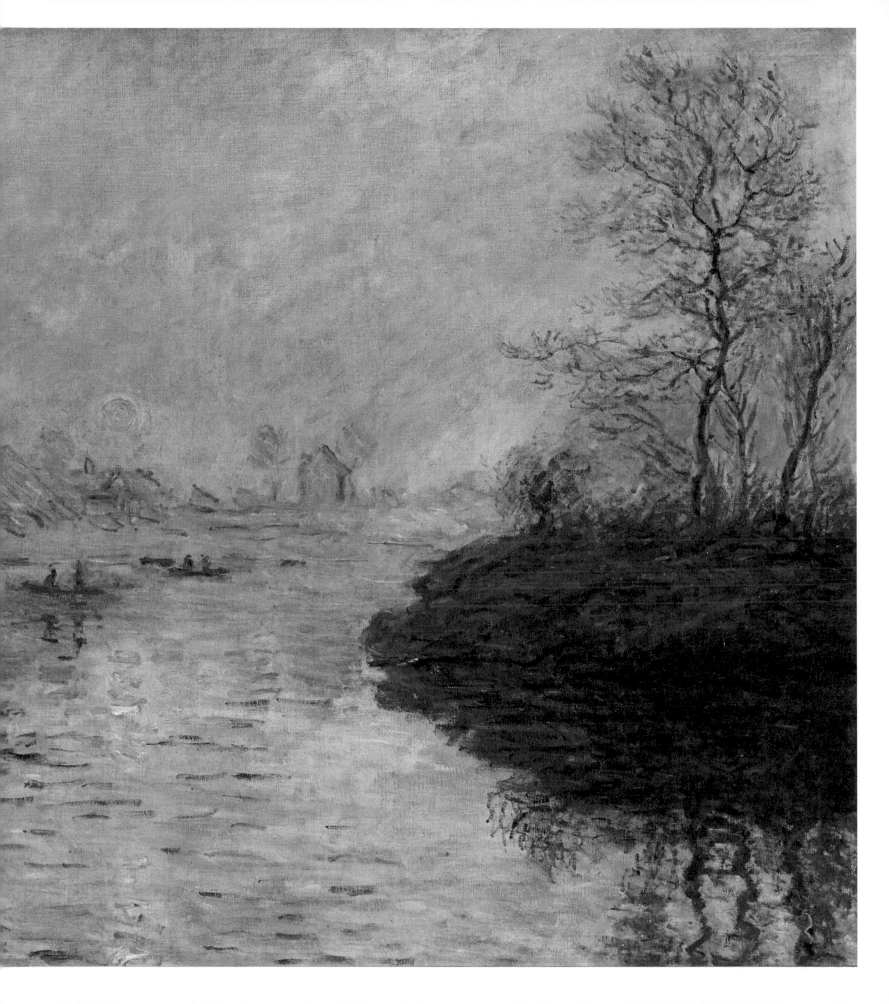

The Market for Daubigny's Landscapes, or 'The best pictures do not sell'

Lynne Ambrosini

Daubigny participated in an art market that was in the midst of dramatic transformation. In 1845, when Jean Durand-Ruel hired the young artist to embellish his gallery's first illustrated publication, most of the dealer's competitors still sold stationery, art supplies and gifts, with a few paintings for window dressing.[1] By the time of Daubigny's death in 1878, a greatly increased cohort of dealers ran dedicated contemporary art galleries, and many mechanisms of the modern market – gallery exhibitions of works by living artists, auctions of contemporary art, catalogues with essays by art critics and multi-dealer ventures – had already been invented. Drawing on unpublished archival sources, this essay focuses on the ways in which Daubigny adapted to the emerging demand for contemporary art, especially landscape.[2] Intuitively grasping the requirements for success in the new art economy, Daubigny developed a dual approach that involved, on the one hand, pictures that met market demands, and on the other, innovative pictures that mattered to him and to connoisseurs.

Daubigny's early career was economically precarious. From the age of seventeen or eighteen, he supported himself as an illustrator while acquiring what training and practice he could as a painter.[3]

Letters from 1839 to 1852 record financial worries and tally the prices of bread, postage and rented rooms.[4] In 1843, the industrious artist mentioned working on print and drawing commissions in the mornings and evenings, while squeezing in a few hours of afternoon painting outdoors.[5] Fittingly, he inscribed an early state of the etching 'The Studio on the Boat' with the motto 'Work keeps the soul joyous'.[6] Although Daubigny gradually replaced graphic jobs with painting commissions, he attracted little notice at the Salons until the early 1850s.[7] Emile Zola later reported: 'For fifteen years he never sold a painting for more than 500 francs.'[8]

Market Strategies

Throughout his career, Daubigny found ways to enhance his public image and expand his market. First, he learned to choose his submissions to the Salons – the only regular large-scale exhibitions at that time – with great care, understanding that they represented his chief opportunity to display the range of his abilities.[9] At the Salon of 1857, for example, he exhibited the lushly floral *Spring* (fig. 73), the austere, highly structured *Great Valley of Optevoz* (Musée d'Orsay, Paris) and a sketchy *Setting Sun*.[10] Later, he would deliberately pair a daring work with a more

DETAIL fig. 77
CHARLES FRANÇOIS DAUBIGNY
Banks of the Oise at Auvers, 1863

conventional crowd-pleaser: at the Salon of 1872, he exhibited *The Barrelmaker* (private collection), a large, impetuous, loosely painted picture, along with the more tightly drawn, traditional *Mills at Dordrecht* (fig. 51). Critics who found the former unfinished admired the latter.[11] Daubigny's comprehension of the Salon as a publicity vehicle probably informed his decision to stop showing his already popular river views there after 1870.[12] From that date, he chose instead to exhibit annually at least one painting from Auvers, furthering his reputation as the painter of that still-rustic village and its farmlands.

Daubigny also took advantage of alternative exhibition opportunities. In 1859 he sent a *Sluice at Optevoz* to an exhibition in Lyon, doubtless hoping it would sell there, near the depicted site.[13] In 1868, he exhibited seven paintings in Le Havre, and in 1869 showed works in both Marseille and Bordeaux.[14] In Paris, Daubigny was a founding member of the Société Nationale des Beaux-Arts, a non-juried artists' exhibition initiative.[15] From its inception in 1861, a display of paintings, rotated periodically, appeared at the Society's exhibition space on the boulevard des Italiens. Daubigny's large, daringly simple *Villerville Seen from Le Ratier* (fig. 75), which the Salon jury had rejected in 1855, went on view there in 1862.[16] He also exhibited landscapes in the Society's first and only formal exhibition in February 1864.

Outside France, Daubigny's *Banks of the Oise* featured in the International Exhibition of 1862 in London.[17] After his trip to London in July 1865, he exhibited works at the Royal Academy, including *Moonrise* and *Sunrise before the Rain on the Towpath* in 1866 and an English view, *The Thames at Woolwich*, in 1867.[18] In 1872, he showed at the annual exhibition in Brussels.[19]

From early on, Daubigny understood that large exhibition pieces and small cabinet paintings had different markets. In 1852, asking a friend to negotiate with the government over the price of his large *Harvest* (fig. 119), he advised: 'Don't ask for too much … because no private client will buy it.'[20] He later mentioned that 'the big canvases are always made for glory'; he did not count on selling them.[21]

Dealers did not yet serve consistently as middlemen, so Daubigny could and did work directly for collectors. Selling to a renowned patron could in turn bring more sales. Daubigny's most sensational benefactor was Khalil Bey, the Turkish-Egyptian diplomat and *bon vivant* who also owned Jean-Auguste-Dominique Ingres's (1780–1867) *Turkish Bath* and Gustave Courbet's scandalous *Sleepers* and *Origin of the World*.[22] Bey purchased Daubigny's *Ferryboat near Bonnières* in 1864 (fig. 74) from an exhibition at the Cercle de l'Union artistique, an elite gentlemen's club.[23] This sunrise scene, with the nacreous colours of the dawn sky reflected in the Seine, is among Daubigny's most beautiful river views. It is exactly the sort of pellucid image that Monet must have admired, judging by his similar renditions of mirrored sky and trees from a waterborne vantage point, such as his limpid and dazzling *Houses on the Achterzaan* (fig. 76).

Daubigny also received patronage from prominent statesmen and businessmen such as Charles Perrier, a champagne producer and Mayor of Epernay, who purchased *Banks of the Oise at Auvers* (fig. 77) directly from the artist in 1863 for the substantial price of 4,000 francs.[24] Similarly, in 1868 Daubigny sold a picture of *Le Canau*, a rural area west of Bordeaux, to Amédée Larrieu, a *député* in the National Assembly and winemaker from Bordeaux.[25] Among Daubigny's

73
CHARLES FRANÇOIS DAUBIGNY
Spring, 1857
Oil on canvas, 96 × 193 cm
Musée d'Orsay, Paris, on loan to the Musée des Beaux-Arts, Chartres

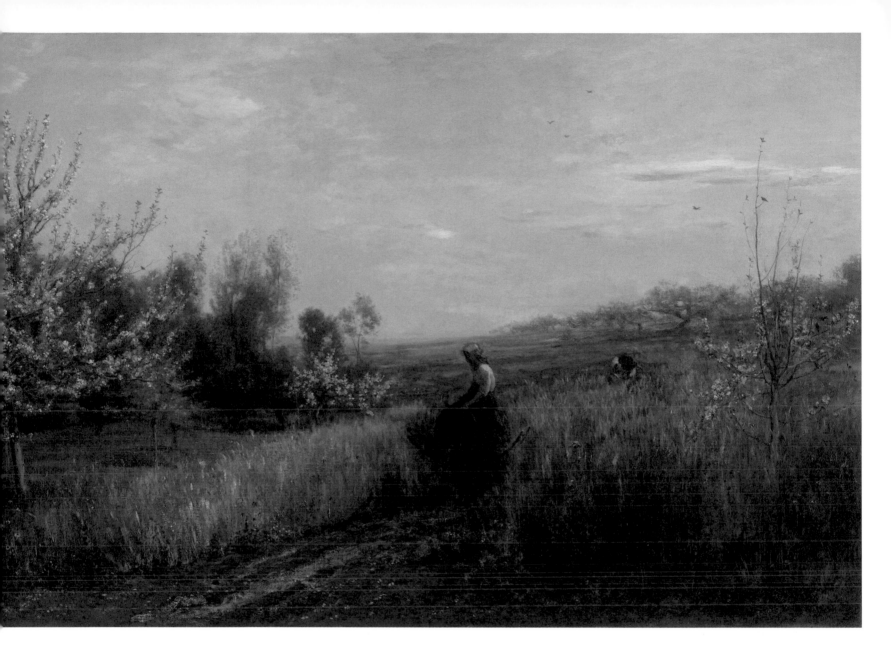

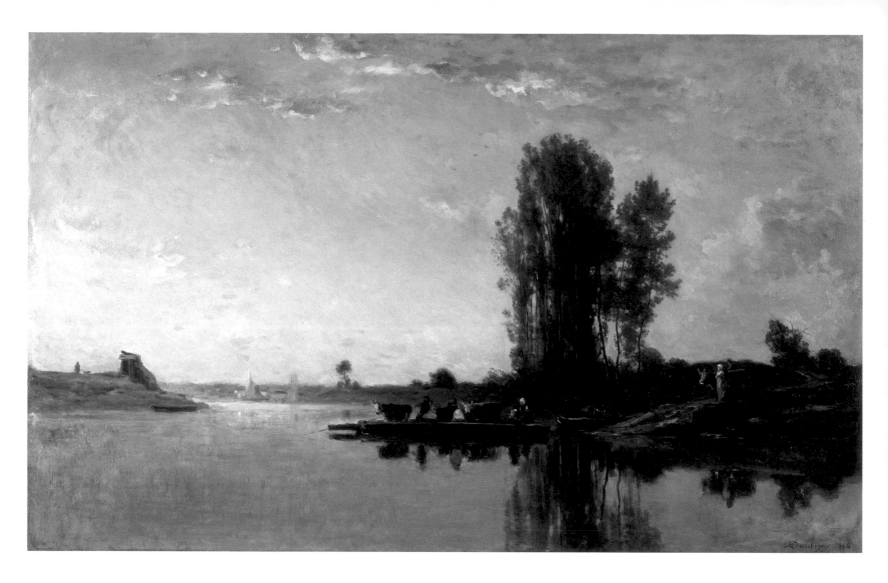

74

CHARLES FRANÇOIS DAUBIGNY
Ferryboat near Bonnières, 1864
Oil on canvas, 62 × 100 cm
Museum der bildenden Künste, Leipzig

75

CHARLES FRANÇOIS DAUBIGNY
Villerville Seen from Le Ratier, 1855
Oil on canvas, 54.2 × 116.2 cm
The Cleveland Museum of Art, Bequest
of William G. Mather, 1951.323

76

CLAUDE MONET
Houses on the Achterzaan, 1871
Oil on canvas, 45.7 × 67 cm
The Metropolitan Museum of Art, New York,
Robert Lehman Collection, 1975, 1971.1.196

aristocratic collectors figured the connoisseur Count Armand Doria, who bought *Villerville Seen from Le Ratier* (fig. 75) in 1858.[26] Daubigny also sold works to the photographer Nadar and the English painter Frederic, Lord Leighton (1830–1896), as well as to the writers Alexandre Dumas fils and Jules Janin.[27] The Dutch painter and banker Hendrik Willem Mesdag (1831–1915) would collect over twenty-five paintings by Daubigny, most of them after the latter's death.[28]

From his letters, it appears that Daubigny raised his prices regularly as his sales improved. For instance, he wrote to the dealer Adolphe Beugniet: 'But I must warn you that this year the prices have gone up, in view of the <u>numerous commissions</u> that I have received. The size that you usually take is [now] a thousand francs, and for collectors 1,500 francs. I believe that if you sell them at 1,500 francs

you will still come away with a tidy profit.'[29]

In 1868, by which time his works were keenly sought after, he sold a pair of large river views for 7,000 francs apiece, the highest prices he commanded during this decade.[30] Durand-Ruel's strategic support of Daubigny's prices at auction must have helped fuel this escalation.[31] By the 1870s, Daubigny's largest paintings commanded extravagant prices; he sold a *Beach at Villerville* in 1872 for 12,000 francs.[32]

Daubigny and his Dealers
Perhaps Daubigny's most effective commercial decision was to engage directly with dealers. By contrast, Jean-François Millet relied heavily on the agent and art writer Alfred Sensier to broker sales.[33] Daubigny worked with a surprising number of dealers,

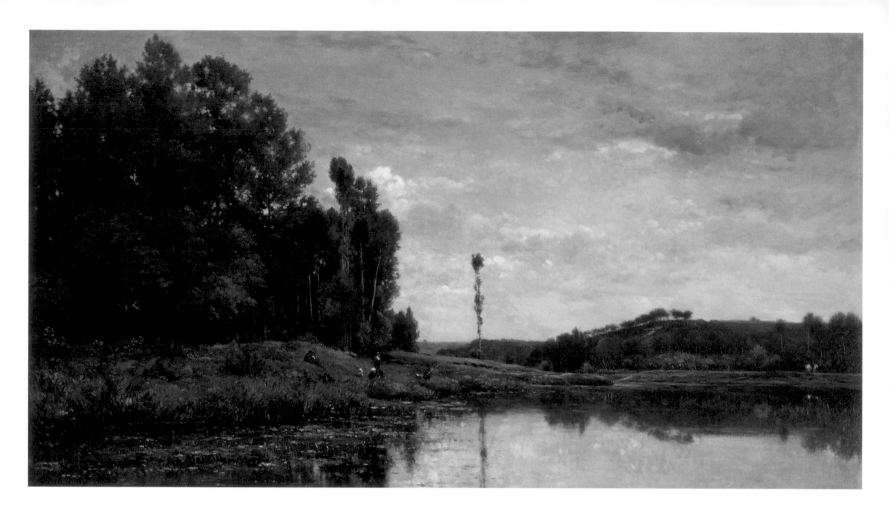

even for this largely pre-monopolistic era: at least thirty-eight.[34] This included a few frame suppliers and colour merchants, since the boundaries between art dealing and other art businesses remained quite flexible.[35]

Among the dealers with whom Daubigny maintained longstanding commercial relationships was Beugniet, whose rise to prominence in the mid-1850s coincided with Daubigny's. Beugniet's showroom was the largest, 'the best stocked [and] most elegantly decorated' on the rue Laffitte, where several new galleries of contemporary art were then opening.[36] He bought about two to four pictures per year from Daubigny from 1859 into the 1870s.[37] Daubigny wrote this affable note to him from Auvers in 1863: 'Your painting is well underway. You ought to come see it as you promised and have some lamb chops with us on Wednesday or Thursday. I'll be in Paris on Friday in case your business won't let you come here. I'll bring the measurements which are pretty close to the other painting anyway, and at the same time I will ask you to advance me one half of

the price of the painting. Having some balances of bills to pay off in Auvers, I am running a bit low [on cash]. Best to you and do try to come. My regards to your wife.'[38]

Beugniet commissioned neatly finished, small to medium-sized pictures that were quite marketable. For example, in 1867 he spent 1,900 francs on the attractive *The Bridge between Persan and Beaumont-sur-Oise* (fig. 78), which included a scenic view of the medieval town with its thirteenth-century church tower and ancient bridge.[39] In the foreground, goose girls and their charges provided an arcadian setting; Beugniet's clients could feel reassured that all was right in rural France. Compared to Daubigny's more daring pictures, this mild-mannered panel represented the conservative end of his production.

The enterprising George A. Lucas, who served as an agent for fellow American collectors and the New York art dealer Samuel P. Avery, first visited Daubigny's studio in December 1862, with the Baltimore collector William T. Walters in tow.[40] He ordered his first four paintings from Daubigny in December 1863, and

the next year commissioned two landscapes, paying 2,900 francs.[41] He visited Daubigny's studio ten times in 1864, buying a total of seven paintings.[42] Lucas bought art for other American patrons, too, including William Henry Vanderbilt, John Taylor Johnston and William Henry Huntington.[43]

Through Lucas and Avery, Daubigny's paintings entered the mid-Atlantic United States. Further north, Seth M. Vose began importing paintings by Daubigny for his gallery in Providence, Rhode Island, in 1857. Vose's son recalled: 'Next to Corot, Daubigny was father's favourite and he had many fine examples.'[44] Consequently, when the young American landscapist Dwight W. Tryon arrived in Paris in 1877 to study with Daubigny – to the latter's bemusement – the American explained 'that his name was as well known in my own country as in France, and that his work [was] to be found in all of our larger cities. [Daubigny] seemed quite surprised at this, and said he knew of but one of his pictures owned in America … but he added: "The dealers scatter them, and I rarely know their destination."'[45]

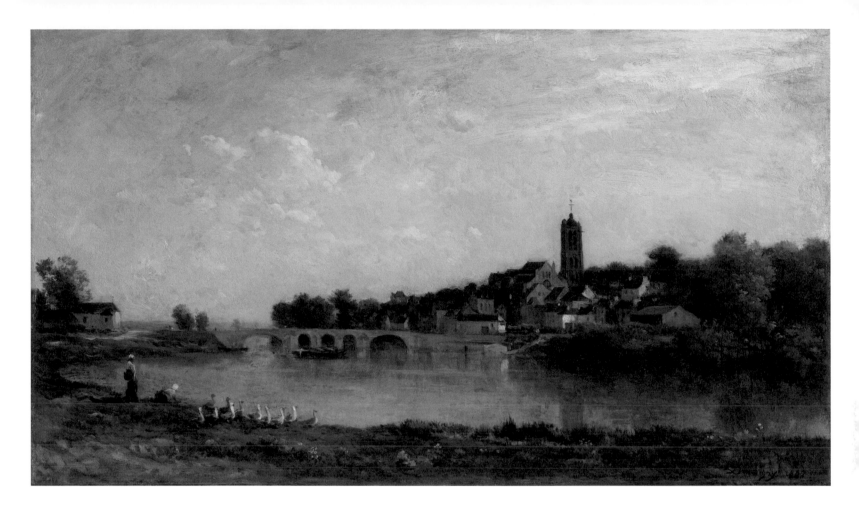

77

CHARLES FRANÇOIS DAUBIGNY
Banks of the Oise at Auvers, 1863
Oil on canvas, 88.9 × 161.3 cm
Saint Louis Art Museum, Friends Endowment and
gift of Justina G. Catlin in memory of her husband,
Daniel Catlin, by exchange, 84:2007

78

CHARLES FRANÇOIS DAUBIGNY
The Bridge between Persan and Beaumont-sur-Oise,
1867
Oil on panel, 38.4 × 67.1 cm
Sterling and Francine Clark Art Institute,
Williamstown, Massachusetts, 1955.694

The upmarket Austrian dealer-collector Charles Sedelmeyer commissioned works from Daubigny in the early 1870s. Active in Paris and Vienna, he had an international client base and helped form important collections like those of Eugène Secrétan and János Pálffy.[46] He ordered three paintings from Daubigny in 1872, two of which were grand-scale repetitions of Salon pictures: *The Beach at Villerville* for 8,000 francs and the *Moonrise* from the 1868 Salon (fig. 79) for the astronomical price of 20,000 francs, probably the highest sale price in Daubigny's lifetime.[47]

Like Sedelmeyer, the dealer Breysse operated at the high end of the market. He acquired paintings from Daubigny from 1871 until 1873, including the monumental *Mills at Dordrecht* (fig. 51), for which he paid 4,500 francs.[48] In 1872, he purchased Daubigny's *Snow* (Musée d'Orsay, Paris), a sizeable, audacious winter scene heaped with thick impasto, for 11,000 francs and, the following year, *Moonlight* for 8,000 francs.[49] For these substantial, time-consuming projects, Daubigny prudently required a partial down payment.

Daubigny had a highly significant commercial relationship with Goupil & Cie, the Paris-based firm that expanded to London, New York, Berlin, The Hague, Vienna and Brussels between 1841 and 1866, modelling capitalist expansion within the art economy.[50] The director of its London branch, Ernest Gambart, was the first to purchase and exhibit Daubigny's landscapes in 1856.[51] The Paris gallery, too, soon diversified its stock, expanding from academic figure paintings and genre to include more landscapes. By 1860, Goupil's 'rich and brilliant clientele' could see in its 'elegant, tastefully arranged and furnished gallery' a wide selection of contemporary art (fig. 80), including Daubigny's *View from the Morvan*.[52]

Beginning in 1870, Adolphe Goupil and his partner Léon Boussod invested heavily in Daubigny's work. In 1872, for example, they commissioned three very large paintings: *A Marsh in the Morvan* for 10,000 francs, *The Beach at Villerville* at 12,000 francs and *The Flock of Sheep, Moonlight* for 11,000 francs.[53] In this decade, the firm would sell no fewer than

ninety-nine of his paintings.[54] A third of these came directly from Daubigny for a total purchase price of 129,500 francs; Goupil's secured the remainder from the secondary market.[55] The firm's international brand advanced Daubigny's reputation overseas, for many foreign clients visited the Paris gallery, including British and American dealers.[56] The firm marked up its stock more highly than would Durand-Ruel, as we will see, and made superior returns, averaging 47 per cent profit on Daubigny's work in the 1870s. For example, in 1873 Goupil's bought a Daubigny landscape for 2,300 francs and sold it a week later for an astonishing 8,000 francs.[57] In 1877, the dealers paid Daubigny 11,000 francs for *Moonrise at Auvers* (fig. 31) and sold it within three years for 20,000 francs to the French copper magnate Eugène Secrétan.[58]

When Daubigny died in 1878, the Goupil Gallery exhibited this same grand-scale *Moonrise* (Museum of Fine Arts, Montreal) in homage.[59] Not surprisingly, the firm continued to benefit after his death: the number of his works it sold doubled in the 1880s, and their average price climbed to just over 8,000 francs.[60] Goupil's margin also rose in that decade to

an average of 52 per cent over the purchase price.

Contrary to prior assertions, art dealers did not seek out Daubigny's river views exclusively. In fact, only 36 per cent of works Goupil's sold in the 1870s portrayed rivers.[61] In Daubigny's posthumous market, however, the river pictures attained higher values and status, climbing to 52 per cent of his total subjects sold at Goupil's in the 1880s, then to 61 per cent in the 1890s. This suggests an *ex post facto* commodification of his river pictures, which helps explain their dominance in discussions of the artist even today.[62]

Daubigny and Paul Durand-Ruel

The most important of Daubigny's dealers for his early patronage (from 1857 at least), support of the artist's prices and purchases of risky paintings was Paul Durand-Ruel.[63] Initially committed to the art of Eugène Delacroix (1798–1863) and the landscapists of the July Monarchy, Durand-Ruel came to appreciate Daubigny, Courbet, Edouard Manet and the Impressionists.[64] Beginning in the late 1850s, he made joint purchases with the younger Hector Brame, who shared his tastes in art and whom he described

as active, enthusiastic and a talented salesman.[65] Between 1857 and 1867, they bought three to eight landscapes annually from Daubigny, paying an average of 5,000 francs per year.[66]

In 1868, Durand-Ruel and Brame dramatically increased their acquisitions from Daubigny, spending some 33,900 francs that year alone. About this time, too, Brame insisted that Daubigny leave his old studio on the Ile Saint Louis for a new one in the exclusive Right Bank, near the centre of art commerce. A former actor, Brame understood the importance of stage scenery and props. He equipped the space with draperies, Middle Eastern carpets and splendid Louis XIV-style armchairs to enhance Daubigny's image and encourage acquisitions.[67] Over the next five years, Durand-Ruel and Brame continued to buy aggressively from Daubigny, with an average annual expenditure of 21,000 francs.[68] By 1872, they had ordered 141,100 francs in purchases, which exceeded Goupil's total commissions.[69]

Durand-Ruel and Brame's patronage spanned the full range of Daubigny's subject matter and included a mix of standard 'dealer sizes' and larger paintings, such as the *Graves de Villerville* that Durand-Ruel

79
CHARLES FRANÇOIS DAUBIGNY
Moonrise, 1868 and 1873
Oil on canvas, 172 × 305 cm
Museum of Fine Arts, Budapest

80
Anonymous, 'Galerie Goupil', *L'Illustration*, vol. 35,
10 March 1860, p. 155

bought on his own in 1869 for 7,000 francs.[70] About half were river views, such as *Evening at Andrésy, Twilight* (Walters Art Museum, Baltimore) from the Salon of 1867.[71] Unlike most other dealers, they selected some of Daubigny's most uncompromising efforts; Brame purchased the sweepingly executed *The Barrelmaker*, at a price of 10,000 francs. This kind of acquisition was an act of faith, for sometimes such a picture did not sell until years later.[72] Similarly, they bought an atypical Breton coastal scene, *The Approach to Kérity, Brittany* (fig. 82), a windswept, impetuously painted panel, perhaps created outdoors.[73] Durand-Ruel's appreciation of this kind of painting helps explain his positive reactions to the early works of Claude Monet and Camille Pissarro, whom Daubigny introduced to him.[74]

Durand-Ruel's innovative promotional methods further benefited Daubigny.[75] For example, *La Revue international*, the art magazine the dealer published from January 1869 to August 1870, included laudatory accounts of Daubigny's pictures.[76] This veiled marketing tool pumped up the artist's reputation and the market values of the dealer's investment. In 1872 Durand-Ruel conceived another

advertising vehicle, a sequence of five handsome folios with etched reproductions of outstanding works from his stock.[77] Daubigny's *Mills at Dordrecht* (fig. 51), which the dealer had bought from Breysse that year for an impressive 9,550 francs – over double Breysse's purchase price – was among the works included in the folios.[78]

Durand-Ruel's stock books reveal that he usually profited nicely from Daubigny's paintings, especially when selling to private collectors. For instance, in November 1867 he bought another Daubigny *Twilight* from the dealer Père Martin for 2,000 francs; he sold it a month later to the Cincinnati hardware merchant Henry Probasco for 4,000 francs.[79] On deals made with colleagues, however, Durand-Ruel's profits were much less exciting, usually ranging from 5 to 15 per cent of the purchase price. Overall, Durand-Ruel's books show an average profit margin of 32 per cent on sales of Daubigny's works in the 1860s.[80] As Daubigny's prices climbed in the 1870s, Durand-Ruel's average profit increased to 38 per cent, which still lagged behind Goupil's margins.

Durand-Ruel greatly expanded Daubigny's market through his concentrated activity in London during

and after the Franco-Prussian War. Of course, some Londoners already knew Daubigny's work from its inclusion in private galleries and exhibitions there in 1862, 1866 and 1867.[81] A British critic visiting the 1870 Salon in Paris could think of no more apt way to describe the brushy quality of French landscape than to call it a 'Daubigny tendency'.[82] Between 1870 and 1875, Durand-Ruel launched an ambitious series of eleven exhibitions of French art in London, each with its own catalogue.[83] To enhance their prestige, he credited an organising committee, the 'Society of French Artists', in fact just a list of artists whom he represented.[84] Daubigny's name headed the list of seven artists mentioned for the *First Annual Exhibition* of 1871; Durand-Ruel evidently thought it would help attract visitors.[85] The selection of works in these shows reveals his intention to present a balanced representation of Daubigny's subjects. The dealer included approximately thirty of his pictures, spanning a range of motifs chosen in part to appeal to British tastes.[86] One evening scene, featuring a herd of cows, was presented with a quotation from Robert Burns: 'Twixt the gloaming and the mirk, when the kye come hame.'[87]

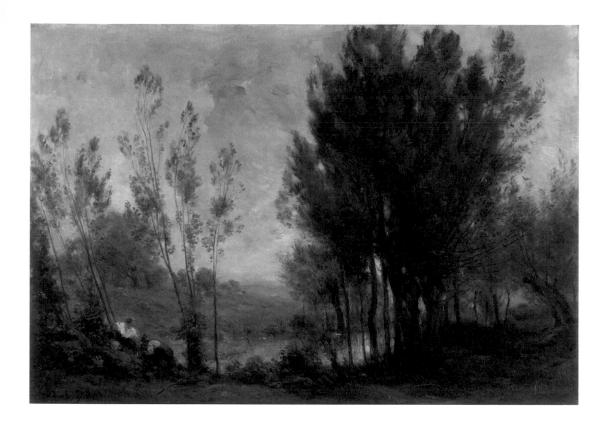

The International Exhibition of 1871 in London further advanced Daubigny's reputation. No French art could be sent from embattled Communard Paris for the opening on 1 May, so the organisers asked Durand-Ruel to supply paintings. Among them were ten pictures by Corot and nine by Daubigny.[88] Durand-Ruel's promotion of Daubigny and other French painters in London had long-lasting effects, enhancing their status and sales in the United Kingdom.[89] For instance, the Scottish collector and sugar refiner James Duncan of Benmore, who started collecting mid-century French landscapes in 1870, owned one of Daubigny's *Banks of the Oise* (Metropolitan Museum of Art, New York).[90] Benefiting from Durand-Ruel's London campaign, Goupil's also sold many Daubignys to British collectors during the 1870s.[91]

Paintings for Sale and Paintings that Mattered
In the mid-nineteenth century, the appetite for landscapes and the proliferation of contemporary art dealers encouraged the creation of 'dealer pictures', small, accessible, highly finished paintings specifically for the market (fig. 78).[92] After each of Daubigny's grand-scale successes at the Salon, dealers vied to acquire smaller versions of it.[93] In the 1860s, Jules-Antoine Castagnary described a bifurcation in the artist's production: 'In Daubigny there are two distinctly different painters. One is severe, vigorous, disdaining little details ... going straight to what is simple and broad, and attaining grandeur by restraining his means. This is the true Daubigny ... There is another Daubigny that the crowd understands more easily and likes better: the one who makes a considerable number of the *Banks of the Oise* in a soft grey tone, or else small appealing farms, with pleasant clusters of trees. That painter, we leave to the dealers of the rue Laffitte, right, master?'[94]

Such market pictures provided perfect ornaments for small-scale parlours in Parisian apartments and afforded Daubigny a reliable income, freeing him to paint however he wished in his more serious work.

A painting in the National Gallery, London, *Willows* (fig. 81), illustrates the commodification of one of Daubigny's popular themes. The first instance of a similar composition, titled *Fishing for Crayfish*, was recorded in 1867, when he sold it to the dealer Emmanuel Weyl.[95] Weyl returned for another in 1871; subtitled 'rising sun' and larger, it cost 3,000 francs.[96] The following year, the dealer Cléophas requested a smaller version for 2,000 francs.[97] The National Gallery's picture, which probably dates from 1874, is a fourth variant; more freely brushed, it is likely that it was destined for the dealer Gustave Tempelaere, whose stamp appears on the back of the canvas.[98]

When creating a variation on a theme, Daubigny significantly varied the dimensions, changed the weather or time of day and altered the figures. The later versions are studio pictures. Sometimes Daubigny jotted down a new order as 'repetition of Mr X's painting'.[99] When the American Dudley Williams visited the studio in October 1873 to commission three paintings, Daubigny recorded the request in his own shorthand as 'subject of Mr Bogaluboff, Oudinot subject, Brame subject'.[100]

Contemporary accounts make clear the degree to which Daubigny himself thought about his work

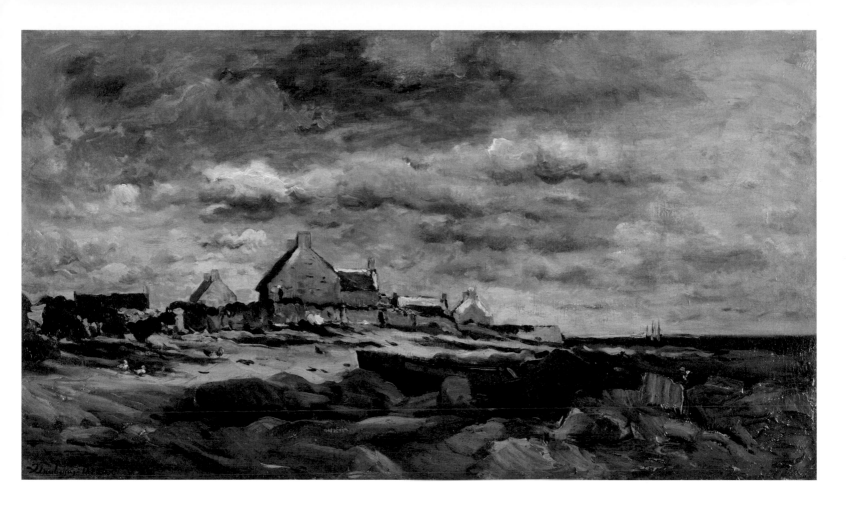

in binary categories. Zola reported in 1866: 'Ask Mr Daubigny which of his paintings sell best. He will reply that they are precisely those which he values the least. People want truth sweetened, nature cleaned up and carefully washed, and dreamy distant perspectives. But should he vigorously paint heavy earth, dark skies and powerful trees and islands, the public finds that very ugly, very coarse.'[101]

One day in Daubigny's later years, when a visitor began to request more river views, the irritated artist cried out, 'Leave me in peace! The best pictures are those which do not sell!'[102] In 1877, Daubigny's American student Tryon expressed admiration for two of Daubigny's last, most sweepingly executed canvases: 'Daubigny seemed pleased ... adding, "They are for my family". I asked if they were not for sale, and he replied: "They are both too large and too bold to find a purchaser; all my best work remains with me, and [is] *pour la famille*."'[103] Evidently Daubigny thought of his most serious efforts as a kind of life insurance policy.[104]

The repetitive river subjects were probably the price Daubigny felt he had to pay to support his real painting. In the last decade of his life, however, with his interest in these pictures flagging, he devoted less time and energy to them, with an attendant decline in their quality.[105] Even Frédéric Henriet admitted that 'to meet the demands of dealers, he had multiplied with a somewhat excessive profusion the countless views of the banks of the Oise and Seine'.[106] His health declining, it is very likely that Daubigny was trying to amass savings for his family. By then, they lived comfortably, renting an apartment in central Paris and living part-time in one of their three properties in Auvers.[107] By any measure, he was doing well financially compared to earlier years.[108] Between 1871 and 1873, he earned 369,800 francs, which meant true affluence.[109]

Aided materially by Durand-Ruel and Goupil, Daubigny achieved commercial success by adroitly exploiting the booming market for landscapes. Like Monet, he enjoyed material ease at the end of his life.[110] For every Rembrandt van Rijn (1606–1669)

and Vincent van Gogh whose careers ended in poverty, there have always been other artists who had a knack for the business of art. Along with the pretty little paintings ornamented with ducks, Daubigny also created many daring works that furthered progressive art. He was right: the 'pictures that did not sell' are those we value most today.

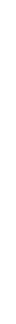

Auvers-sur-Oise as an Artists' Colony: from Daubigny to Van Gogh

Frances Fowle

Daubigny established himself in the picturesque village of Auvers-sur-Oise in 1860, thirty years before Vincent van Gogh stayed there, in the final months of his life. In the interim Impressionist artists such as Berthe Morisot, Camille Pissarro, Paul Cézanne, Armand Guillaumin and Pierre-Auguste Renoir all worked there. What was it that attracted these artists to the area and what role did Daubigny and others play in establishing Auvers as an artists' colony and an important Impressionist site?

Auvers's popularity as a destination coincided with the expansion of tourism in France and a plethora of literature on the benefits of nature.[1] As the century progressed, the extension of the railway system provided ease of access for the urban traveller seeking the restorative air of the countryside. A new craze for painting out of doors meant that artists, too, were heading for the provinces. Every summer, armed with paint boxes, tubes and easels, they escaped the heat of Paris and headed for the shimmering light of Brittany or the wide beaches and limestone cliffs of the Normandy coast. Others preferred the cool of the forests at L'Isle-Adam or Fontainebleau, where they recorded animals grazing in tranquil woodland clearings, peasants working on the plain, or fishermen on the river.

The most successful artists' colonies were established at Barbizon and Grez-sur-Loing in the Ile de France, at Giverny in Normandy and at Concarneau and Pont-Aven in Brittany, all within striking distance of Paris.[2] Barely eighteen miles from the capital, Auvers could be reached by carriage or boat until 1846, when a railway from Paris was constructed, opening up the area to artists and tourists alike. However, in order for an area to attract a 'colony' of artists it required not only ease of access, but also inexpensive accommodation. There were several choices of hotel at Auvers for the weary traveller: when Daubigny and Corot first worked there they rented rooms at the Auberge Partois, close to station; some years later, Cézanne stayed at the seventeenth-century Hostellerie du Nord, opposite the church.

Ideally an artists' colony had at its head a charismatic individual to provide some kind of guidance or focus: Jean-François Millet and Théodore Rousseau were the leaders of the Barbizon School; Pont-Aven is synonymous with Paul Gauguin (1848–1903); Armand Guillaumin (1841–1927) led the Crozant School; while Claude Monet inspired the American colony at Giverny.[3] As far as Auvers is concerned, it was initially Camille Corot who fulfilled this role, followed quickly by Daubigny in the 1860s

DETAIL fig. 89
VINCENT VAN GOGH
Farms near Auvers, 1890

83
BERTHE MORISOT
Old Path at Auvers, 1863
Oil on canvas, 45.5 × 32.3 cm
Private collection

84
Daubigny's studio at Auvers-sur-Oise, detail
of interior

85
CHARLES FRANÇOIS DAUBIGNY
Fields, 1862
Oil on panel, 16.5 × 32.5 cm
Sinebrychoff Art Museum, Helsinki, H.F. Antell
Bequest

and the amateur artist and homeopathic doctor Paul Gachet (along with Pissarro at nearby Pontoise) from 1872 onwards.

Above all, however, the successful colony required an attractive location, 'untainted' by modernity. Auvers was situated in a picturesque spot overlooking the River Oise and the quaint village with its whitewashed, thatched cottages provided numerous motifs to satisfy the artist. The most distinctive architectural feature was the church of Notre-Dame-de-l'Assomption, noted for its twelfth-century Romanesque chapel, its distinctive bell tower and elegant early Gothic apse.[4] Another important landmark, the Château of Auvers, was built in 1632 for Zanobi Lioni (d. 1655), a rich Florentine banker who moved to France with Maria de Medici and her court.[5] The land around Auvers is extremely fertile: the wheatfields above the village were recorded by Daubigny and appear in numerous canvases by Van Gogh. There were also extensive vineyards and, from the early sixteenth century, the village made its living primarily from grape production.[6] By the mid-1850s, however, the principal industry was the quarrying of local stone, which was used for the rebuilding of

Paris under Baron Haussmann.[7] As we shall see, many of the artists who settled at Auvers may have paved the way for modernism, but carefully avoided any references to modernity, preferring to capture the sense of a rural haven, unaffected by change.

Daubigny and Auvers

When Daubigny settled in Auvers, he was returning to the landscape of his early childhood, for which he felt a strong emotional bond.[8] He was brought up by Mère Bazot, a wet nurse, in the neighbouring village of Valmondois, where he lived until the age of nine.[9] He returned there frequently throughout his life, initially in 1834, with his childhood friend the sculptor Adolphe-Victor Geoffroy-Dechaume and again in the mid-1840s, when he stayed with M. Pillon, the local grocer.[10] His first dated view of Auvers, *The Painter at his Easel* (private collection, Switzerland), was executed in 1843 and shows an artist, shaded by a white parasol, sketching in oils at the edge of the wheatfields above the village, an indication of Daubigny's own working practice.

By this date Daubigny had met the landscape painters Théodore Rousseau and Jules Dupré and was working alongside Dupré at L'Isle Adam and in the Oise valley. He visited Auvers again in 1850, but it was not until 1854 that he began to use the village as a regular base, accompanied and encouraged by Corot. At this date Auvers was remarkably unspoiled, its narrow streets lined with tumbledown thatched cottages and populated by local peasants who still made their living from the land. That summer there was already a sense that the village was developing as an artist's colony. Staying at the Auberge Partois, Daubigny and Corot were, according to Moreau-Nélaton, 'surrounded by their pupils, the Lavieilles, Oudinot and others' with Corot as 'the heart and soul of the colony'.[11] On this occasion Daubigny appears to have worked largely at Valmondois, producing a *sous-bois* (woodland scene – literally, undergrowth) of *The Ru de Valmondois* (Legion of Honor, Fine Arts Museums of San Francisco) and *Meadow at Valmondois* (current location unknown), one of four submissions to the 1855 Exposition Universelle, for which he received a third-class medal.

Zola recorded that Daubigny 'adored' the area around Auvers, '… irrigated by numerous streams, its vegetation – rather a crude green in hue – softened by the silvery vapour of mist rising from the river.'[12] What attracted him primarily was the village's situation on the Oise, enabling him, travelling on his studio boat (the *Botin*), to visit with ease the neighbouring villages of Pontoise and Eragny to the south-west, and Valmondois and the forest of L'Isle Adam to the north-east.

It is difficult to be certain about the exact location of many of Daubigny's paintings of this area, but Hellebranth identifies around thirty views of the River Oise with the Ile de Vaux at Chaponval in the distance. One of the most notable examples from the 1850s is the painting now in Bordeaux, *Banks of the Oise* (fig. 54), which was exhibited at the Salon of 1859. Typically Daubigny has adopted an oblique viewpoint, the translucent waters of the Oise creating a wedge of reflected light on the right of the composition. The painting prompted the critic Louis Auvray to comment on Daubigny's love of 'le vague' … 'He half closes his eyes and sees nature through a veil'.[13]

It was Corot who advised Daubigny to buy property in Auvers, since it would be much more agreeable and convenient than renting temporary accommodation.[14]

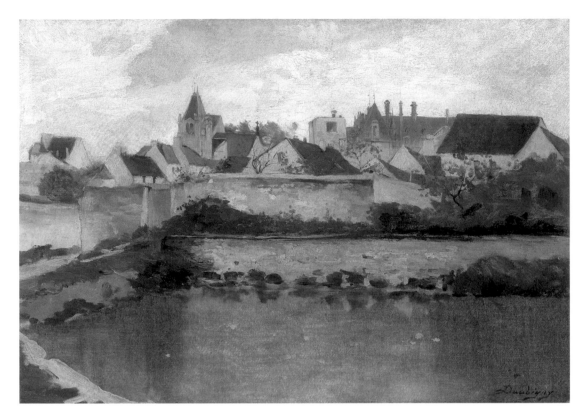

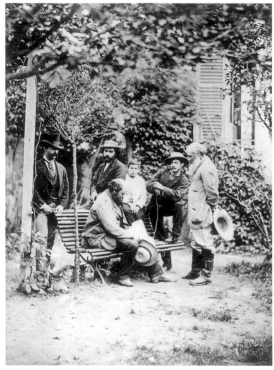

In 1860, therefore, Daubigny acquired a strip of land, previously used to grow haricot beans, in a quiet spot between the grounds of the château and the Maison Colombières in the rue de la Sansonne.[15] He employed the painter and architect Achille-François Oudinot to draw up the plans, reporting to his friend Frédéric Henriet: 'I have bought a plot of land in Auvers, currently covered in haricot beans … where they are building me a studio, 8m × 6m, with a few rooms attached, which I hope will be ready by next spring. Corot really likes Auvers and persuaded me to settle there for a good part of the year. As I want to paint some rustic landscapes with figures, it will serve me very well, surrounded by farmland and where the ploughs are not yet steam-powered.'[16]

The house, known as the 'Villa des Vallées', was completed in 1861, but only after Oudinot's rather ambitious plans had been somewhat adjusted. The family, who had previously stayed in a small three-room house at the top of the ruelle des Calleponts, close to the church, was able to move in the following year. Corot designed landscape panels for the studio, which were largely executed by Daubigny's son Karl (fig. 84). Daubigny decorated his daughter Cécile's bedroom with flowers, birds and foliage

and illustrations from La Fontaine. Later, in 1865, he decorated the walls of the dining room with landscapes, while Cécile and Karl added a bouquet of flowers and a cockerel respectively.[17] In 1867 Honoré Daumier (1808–1879), who was living nearby in Valmondois, produced a witty sketch of *Don Quixote and the Dead Mule* (now Musée d'Orsay, Paris) for a panel in the entrance hall.

Once he had established himself in the village, Daubigny attracted a large number of followers and admirers to the Villa des Vallées, among them Berthe and Edma Morisot, who visited with Oudinot in 1863.[18] The Morisots had rented a house at Le Chou, a small hamlet between Pontoise and Auvers, and the sisters were working towards their first submission to the Paris Salon the following year. Berthe succeeded with *Old Path at Auvers* (fig. 83) – a fresh *plein-air* work, featuring a female figure seated among pollarded willows, whose silvery-grey tonality owes much to Corot.[19] She also exhibited the more progressive *Souvenir of the Banks of the Oise* (private collection),[20] a river scene, painted at Le Valhermeil, whose oblique composition and evening sky suggest the influence of Daubigny, even if the emphasis is very much on leisure and modernity; there are canoes

in the river, a woman fishing from a bench and people strolling along the towpath.

Morisot's small sketch of the Oise demonstrates the extent to which Daubigny edited out any contemporary references. He frequently worked on the river but the landscape invariably took precedence over any human activity. Nevertheless, in line with his stated intentions, he produced a small group of 'rustic landscapes with figures' at Auvers. These included familiar themes such as *Washerwomen on the Banks of the Oise* of 1861 (private collection), but also more traditional farming scenes such as *Fields* of 1862 (fig. 85), which shows a fieldworker scarifying the soil using horses and wooden harrows. The vineyards around Auvers were still productive in the 1860s and Daubigny addressed this subject on at least three occasions.[21] Later in the early 1870s he produced a series of prints on rural motifs such as *Herd of Cows* of 1873, which, set against an idyllic backdrop of rolling fields and thatched cottages, depicts a herdsman with his dairy cattle.[22] From this later period date some of his most outstanding landscapes featuring rural workers, notably *Fields in the Month of June* of 1874 (fig. 109), which shows labourers scything grass and gathering produce

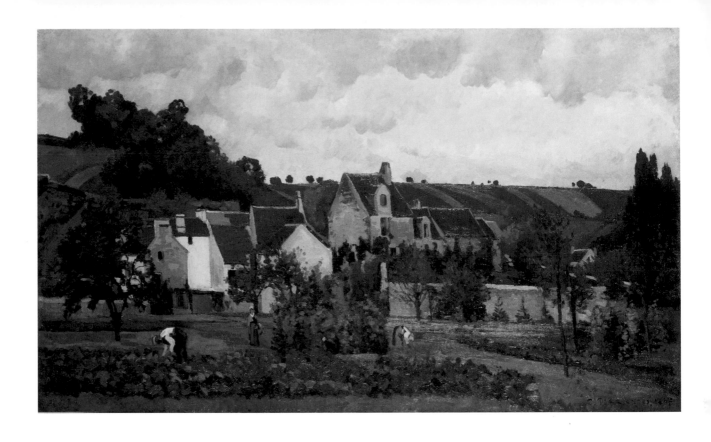

86
CHARLES FRANÇOIS DAUBIGNY
The Village of Auvers, undated
Oil on canvas, 42.6 × 61.6 cm
Private collection

87
Group gathered in Pissarro's garden,
featuring Cézanne (seated on the bench)
and Camille Pissarro (far right), 1872/5
Musée Pissarro, Pontoise

88
CAMILLE PISSARRO
L'Hermitage near Pontoise, 1867
Oil on canvas, 91 × 150.5 cm
Wallraf-Richartz-Museum & Fondation Corboud,
Cologne

in meadows that are alive with poppies and white chamomile flowers. Living at Auvers gave Daubigny a respect for the local inhabitants and he evokes in his later oil paintings a sense of their connection to the landscape and the cycle of the seasons. One of his last and most atmospheric canvases *Moonrise at Auvers*, also known as *The Return of the Flock* of 1877 (fig. 31), shows a shepherd guiding his sheep across a mist-covered plain.

Daubigny only occasionally recorded the village itself. In 1872, for example, he painted *A Byway at Auvers-sur-Oise*, a view of the rue des Ruelles at Chaponval with its picturesque cottages (fig. 97).[23] By the end of the nineteenth century these *chaumières*, with their steep sloping roofs, were becoming increasingly rare. This was partly because thatched roofs were considered to be a fire hazard, but also due to changing agricultural practices, notably the replacement of sickles (used to cut and clean the straw for thatching) with more efficient, but less dexterous, scythes. These Auversois cottages would also fascinate Cézanne, Pissarro and Van Gogh and the composition of Daubigny's painting, with its focused view and lack of background and aerial perspective, was almost certainly an inspiration

to Cézanne, who moved to the village at the end of that year.

The 'Atelier d'Auvers'
Until his death in 1878 Daubigny continued to be an important and enduring point of reference for newcomers to the area. These included Camille Pissarro, who established himself at Pontoise in 1872 heralding a new phase in the development of the 'colony'. Pissarro invited Cézanne to join him there and photographs of the period show them together (fig. 87). He likewise invited several artists on the fringe of Impressionism, such as the Puerto Rican Francisco Oller (1833–1917).[24] Gachet also recorded that the Barbizon painter Charles Jacque (1813–1894) 'painted sheep in the second atelier', referring to Daubigny's additional property (originally a pig barn), next door to the Villa des Vallées, which he acquired and converted in 1870. Later, in 1890, Van Gogh would record Daubigny's third house opposite the station, acquired in 1875 (fig. 123).[25]

Among Daubigny's most ardent disciples in this second 'wave' was the Lyonnais painter and printmaker Charles Beauverie (1839–1924) who was introduced to Dr Gachet through printmaking

circles, and especially his associations with the print publisher Alfred Cadart.[26] His frequent visits to Auvers, from 1874 to 1878, coincided with the presence of Pissarro and Cézanne in the village, but it was Daubigny whose company and advice he sought and whose approach he emulated.

Daubigny also attracted a number of pupils, some on an official basis, such as Léonide Bourges (1838–1910), the daughter of one of his dealers;[27] others more informally, as was the case with his son Karl Daubigny (1846–1886). Neither Pissarro nor Cézanne had forgotten Daubigny's support during the 1860s,[28] and he undoubtedly exerted a strong influence on both artists. Certainly Cézanne visited Daubigny when he was living in Auvers and the older artist's undated view of *The Village of Auvers* (fig. 86), looking back across the river to the walled village, anticipates both Cézanne and Pissarro in the way the houses are huddled together and reduced to geometric blocks of colour (fig. 88).

Like Daubigny, Cézanne and Pissarro ignored any signs of encroaching modernity and focused on the more picturesque aspects of the village, particularly the distinctive traditional cottages.

Under the influence of Impressionism they lightened their palettes and – especially in Cézanne's case – developed a more analytical response to the landscape. Cézanne first visited the Auvers region in the summer of 1872 when he stayed at the Hôtel du Grand-Cerf in Saint-Ouen-l'Aumône with his mistress Hortense Fiquet and baby Paul. The aim of this first visit was to spend some time working out of doors with Pissarro, who had moved to Pontoise, the neighbouring town, in April that year.

In September 1872 Cézanne returned to the region with Armand Guillaumin and on this occasion visited Dr Paul Gachet who had recently bought a house in Auvers. It was probably Guillaumin (rather than Pissarro) who provided the introduction, since he had met Gachet that summer while visiting the village with his childhood friend, the novelist, restaurateur, pastry cook and collector Hyacinthe-Eugène Meunier, known as Eugène Murer (1841–1906).[29] On the other hand, Pissarro had known Gachet since late November or December 1871, when he had asked the doctor to attend to his infant son Manzana.[30]

Gachet had moved to the village at the beginning of 1872 in order to provide a healthier environment

for his wife and their two children. He spent three days a week in the country and the remaining four days in Paris, where he ran his medical practice. Murer visited Gachet on a regular basis and moved there permanently in 1881. He constructed a large, somewhat pretentious house, for himself and his sister Marie, which Gachet referred to as the 'Castel du Four'.[31]

Both Gachet and Murer were important early collectors of Impressionist art and their presence at Auvers goes some way to explaining the continuing attraction of the village for Pissarro, Cézanne, Guillaumin and later Gauguin and Renoir. Pissarro was initially more closely linked to Murer, whose most active period of collecting Impressionist paintings was between 1877 and 1879, when Cézanne was no longer living in the village. Murer commissioned Pissarro to paint his portrait in 1878 (Museum of Fine Arts, Springfield, MA) and, around the same date, both he and Renoir decorated Murer's Paris apartment at 95 boulevard Voltaire. By 1887 Murer's collection included as many as 122 works by the Impressionists, among which were fifteen of Renoir's best works. He described Renoir as 'the greatest artist of our

89
VINCENT VAN GOGH
Farms near Auvers, 1890
Oil on canvas, 50.2 × 100.3 cm
Tate, London, bequeathed by C. Frank Stoop 1933

90
PAUL CÉZANNE
House of the Hanged Man, Auvers, 1873
Oil on canvas, 55.5 × 66.3 cm
Musée d'Orsay, Paris

century'[32] and it is possible that he showed Renoir's 1877 *Portrait of Murer* (Metropolitan Museum of Art, New York) to Van Gogh, inspiring him to adopt the same pose for his first *Portrait of Dr Gachet,* 1890 (private collection).[33] Renoir evidently visited Murer in Auvers, but the few works that he produced in this area date from a later period, around 1901.

Whereas Murer's closest ties were with Guillaumin, Renoir and Pissarro, Gachet exercised most influence on Van Gogh and was the first collector to acquire a work by Cézanne. (The two had an immediate connection, since the doctor was acquainted with Cézanne's father, a possible explanation for the doctor's early support of the Provençal artist.)[34] He also encouraged Cézanne, Pissarro and Guillaumin, and his distinctive white house, which features in as many as six works by Cézanne, provided a congenial meeting place for the three friends.[35] Gachet not only allowed them the run of his studio on the top floor, but also encouraged them to develop their printmaking skills.

Both Pissarro and Guillaumin, already skilled printmakers, took a particular interest in etching during this early period at Auvers. Daubigny's printmaking activity must have been an incentive, but Gachet's own enthusiasm and associations with Cadart were surely a contributing factor.[36] Cadart had published Daubigny's *Voyage en bateau* in 1862 and played a major role in the etching revival in France.

The four printmakers from the 'Auvers studio' marked their copper plates with an identifying emblem: Guillaumin's was a cat, Pissarro's a flower and Gachet's a duck, while Cézanne signed a portrait of Guillaumin with a hanged man.[37] Although Guillaumin produced only one or two landscapes of the area around Auvers, he thrived in Pissarro's and Cézanne's company and as part of a veritable 'colony' of artists. He was also introduced by Gachet to Richard Lesclide, who in 1873 published some of his etched vignettes in the magazine *Paris à l'eau forte*.[38]

Cézanne tried his hand at printmaking for the first and only time at Auvers, producing a handful of slightly clumsy works. These included a small landscape, *Landscape at Auvers-sur-Oise, Farm Entrance* 1873, made after a painting now in a private collection in Texas.[39] The etching shows Cézanne's fundamental interest in structure: a tree on the left lends a diagonal movement to the composition, which is otherwise concerned with the intersecting roofs and gable ends of a collection of small cottages. Indeed, the etching process may have taught Cézanne the potential for dividing a composition up into discrete elements.

Of the four artists it was probably Cézanne who benefited most from this period of collaboration. The early years at Auvers, and the opportunity to work side by side with Pissarro, marked a turning point in Cézanne's development as an artist. As Coutagne has observed, it forced him out of the studio and into the open air.[40] Under Pissarro's influence he brightened his palette and developed a lighter touch, applying the paint more sparingly than in his previous typically Provençal manner.[41] Dr Gachet noted that Cézanne's method was far from impressionist 'instantaneity'. He strove to get the right effect and, like Monet, often worked on the same motif at different times of day. According to Gachet he 'came [back] to the motif twice a day, in the morning and in the evening, in grey weather and in clear'. However, he often laboured to get the right effect and 'it so happened that he frequently slaved away at a painting from one season to another, from one year to another, so that in the end the spring of 1873 became the effect of snow, 1874'.[42]

The paintings that Cézanne produced during his first stay in Auvers are now considered to be the key works of his Impressionist period, created when he was living in the village at 66 rue Rémy. In works such as *House of the Hanged Man, Auvers* (fig. 90) Cézanne lightened his palette and developed a more divided brushstroke, even though he continued to build up the paint in thick layers of impasto. Meanwhile, Pissarro, in response to Cézanne, became more aware of the structure of his compositions and the underlying architecture of the landscape, reducing buildings to their basic components. This was a tendency that he had already observed in Daubigny's paintings of Auvers and which manifests itself in some of his earliest works of the area, such as *L'Hermitage near Pontoise*, 1867 (fig. 88).

Pissarro, in his paintings of Louveciennes and Pontoise, invariably uses a feature such as a pathway or village street to guide us into the composition. Cézanne adopts a similar pictorial device in works such as *The Old Road to Auvers-sur-Oise* (Musée d'Orsay, Paris) and *House of Doctor Gachet at Auvers* (fig. 91). However, in both works the road appears to dissolve as it curves round, merging with trees, buildings and other abstract shapes. Cézanne often set up his easel at a point in the road where several buildings converged, blocking the way forward and flattening the picture space. An example is *Crossroads at the Rue Rémy, Auvers* (fig. 93), painted around 1872: the buildings huddle together creating an *impasse* in the centre of the composition. Windowless gable ends and neglected façades overgrown with vegetation obstruct our path. Even the view beyond is blocked by the slopes of the distant hillside. Similarly,

in *House of the Hanged Man, Auvers*, the twisting
downward path is steep and rocky and there is no
clear route through the tangle of houses.

These works by Cézanne anticipate the organic,
expressive quality of Van Gogh's later views of
Auvers, where the thatches appear to merge with the
landscape or melt into the road (fig. 89). Cézanne's
views of Auvers, like many of Van Gogh's are
completely silent; but Van Gogh, like Pissarro, would
occasionally include one or two 'rustic figures', just as
Daubigny did in prints such as *Herd of Cows* or *Path
through the Wheatfield*. Pissarro's views of Auvers
are invariably animated by the local inhabitants. *Rue
Rémy, Auvers* of 1873 (fig. 92), for example, shows
a road lined with cottages disappearing into the
distance. The villagers are going about their everyday
activities: a woman overlooks a child sweeping the
path with her broom; a man, balanced on a ladder, is
trimming ivy, observed by two passers by.

Early in 1874 Cézanne left Auvers and moved
back to Paris, renting accommodation at 120 rue
de Vaugirard. Thereafter he paid more sporadic
visits to the area, either to see Gachet or Pissarro.
He visited Gachet again in November 1874, when
he may have painted the panoramic view of Auvers
now in the Art Institute of Chicago (fig. 95). While
he was resident in the village he had recorded the
narrow streets and picturesque cottages, but now
that he was a less frequent visitor he adopted a more
distant view, taking in the entire panorama, including
the surrounding fields and the houses reduced to
geometric coloured shapes.

Pissarro, meanwhile, remained at Pontoise and
painted more and more frequently in the countryside
around Valhermeil, a small hamlet to the west of
Auvers. In 1878, the year of Daubigny's death,

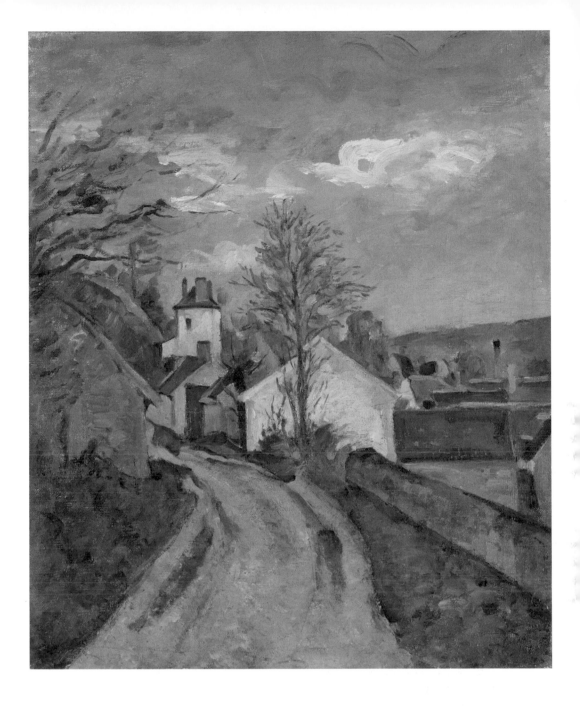

91
PAUL CÉZANNE
House of Doctor Gachet at Auvers, c. 1873
Oil on canvas, 46 × 38 cm
Musée d'Orsay, Paris

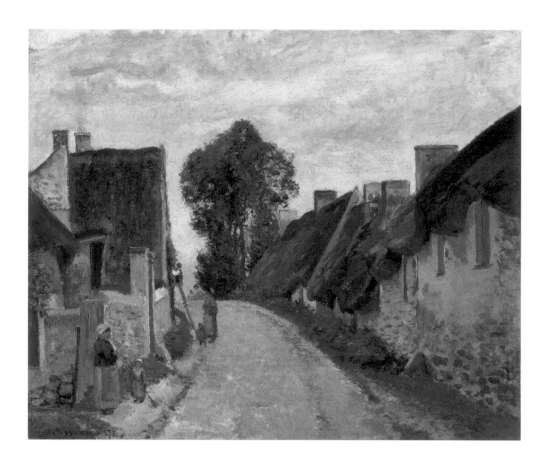

he produced *Banks of the Oise at Auvers* (private collection), possibly painted with the older artist in mind.[43] The diagonal viewpoint, looking across to a village on the opposite bank, is certainly reminiscent of Daubigny, and, like his predecessor, Pissarro includes signs of activity: a child paddling in the foreground, a woman with her cow, which refreshes itself at the water's edge, and a distant barge or fishing boat. He also shows the influence of Cézanne in the way that he frames the view with the overhanging mantle of leaves from the tree on the left. This has the effect of uniting background and foreground, thus flattening the perspective.

Cézanne returned to the area for a longer period in 1881 and spent the following summer with Pissarro at Pontoise. The two men were joined on this occasion by Guillaumin and, for the first time, Paul Gauguin. The four artists worked together in the undulating landscape at Le Chou, where Morisot had stayed nearly twenty years earlier. Gauguin produced three views of the Chou quarries, employing a light palette and short, repeated brushstrokes.[44] The absence of any figures in these landscapes belies the convivial atmosphere of these expeditions. A very

different tone is set by the young Manzana Pissarro's drawing *Impressionists' Picnic* (fig. 94), set in the same location.

Pissarro's *Les Coteaux de Chou* or *Path and Slopes Auvers* (private collection, Mequon, Wisconsin) and Cézanne's *Houses near Valhermeil, Looking towards Auvers-sur-Oise* (private collection, Japan) are set in the same location, but facing in a different direction. They each recorded the same view, but whereas Pissarro applied the pigment with small, fragmented brushstrokes, giving a sense of penetrating light, air and movement, Cézanne's slightly larger canvas is more solid and constructed, and the landscape built up in discrete 'patches'.

In 1882 Pissarro moved to Osny and by 1884 had settled in Eragny, effectively curtailing Cézanne's visits to Pontoise and Auvers. Nevertheless the village continued to attract newcomers and around 1885 the Bostonian artist Charles Sprague Pearce (1851–1914) settled there.[45] Pearce was a great admirer of Daubigny and his contemporaries and it was almost certainly the artist's association with the Oise valley that initially attracted him to the area. Moreover, the village and its environs still provided

the perfect unspoiled environment for *plein-air* painting. Pearce was inspired less by Impressionism than by the Salon naturalism of artists such as Jules Breton and Jean-Charles Cazin, which was also very much in vogue among the American colony at Giverny. He was especially influenced by the figure paintings of Jules Bastien-Lepage, who died at the height of his success in 1884. In the second half of the 1880s Pearce produced a series of naturalistic but highly commercial paintings of (mainly female) peasants, often with sentimental titles such as *Troubles of the Heart* (private collection), his submission to the Salon of 1885.

The market for such works was at its height in the 1880s, giving artists further incentive to travel to Auvers. Indeed, in August 1887 the writer Paul Alexis published a brief notice in *Le Cri du Peuple*, in which he described Auvers as a vibrant 'colonie artistique', a close community of artists, including printmakers in Gachet's circle such as Martinez and Paul-Adolphe Rajon (1842–1888), the sculptor Précaut and the painter Fany Louise Lecomte Daniel (1856–1894).[46] Alexis also highlighted Murer's and Gachet's collections of Impressionist pictures.

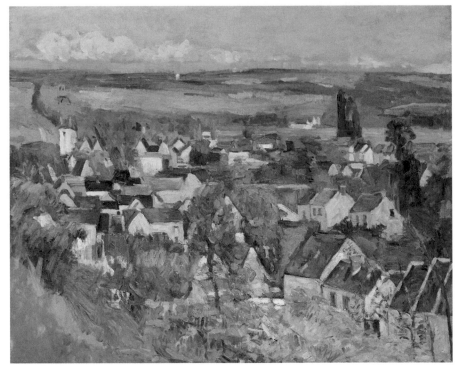

92

CAMILLE PISSARRO

Rue Rémy, Auvers, 1873
Oil on canvas, 54.6 × 65.4 cm
Private collection

93

PAUL CÉZANNE

Crossroads at the Rue Rémy, Auvers, c. 1872
Oil on canvas, 38 × 45.5 cm
Musée d'Orsay, Paris

94

**GEORGES HENRI PISSARRO,
KNOWN AS GEORGES MANZANA PISSARRO**

Impressionists' Picnic (featuring Guillaumin,
Pissarro, Gauguin, Cézanne, Madame Cézanne
and Manzana-Pissarro), c. 1881
Pen and ink on paper, 20.5 × 26.2 cm
Lionel and Sandrine Pissarro Collection

95

PAUL CÉZANNE

Auvers, Panoramic View, c. 1873–5
Oil on canvas, 65.2 × 81.3 cm
The Art Institute of Chicago, Mr and Mrs Lewis
Larned Coburn Memorial Collection, 1933.422

It was Gachet's enduring presence at Auvers that supported the colony, but it was Van Gogh who guaranteed its continuity as an artistic site. Like many artists before him, Van Gogh was attracted to Auvers because it was unspoiled, a tranquil haven from the modern world. Yet by the time he moved there in 1890 modern houses were replacing the traditional cottages and a new railway station had been built at Chaponval. Indeed, Alexis had grumbled that the village was 'un peu gros bourg': a sprawling town and far less rustic than he had expected.[47] Van Gogh described the area to his brother Theo as 'changed since Daubigny. But not changed in an unpleasant way … no factories, but beautiful greenery in abundance.'[48] Like Daubigny he was taken by the 'many old thatched roofs', which, he noted, 'are becoming rare'.[49]

As Nienke Bakker will discuss in more detail in the next chapter, the motifs that Van Gogh recorded – the wheatfields and thatched cottages (fig. 89) – were those of the artists that had preceded him, and it is this continuity of subject that characterises and unifies the colony at Auvers. While one might have expected Pissarro and Cézanne, as key members of

the Impressionist group, to focus on modern motifs such as the local stone quarry, the railway station and the modern villas that were popping up in the region, they preferred the beauty of the 'unspoiled' Auvers and its surrounding countryside. Like Daubigny and Van Gogh, they edited out any signs of change and were more interested in finding a new way of painting traditional motifs – whether through achieving a particular effect of light, or through the expressive use of colour – than recording the encroachment of modern life. Potentially their move towards the picturesque reflected a desire to paint for the market, but it was also evidence of a more profound artistic impulse to paint in front of nature, an impulse that was shared by Daubigny, the colony's originator, as much as by Van Gogh.

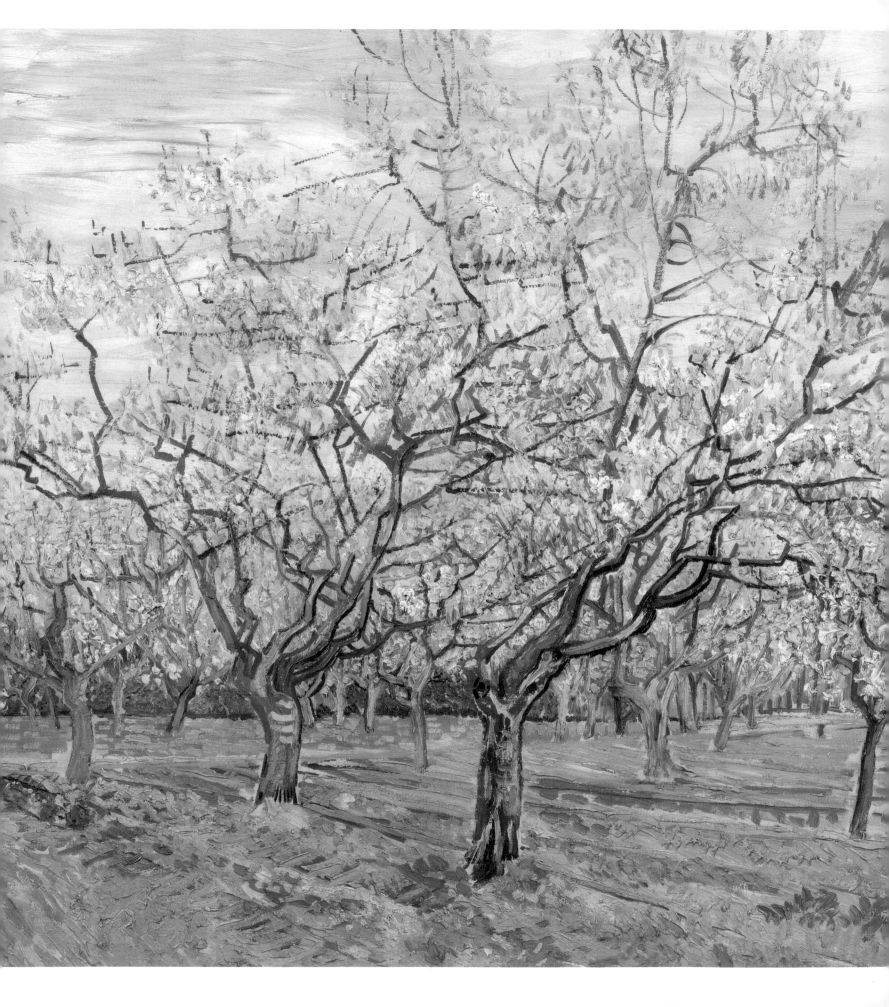

CHAPTER 6

In Daubigny's Footsteps: Vincent van Gogh

Nienke Bakker

In March 1878, when Van Gogh heard that Daubigny had died, he wrote: 'it must be truly good, when one dies, to be conscious of having done a thing or two in truth, knowing that as a result one will continue to live in the memory of at least a few, and having left a good example to those who follow. … if others appear later, they can do no better than to follow in the footsteps of such predecessors and to do it the same way.'[1] Van Gogh could not have imagined that he himself would follow in Daubigny's footsteps. At that time he still wanted to be a minister, but once he had made up his mind to become an artist Daubigny was one of his exemplars. His admiration for the French landscape painter never wavered in the ten years of his artistic career and was heightened at the end of his life when he found himself in Auvers-sur-Oise, where Daubigny had lived.

The seeds of Van Gogh's love of Daubigny's landscapes were planted in the years he spent working in the art trade as a young man. When he was sixteen he started at the Hague branch of the international art gallery Goupil & Cie, where his uncle Vincent van Gogh, who was a partner in the business, had secured him a position as junior clerk. Four years later Vincent's younger brother Theo also joined the firm. Their first impressions of the art world were acquired from this 'Uncle Cent', who had a large collection of contemporary art, and from another uncle, Cor van Gogh, who owned a book and print shop in Amsterdam.[2]

Vincent worked for different Goupil branches from 1869 to 1876: four years in The Hague, almost three in London and just over twelve months in Paris. Goupil sold the work of established artists and published reproductive prints of Old Masters and contemporary painters, so Van Gogh was exposed to a huge range of artworks and developed a good eye. His early inclinations, we can infer from his letters, largely reflected the prevailing taste: seventeenth-century Dutch paintings, realism, the Barbizon School and the Hague School. Daubigny, one of the most popular and successful artists of the age, consequently featured on the list of fifty-nine names of artists 'whom I like very much indeed' that Van Gogh compiled in a letter he wrote from London in 1874.[3] Goupil frequently sold works by Daubigny, so Van Gogh saw a great many of his paintings.[4] In Paris, where he went to work the following year, he often visited the Musée du Luxembourg, where Daubigny's *Spring* (fig. 73) was one of the works that made an impression on him.[5] As soon as he began his job at Goupil's, Van Gogh started to collect reproductions: photographs,

DETAIL fig. 106
VINCENT VAN GOGH
The White Orchard, 1888

LE BUISSON.

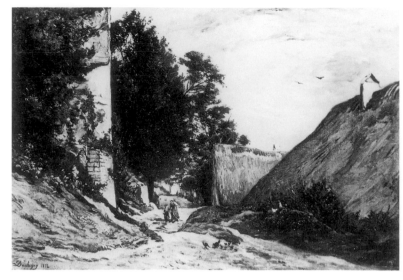

photogravures and prints of works by Old Masters and contemporary artists. He had Daubigny's etching *Dawn, Cock Crowing* hanging in his room in Paris. In the scrapbook he put together during this period there are two reproductions of landscapes by Daubigny.[6] In 1875 he had Daubigny's etching after Ruisdael's *The Bush* (fig. 96) on the wall of his room and when, five years later, as an aspiring artist in the Borinage, he was trying to get to grips with drawing, he asked Theo to send him an impression of this 'masterly etching' to copy, along with prints by Jean-François Millet and Théodore Rousseau.[7]

In the early years of Van Gogh's artistic career, concepts like 'truth', 'feeling' and 'sentiment' were central to his appreciation of art; later he paid more attention to technique and the use of colour.[8] Daubigny – whom he often mentioned in the same breath as Camille Corot, Millet or Rousseau – was one of the painters he admired for the way they could capture on canvas the poetic emotions that the landscape evoked. Van Gogh grew up in rural Brabant, in a small village surrounded by heathland, woods and marshes, and for the whole of his life retained a great love of nature and a nostalgic

longing for the countryside, where 'everything … speaks more clearly, everything holds firm, everything explains itself'.[9] Daubigny's paintings, which conveyed an image of idyllic country life, appealed to these feelings.

Entirely in line with Dutch art criticism of the period, Van Gogh regarded Daubigny, Rousseau, Corot and the other Barbizon artists as the pioneers of modern landscape painting and the successors to seventeenth-century Dutch masters like Jan van Goyen (1596–1656), Philips de Koninck (1619–1688) and Jacob van Ruisdael (1628/9–1682). The painters of the Hague School – the predominant movement in the Netherlands at that time, with leading lights like Anton Mauve (1838–1888) and the Maris brothers – were influenced in turn by the Barbizon painters and through them, but also directly, by the landscape painters of the Dutch Golden Age. It was natural for Van Gogh to take the Barbizon artists as his models when he began to paint landscapes after two years of doing virtually nothing but draw. He had meanwhile moved to The Hague, where he went to see an exhibition of French art in the summer of 1882 with works by Daubigny, Gustave Courbet, Rousseau,

96
CHARLES FRANÇOIS DAUBIGNY
The Bush (after Jacob van Ruisdael), 1855
Burin etching, 43.3 × 48.2 cm
Musée du Louvre, Paris

97
CHARLES FRANÇOIS DAUBIGNY
A Road in Auvers, 1872
Oil on canvas, 65 × 94 cm
Location unknown

98
VINCENT VAN GOGH
Landscape with Leaning Trees, 1883
Oil on paper on canvas, 32 × 50 cm
Private collection

99
VINCENT VAN GOGH
Twilight (*Old Farmhouses in Loosduinen, near The Hague*), 1883
Oil on paper on panel, 33 × 50 cm
Centraal Museum, Utrecht, loan Stichting van Baaren 1980

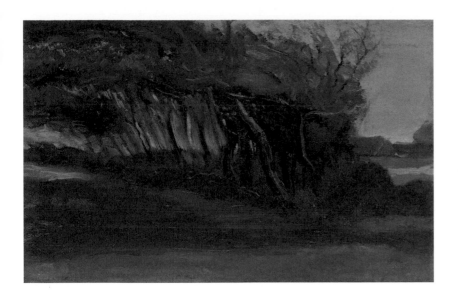

Jules Dupré, Jules Breton and others. It fanned the flames of his enthusiasm for the landscape and he came to realise that 'those first modern masters' had died or were very old, and needed successors: 'All the more reason to get on with things vigorously and not to slacken.'[10] There were five of Daubigny's paintings in the exhibition, among them one of 'big thatched roofs against the slope of a hill, that I couldn't get enough of'.[11] This was *A Road at Auvers* (fig. 97), depicting the thatched cottages that he would later paint for himself in Auvers. It was undoubtedly these characteristic houses that reminded him of Brabant, his birthplace, which particularly attracted him to this work.[12] Seeing Daubigny's painting and Dupré's *Evening* (The Mesdag Collection, The Hague) hanging in the same exhibition – the latter featuring dark cottages against a blue and pink sky – may have prompted him to paint this sort of subject himself.

Van Gogh looked on sadly as tourism and industry increasingly made their mark on the landscape, and sought places that still had 'their true character'. During a walk in the summer of 1883 he was profoundly struck by the countryside in a deserted area of the dunes on the outskirts of The Hague.

He associated the place with Ruisdael's *The Bush* – which expressed for him 'that moment and that place in nature where one can go alone, without company'[13] – with Georges Michel's (1763–1843) landscapes, and above all with those by Daubigny. 'That walk alone at a remote spot in the dunes made me much calmer because of a feeling that one hadn't been alone but had talked to one of the old figures from the time of the beginning, Daubigny.'[14] A few weeks later he returned to this area 'where everything was Ruisdael, Daubigny or Jules Dupré' and painted a landscape with windswept trees (fig. 98) and a view of farmhouses in the meadow (fig. 99).[15] Soon after this the need to escape from the pressure of the city to rural surroundings where he could penetrate deeper into nature drove him to Drenthe, a remote northern province with heathland and peat moors, where he painted landscapes and cottages in a tonal palette. In this setting, the Barbizon painters and the old Dutch masters took even stronger possession of his mind. He described the banks of the canals as 'miles and miles of Michels or T. Rousseaus, say, Van Goyens or P. de Koninck', roots in a muddy pool were 'absolutely melancholy and dramatic, just like Ruisdael, just

like Jules Dupré', and the heath as the sun set was exactly like a Daubigny.[16]

In the years that followed Daubigny remained a beacon for him, as one of 'the great forerunners' whose paintings were 'beyond the paint' (in Dutch: 'buiten de verf') – a popular expression at the time which signified that the material served solely as a vehicle for conveying feelings, and one which Van Gogh used in direct opposition to the soulless technical contrivance of the academic artists he detested.[17] With passion he declared himself to be a romantic colourist who placed poetic imagination above realism: 'Delacroix, Millet, Corot, Dupré, Daubigny, Breton, 30 more names, do they not form the heart of this century where art is concerned, and all of them, do they not have *their roots* in romanticism, *even if they surpassed romanticism*? Romance and romanticism are our era, and one must have imagination, sentiment in painting.'[18] He continued to cling to the essence of this view, even when he encountered Impressionism and Japanese printmaking in Paris in the years 1886 to 1888 and his painting style and palette underwent a transformation that was as swift as it was radical.

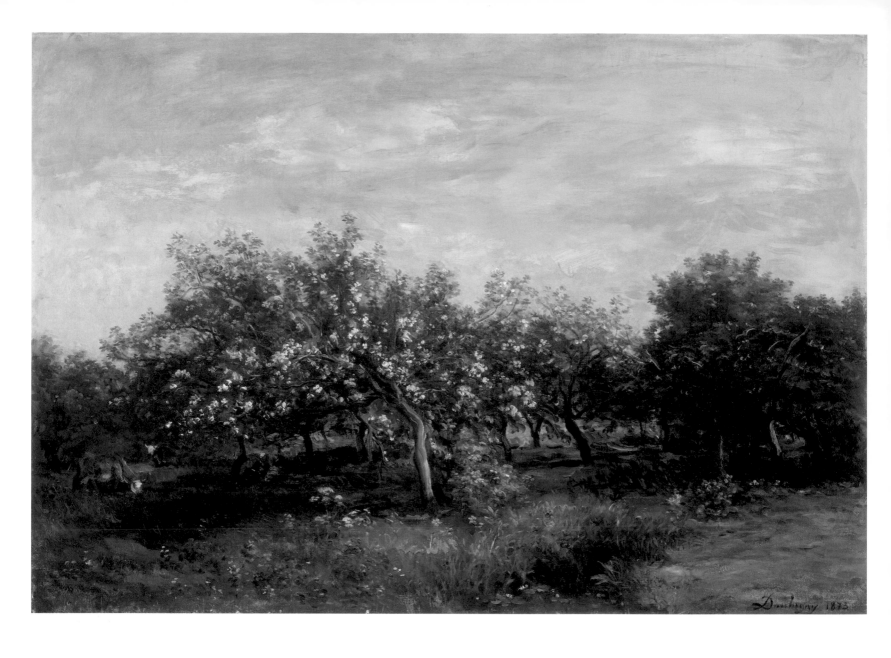

100

CHARLES FRANÇOIS DAUBIGNY
Apple Blossoms, 1873
Oil on canvas, 58.7 × 84.8 cm
The Metropolitan Museum of Art, New York,
bequest of Collis P. Huntington, 1900, 25.110.3

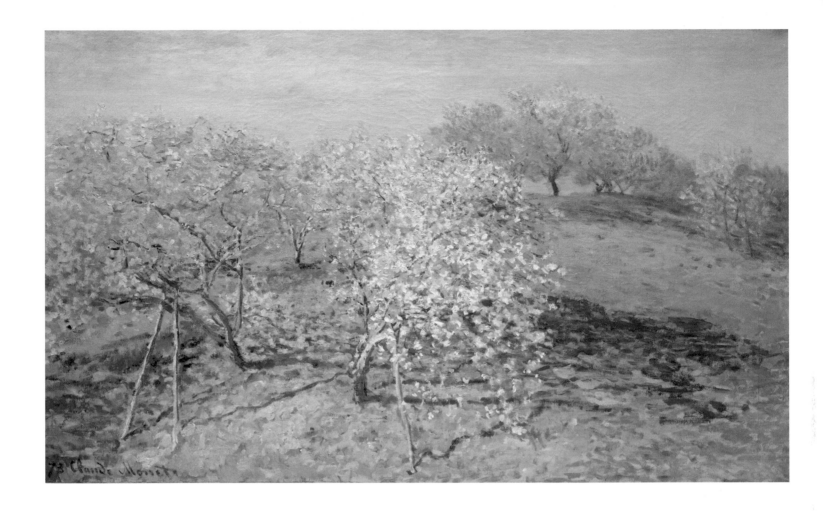

101

CLAUDE MONET

Spring (Fruit Trees in Bloom), 1873
Oil on canvas, 62.2 × 100.6 cm
The Metropolitan Museum of Art, New York, bequest
of Mary Livingstone Willard, 1926, 26.186.1

His style and technique were unmistakably influenced by modern French painting, yet, after his move to Provence, Van Gogh found that he was increasingly returning 'to my ideas that came to me in the country before I knew the Impressionists'.[19] Here he was referring to Delacroix, whose ideas about colour would remain guiding principles for him, and the Barbizon painters, with their timeless images of rural life and man's connection to nature. He wrote to his sister, 'I hope that you'll often go and look at the Luxembourg and the modern paintings in the Louvre so that you get an idea of what a Millet, a Jules Breton, a Daubigny, a Corot is. You can keep the rest. Except – Delacroix.'[20]

Daubigny's *Spring* (fig. 73), one of Van Gogh's old favourites, hung in the Musée du Luxembourg, where it had been joined in 1878 by *The Grape Harvest in the Bourgogne* (fig. 102), an autumn scene of women picking grapes in a vineyard.[21] The cycle of the seasons and rural labour were themes that

had always interested Van Gogh. In Provence he painted, one after another, the orchards in blossom, the wheatfields and the vineyards as symbols of the seasons. Not long after he arrived in Arles at the end of February 1888 the fruit trees began to blossom, and he made a series of paintings of them – cheery, colourful impressions of spring that he hoped to exhibit and sell. He was aware that the subject was not new, 'but when I think that many painters will do the same I reckon it by no means immaterial to work in nature which, although it's the same as at home [in the Netherlands] in subject and fact, is undoubtedly much richer and more colourful.'[22] The scenery of the south had to be painted in heightened colours, after the example of brightly coloured Japanese prints. Van Gogh associated Provence with the Japan he knew from the prints, in which blossoming trees were a common feature, symbolising spring and new life.[23] Other important sources of inspiration were the orchards in flower that Daubigny and Millet had

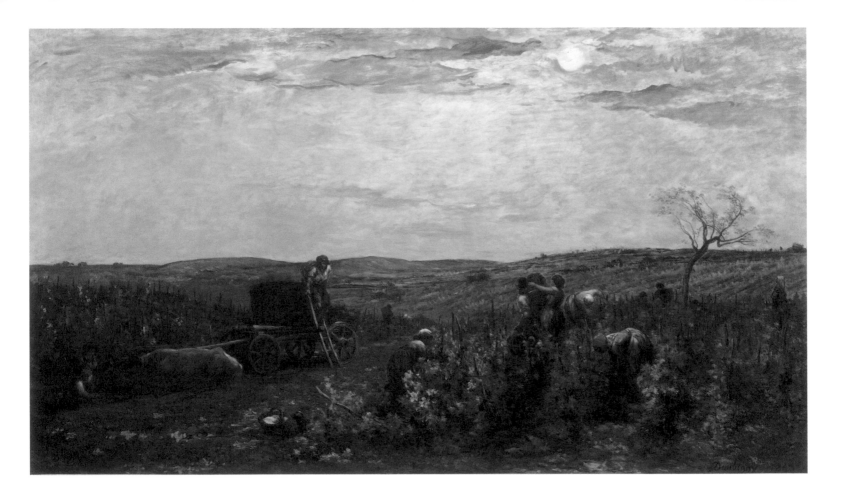

painted as signifiers of spring: Millet's *Spring* in the Louvre and Daubigny's Salon picture of the same title in the Musée du Luxembourg.[24] In his time at Goupil's Van Gogh may well have seen other orchards by Daubigny; it was a subject the artist often painted in that period and one with which he was extremely successful. Van Gogh knew that in choosing this subject he was joining a tradition that Daubigny had started, as we learn from a later letter in which he wrote that artists would discover the olive tree just 'as they have painted the Norman apple tree since Daubigny and César de Cock'.[25]

Daubigny had painted orchards in blossom almost every spring since 1857 and was regarded as the first to have pictured the subject.[26] Following in his footsteps Monet and Pissarro had painted fruit trees in bloom in the 1870s. Daubigny's late orchards, such as *Apple Blossoms*, 1873 and the large *Orchard in Blossom*, 1874, echo the bright palette and loose brushstroke of the Impressionists (figs 100 & 103). With their rather traditional compositions and

anecdotal details (a grazing cow, figures sitting on the grass) Daubigny's orchard pictures might appear to be generic representations of spring, but he shared the younger generation's interest in capturing the impression of the moment and he included many indications of locale, weather and time of day. However, a comparison of Monet's *Spring (Fruit Trees in Bloom)* (fig. 101) with Daubigny's *Apple Blossoms* of the same date reveals that he was less daring than the Impressionists in his brushwork, approach to composition and use of light. Monet rendered the blossom with swift, loose brushstrokes in delicate pastel shades and chose a high vantage point to show the shadows cast by the trees and evoke the sense of a bright, sunny day in early spring.

In his paintings of blossoming trees Van Gogh employed 'no system of brushwork at all; I hit the canvas with irregular strokes which I leave as they are, impastos, uncovered spots of canvas – corners here and there left inevitably unfinished – reworkings, roughnesses; well, I'm inclined to think that the result

102
CHARLES FRANÇOIS DAUBIGNY
The Grape Harvest in the Bourgogne, 1863
Oil on canvas, 169 × 296 cm
Musée d'Orsay, Paris

103
CHARLES FRANÇOIS DAUBIGNY
Orchard in Blossom, 1874
Oil on canvas, 85 × 157 cm
Scottish National Gallery, Edinburgh

is sufficiently worrying and annoying not to please people with preconceived ideas about technique.'[27] Some of these paintings are still dominated by the Impressionist style that characterises his Paris work (fig. 105); others show a new approach with an emphasis on outlines and solid planes of colour that owes a debt to the Japanese prints. *The White Orchard* (fig. 106), which Van Gogh himself regarded as one of the most successful paintings in the series, is a combination of the two. To catch the constantly changing effect of the sunlight and the blossom moving in the wind he used countless tiny pastose brushstrokes for the flowers, applying them to a broadly brushed sky. At the end he accentuated the branches here and there with red and dark blue lines, touches that create a Japanese feel. In the *Orchard in Blossom* (fig. 104) that he painted a year later, he again outlined the tree trunks – this time with a purplish blue. While the blossom is painted in thick impasto, the ground and the sky are built up with parallel brushstrokes. It is typical

of the idiosyncratic, expressive style that Van Gogh developed after absorbing all sorts of influences in Paris. As he himself put it: 'I'm beginning more and more to look for a simple technique that perhaps isn't Impressionist. I'd like to paint in such a way that if it comes to it, everyone who has eyes could understand it.'[28]

In May 1890, after two years in Provence, one of them spent in the asylum at Saint-Rémy, Van Gogh returned to the north – to Auvers-sur-Oise. Living among the mentally ill was becoming increasingly oppressive and he wanted to be closer to his brother, so Theo had looked for a quiet spot where Vincent could work under the supervision of a doctor. Camille Pissarro told Theo about Paul Gachet, a doctor in Auvers who was a friend of the Impressionists and painted in his spare time, and once Theo had spoken to Gachet the matter was soon settled. Although Van Gogh said farewell to Provence with a heavy heart, he was looking forward to making studies of peasants and landscapes in the north. His illness had left

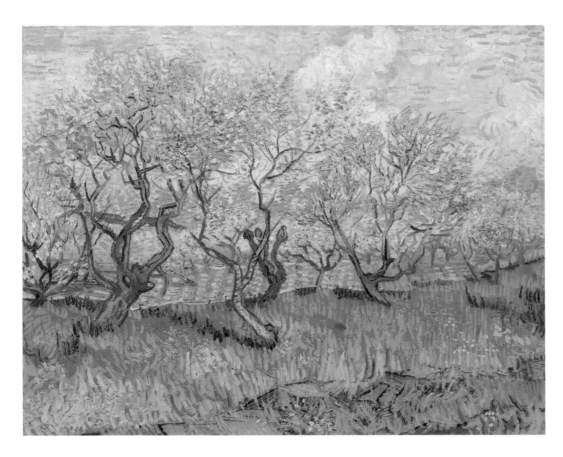

104
VINCENT VAN GOGH
Orchard in Blossom, 1889
Oil on canvas, 73.2 × 93.1 cm
Van Gogh Museum, Amsterdam
(Vincent van Gogh Foundation)

105
VINCENT VAN GOGH
Orchard in Blossom (Plum Trees), 1888
Oil on canvas, 54 × 65.2 cm
Scottish National Gallery, Edinburgh

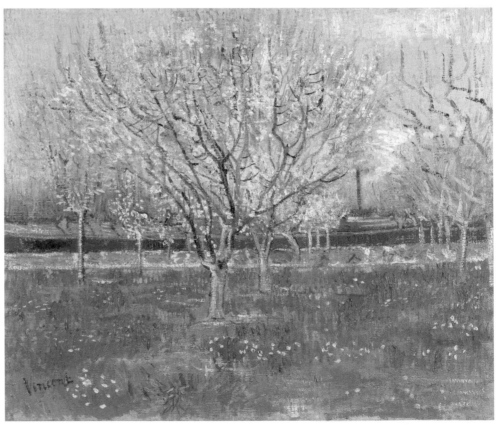

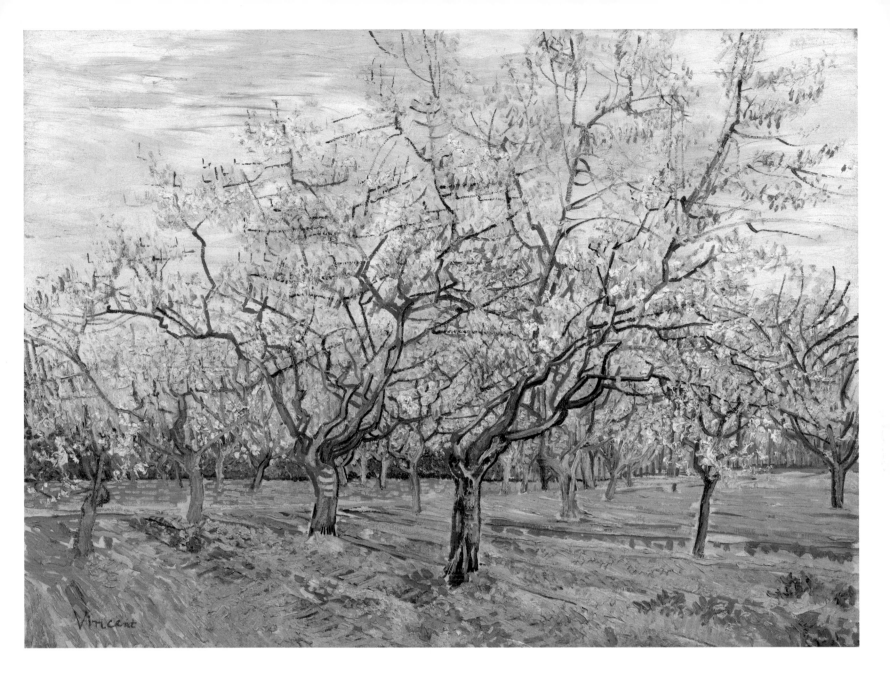

106

VINCENT VAN GOGH
The White Orchard, 1888
Oil on canvas, 60 × 81 cm
Van Gogh Museum, Amsterdam
(Vincent van Gogh Foundation)

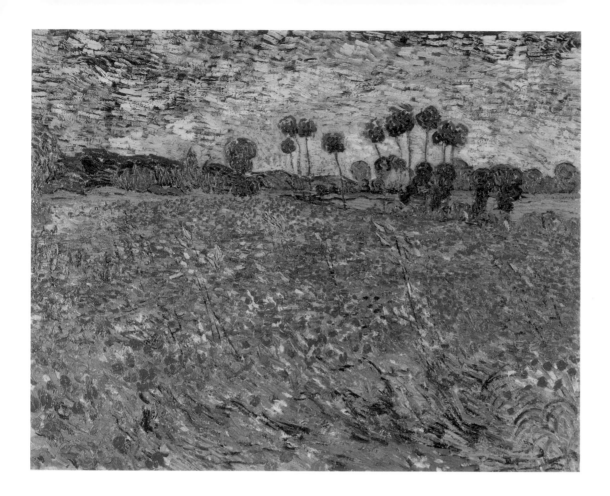

him with no confidence in the future and, doubting the value of his own work and the staying power of the modern trend, he again sought inspiration from the older generation. During this period he painted copies of prints after paintings by Millet and Eugène Delacroix, but Daubigny was in his thoughts, too. What he admired so much about him emerges in a letter to Theo, in which he described the landscape he could see from his window as a painting by Daubigny or Rousseau 'with the expression of all the intimacy and all the great peace and majesty that it [the landscape] has, adding to it a feeling so heart-breaking, so personal. These emotions I do not detest.'[29]

When he arrived in Auvers on 20 May 1890 Van Gogh was probably not aware that some of his favourite artists – Corot, Daubigny, Honoré Daumier – had been there before him.[30] The very first day he was there he saw the paintings by Pissarro, Armand Guillaumin and Paul Cézanne at Dr Gachet's and heard the latter's stories about 'the days of the old

painters', and it must have delighted him to learn that he had come to the village where Daubigny had lived and painted so many landscapes.[31] Van Gogh found Auvers 'really … gravely beautiful, it's the heart of the countryside, distinctive and picturesque'. The modern villas and country houses were 'almost as pretty as the old thatched cottages that are falling into ruin'.[32] The day after he got there he made his first painting of the thatched roofs (State Hermitage Museum, St Petersburg), a motif he would capture many more times, the very subject he had admired in Daubigny's painting at the exhibition in The Hague. Auvers had certainly changed a good deal since Daubigny's time, he found, but not in a bad way: 'there's a lot of well-being in the air. I see or think I see a calm there à la Puvis de Chavannes, no factories, but beautiful greenery in abundance and in good order.'[33]

In short, Auvers was an ideal place for Van Gogh to work, something Gachet encouraged, advising him to work a great deal and boldly and not to think about his illness.[34] A period of unprecedented productivity

began: in the seventy days Van Gogh spent in Auvers he made more than seventy-five paintings, chiefly landscapes. Like Daubigny before him, he painted a field of poppies with powerful contrasts of green and red (fig. 107). Monet had also painted this summery subject, in 1873 (*Poppy Field*, Musée d'Orsay) and in 1881 (fig. 108). In his *Fields in the Month of June* (fig. 109) Daubigny had devoted great attention to the composition of the landscape, with the poppies in the foreground and centre ground, and figures at work, animals and haystacks dispersed across the picture plane. Monet was concerned solely with the effect of colour and light on the landscape, in this case the complementary contrast of red and green; he painted the flowers with swift brushstrokes, not defining them any further. In Van Gogh's painting, the field is a rolling sea of swirling green and red brushstrokes. The horizon is high, creating a bird's-eye view, but the foreground is tilted so that we appear at one and the same time to be looking down on the field from above and standing in the middle of it.

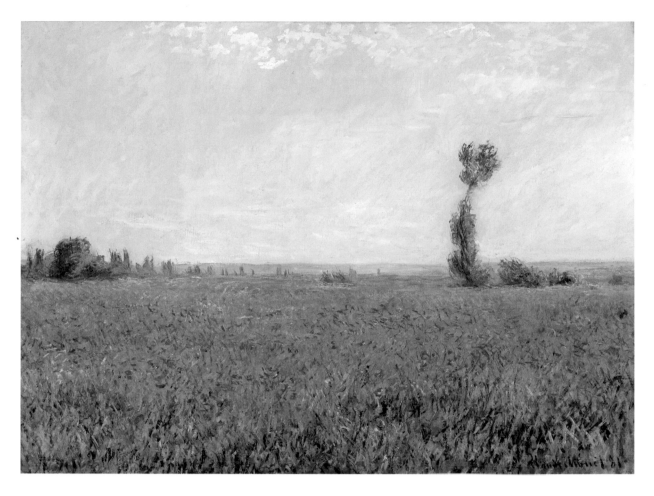

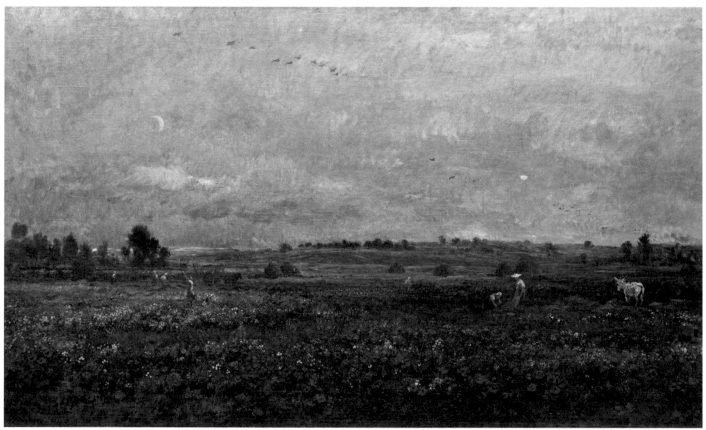

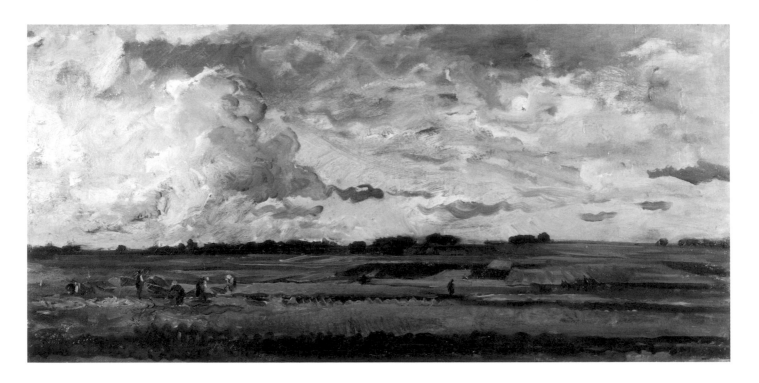

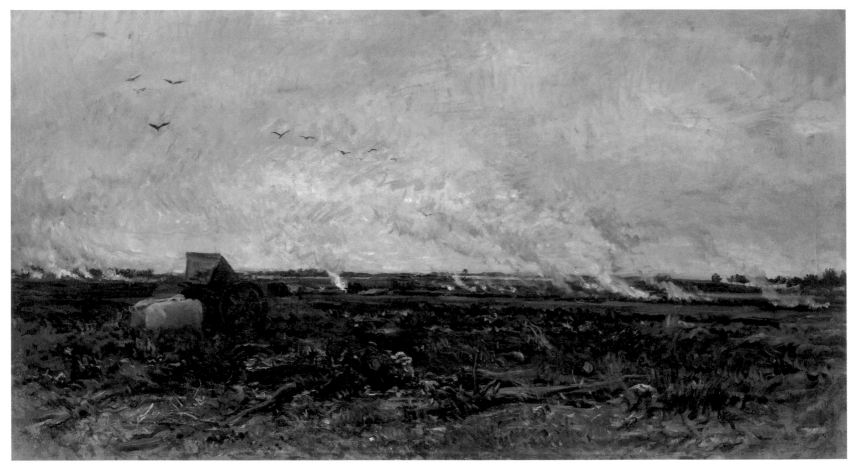

110
CHARLES FRANÇOIS DAUBIGNY
The Harvesters, undated
Oil on canvas, 43.5 × 89 cm
Museum Gouda

111
CHARLES FRANÇOIS DAUBIGNY
October, 1850–78
Oil on canvas, 87.5 × 160.5 cm
Rijksmuseum, Amsterdam, gift of
M.C., Baroness van Lynden-van Pallandt,
The Hague

112
VINCENT VAN GOGH
Wheatfield under Thunderclouds, 1890
Oil on canvas, 50.9 × 101.3 cm
Van Gogh Museum, Amsterdam
(Vincent van Gogh Foundation)

113 (pp. 118–19)
VINCENT VAN GOGH
Wheatfields near Auvers, 1890
Oil on canvas, 50 × 101 cm
Österreichische Galerie Belvedere, Vienna

When Van Gogh painted *Field with Poppies* he had almost run out of supplies and was waiting for an order of canvas and paint from Paris, which arrived three days later.[35] As soon as he received the roll of canvas he embarked on a series of landscapes in what was for him an unprecedented format of roughly 50 × 100 cm, the 'double square', for which he cut the canvas from the roll himself.[36] The result was twelve horizontal landscapes and an upright portrait of the same size (*Marguerite Gachet at the Piano*, Kunstmuseum Basel). These works are among the most expressive and intense paintings of this, his last period, and are regarded as a coherent series in which he pictured the countryside around Auvers.[37] His choice of the double-square format was inspired by Daubigny, who had a strong predilection for canvases that were twice as wide as they were high, ideal for picturing sweeping landscapes.[38] While the focus in Daubigny's early panoramic Salon works like *Spring* (1857) and *Banks of the Oise* (1859) was wholly on the landscape, in late paintings like *October* (fig. 111), *Fields in the Month of June* (fig. 109) and *The Harvesters* (fig. 110) the sky occupies more and more of the space, and it is there that Daubigny's

free, 'impressionistic' brushstroke comes to the fore. *The Harvesters* is a picture of the wheatfields near Auvers under a dramatic, broadly painted cloudy sky. Van Gogh recorded the same effect in *Wheatfield under Thunderclouds* (fig. 112), whose extremely sober composition of just a blue sky and an empty green expanse in a powerful, brutal painting style gives it huge expressive force. In these 'immense stretches of wheatfields under turbulent skies' he had tried to express 'sadness, extreme loneliness', but at the same time how 'healthy and fortifying' the countryside was.[39]

The wheatfields, which Van Gogh depicted many times during his stay in Auvers (figs 112–17), were the key motif of his panoramic landscapes. The striking perspective, in close-up or bird's-eye view, the patterns of the areas of colour and the rhythmic brushstrokes create a decorative effect, as shown in *Wheatfields near Auvers* (fig. 113). In *Rain – Auvers* (fig. 117) the layering of horizontal bands is interrupted by the rain, which lashes down in great streaks across the canvas, and in *Farms near Auvers* (fig. 89) the thatch-roofed houses are surrounded by a patchwork of fields stretching to the